First published as **Das Andere Amerika** by Neue Gesellschaft für Bildende Kunst (NGBK) and Elefanten Press, Berlin (West), 1983

This shortened edition published by the Journeyman Press, 1985

The Journeyman Press Ltd, 97 Ferme Park Road, Crouch End, London, N8 9SA and 17 Old Mill Road, West Nyack, NY 10994

©by Journeyman Press Ltd., 1985

0 904526 94 1 **paperback**

Printed in the Federal Republic of Germany
10 9 8 7 6 5 4 3 2 1

Das Andere Amerika
was originally published in connection with an exhibition of the same title, sponsored by NGBK and funded by the Deutsche Klassenlotterie Berlin. This 554 page catalogue, of which the 3rd edition was printed in 1984, contains more than 1,000 images.
It includes an illustrated history of the U.S. Labour movement by Philip S. Foner and Reinhard Schultz as well as essays by Tim Drescher/James Prigoff, Shifra Goldman, Patricia Hills, Naomi and Walter Rosenblum, Cecile and David Shapiro, and Fred Whitehead.

Editorial staff: Tom Fecht, Philip S. Foner, Matthias Reichelt, Reinhard Schultz

Layout: Jürgen Holtfreter
Archive: Paul Schreiner
U.S. coordinator: Bruce Kaiper

The Journeyman Press edition is a selection of parts of the original catalogue with a few changes and the addition of new images.
Except for the essays by Drescher/Prigoff, the Rosenblums, and the Shapiros, new texts have also been included.

Selections for the Journeyman Press edition were made by Reinhard Schultz.

Editorial staff: Matthias Reichelt, Reinhard Schultz with the assistance of Paul Schreiner

Typescript: Josefine Geier and Gisela Gnoss
Typesetting: Ute Erb
Layout: Jürgen Holtfreter
Printing and binding: Fuldaer Verlagsanstalt

Journeyman

Contents

Every effort has been made to ascertain the names of individual photographers deserving of credit in this book. In the absence of this information, credit has been given to the archive that provided the photograph except for those private collections which requested to remain anonymous.

Philip S. Foner / Reinhard Schultz

THE OTHER AMERICA

Art and the Labour Movement
in the United States

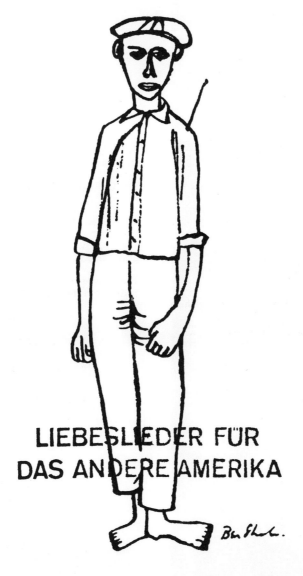

Ben Shahn. Love Songs for the other America, c. 1956
Poster, 40 x 78 cm
New Jersey State Museum, Trenton

JOURNEYMAN

Fred Whitehead
The Exhibition

Yes here at last is our Other America
I've had to come halfway around the world
to find my own culture brought to public view
the bitter irony of our present condition
testament to the obliterative qualities of capitalism
our people are so indifferent to their past
you have to go to another country to find it

The logs of slave ships on the middle passage
horror of the cotton fields and always the whip

Paul Revere and the other artisans
who broke English colonial power and thus
made the first great modern revolution
an inspiration to the oppressed of the whole world

Then the Civil War, bloodiest in our history
blue Union banners and the tattered flag:
 "Strike nobly then for God and Country
 Let all nations see
 How we loved the starry banner
 Emblem of the free"
but freedom was converted into wage slavery

Even a conservative scholar once stated
that the history of the American labor movement
is the most violent of any country on earth

The Grange and Knights of Labor appear on the scene
magical underground lodges of the password solidarity

All the radicals are here too: grizzled Wobblies
American Railwaymen's Union of Gene Debs
The Socialist Party also of Gene Debs
Communists and other "reds" who continued onward

The catalogue is 550 pages & weighs four pounds:
take this and read, in remembrance of yourself

*Emmy Lou Packard. Logging in Mendocino (1870), 1969
Linocut, 38 x 184 cm*

*Opposite: Workers at the West Coast Kaiser Shipyards, Oakland,
c. 1943. Kaiser Industries Archive, Oakland*

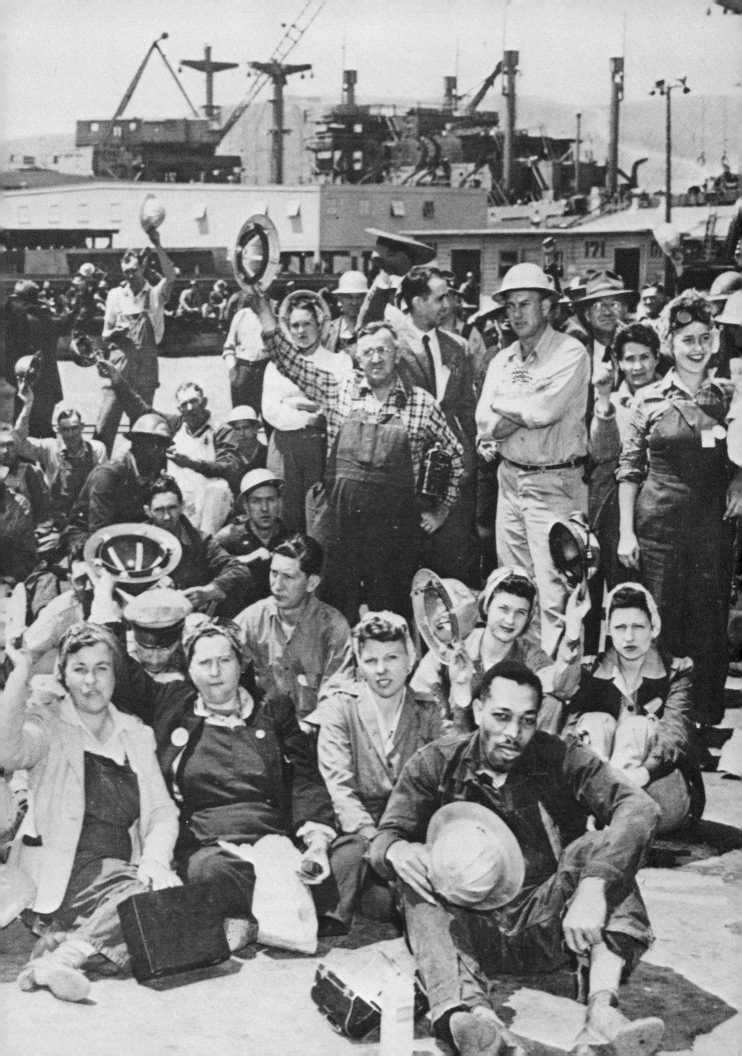

Artists' Index

Photographers' Index

Opposite: Robert Mottar. Workers on the Chase Manhattan Bank Building in New York, 1959
Chase Manhattan Bank Collection, New York

Introduction

Reinhard Schultz

The Other America project was approved for funding by the New Society for Fine Arts (NGBK) in West Berlin at the end of 1980. During the following two years over 100 sources—art collectors, labor unions, private archives, historical societies, and other institutions—came forward to participate in the research for the book and the exhibition. The response from individual artists, "labor buffs", and rank-and-file activists on the labor front was such that many personal friendships have developed and remain to this day.

The exhibition, The Other America, opened in West Berlin on March 13, 1983, the eve of the hundredth anniversary of the death of Karl Marx—that renowned German and inspirator of socialism in the U.S. In fact, the largest memorial meeting anywhere in the world to commemorate his death took place in Cooper Union Hall in New York City. One of the speakers paying tribute to Marx was Samuel Gompers, who helped to found the Federation of Organized Trades and Labor Unions. Five years later in 1886 this union became the American Federation of Labor (AFL).

It was the great American historian, Philip S. Foner, who commented on the significance of the Cooper Hall Meeting in his keynote remarks at the opening of The Other America at the Kunsthalle Berlin. Other speakers to deal with the meaning of the exhibition before a largely German public included Horst Wagner, president of the West Berlin Metal Workers' Union (IGM), and the internationally known lawyer and representative of the Green Party, Otto Schily.

The audience jammed into the art hall that day were also treated to the uplifiting voices of Sweet Honey in the Rock, an a capella group of five Afro-American women, and one of the most important groups doing progressive cultural work in the United States today.

The media response to the more than 2,000 items on display was overwhelmingly positive but the stage was set for controversy as well by a few reviewers who attacked the show for its alledged anti-Americanism. The worst denounciation came from a leading German conservative newspaper, the Frankfurter Allgemeine (FAZ), stating that the "miseries, the subjugation and power of resistance of the 'other America' . . . have again been exploited" and furthermore that "The history of the labor movement is used as proof that America's ruling class is a 'bourgeoisie of hangmen'." With respect to the catalogue FAZ concluded that "the comments found in the more than 500 pages predominantly stem from communist sources." Contrary to the probable wishes of the FAZ review, this kind of redbaiting only served to increase general interest and media coverage for The Other America. Not including the foreign press, almost 100 articles, pictorial spreads, and reviews were published in the first two months alone. The show was also featured on West German national television as

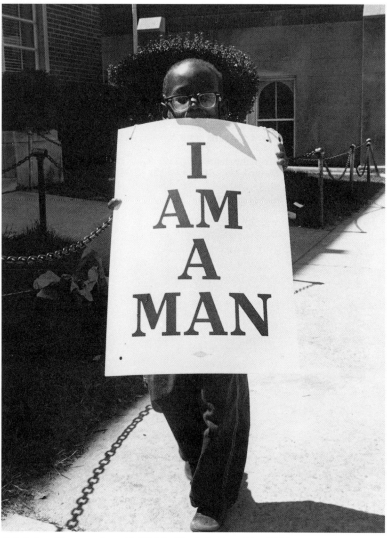

Del Ankers Photographers. Civil Right March in Memphis, AFSCME Local 1644, 1970
AFL-CIO News, Washington, D.C.

well as by the U.S. Public Broadcasting System (PBS). A forty-minute film was produced for the North German and Berlin television networks entitled "Visit from America". It portrayed two men truly representative of The Other America: Milton Wolff, former commander of the Abraham Lincoln Brigade—those more than 3,000 Americans fighting along-side the Republican forces in Spain, 1936—38; and Ralph Fasanella, the worker-painter, union organizer, son of Italian immigrants, and a volunteer in Spain as well. Included in the film are parts of a poetry reading given at the exhibition by Fred Whitehead, a writer, publisher, and labor activist from Kansas City, who after returning home in 1983 wrote the poem, The Exhibition (p. 4).

After its Berlin success, The Other America began its European tour. It first traveled to Oberhausen, a working-class city in the Ruhr, West Germany's heartland of steel and coal-mining industries, which now is severely affected by unemployment.

Then it was on to the Kulturhuset in downtown Stockholm, where additional documents and pictorial material about Joel Higglund (a.k.a. Joe Hill) and the history of Swedish-American labor organizations were integrated. Joe Hill, an International Workers of the World (IWW) artist and poet was killed in Utah in 1915 for a crime he had never committed. In one of his last telegrams to the IWW and miners' leader "Big" Bill Haywood, Joe Hill sent what became his epitaph, "Don't waste any time in mourning. Organize."

The international port city of Hamburg next hosted The Other America. The exhibition was housed in the former Kampnagel Factory, a fitting home for a labor show. Now a community cultural center, the building's future is surrounded by controversy over whether the city can continue to use this facility or whether real estate developers will see their way to another "paradise" of condominiums.

Next stop Rome. L'Altra Faccia Dell'America at the press festival of the Italian newspaper, l'Unita. Approximately 30,000 people visited the exhibition during its stay from August 30 to September 18, 1984. One of them, an American reporter for the NY Times, was unable to detect any signs of latent anti-Americanism, and chose to criticize the festival under the headline of "Salami Communism", dealing (instead) at some length with the sale of Confederate flag T-shirts at the San Marino stand.

The question was raised in Rome but is one people have been asking throughout the life of the project: Why has the title, The Other America, been chosen for an exhibition dealing with the history, art and culture of the U.S. labor movement. For starters "the other America" became a familiar expression ever since the publication of Michael Harrington's 1962 book of the same title about the poverty in the United States. This was the book which helped to spark the "War on Poverty" federal aid programs during the 1960s and 70s. Since then "the other America", at least in both Germanys has become an accepted phrase to include all those Americans excluded from that way of life so opulently faked in "Dallas" and "Dynasty". These are the majority of Americans on the job, out of work, and including the millions of young people—especially Black and other minority youth—who never got the chance. And "the other America", according to this interpretation, especially stands for those who are putting up "The good fight" as the title of a recent film about the Abraham Lincoln Brigade so aptly expresses it. Whether it be layoffs, plant closures with its subsequent unemployment, or—just as bad—no jobs after high school, it all belongs to the "miseries (and) the subjugation" (FAZ) of "the other America". For the working people of the United States there is no need for any abstract commitment to the "power of resistance" or any aesthetic reference to muddle the obvious. Or as the "Wobblies" (IWW) used to say:

AN INJURY TO ONE IS AN INJURY TO ALL—
FALL IN LINE

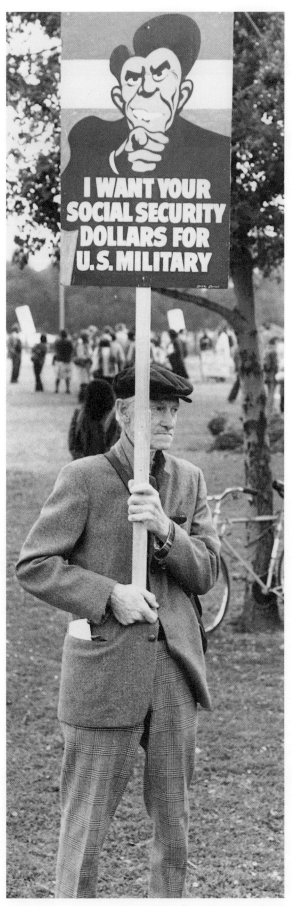

Bruce Kaiper. The Artist Richard Corell at a Demonstration in Oakland, 1983

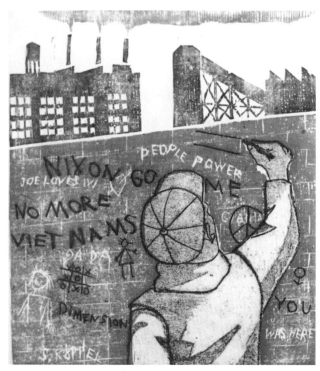

Stanley Koppel. Grafitti II, 1976
Woodcut and softground etching, 22 x 20 cm

Richard V. Correll. Locusts, 1960. Woodcut, 73 x 117 cm

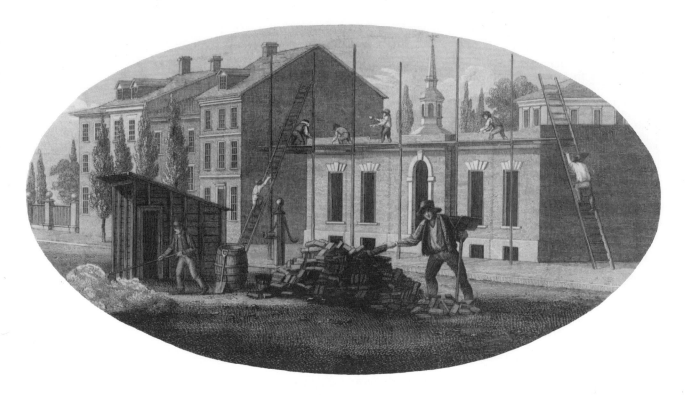

Certificate of the Bricklayers Company incorporated in 1797 in Philadelphia

Art and Labor in the United States

Reinhard Schultz

"Nothing is to be expected thence but by labour", was probably the most important conclusion the English adventurer, Captain John Smith, related to the Virginia Company Stockholders and other merchant capitalists hungry for the riches of the New World back in 1608. There was no gold or silver like Cortéz and Pizarro had looted earlier during the Spanish conquest of Mexico and Peru.

Like the Indians planting corn—as pictured in a famous plate by Theodore De Bry in Frankfort, 1590 (based on drawings by Jacques Le Moyne made in Florida, 1564)—the "gentlemen" had to work. A back-breaking task under the circumstances, the alternative option, of course, was getting others to cut down the forests, plant and harvest the crops, take care of construction and lay the foundations of future wealth.

Since the Native Americans resisted enslavement by all means, "more hands" had to be procured elsewhere. Thus, the colonial financiers launched a vast propaganda campaign in the poverty stricken areas of England, Wales and on the continent to induce the poor to emigrate.

Soon, increasing numbers of people signed indenture documents binding them "to do any work" from five to seven years in return for their passage advanced by the ship owners. Others, like the German "redemptioners" were allowed a certain number of days after arrival "to make their own bargains for the passage payment of ten guineas", as an advertisement in the Maryland Gazette stated.

Before 1776 more than half of the immigrants were reduced to the status of "indentured servants"—human merchandise which could be sold like choice Irish butter, if so desired.

In addition more than 50,000 convicts—many imprisoned for failure to pay small debts—were sold into bondage for the English colonies. And thousands, especially children, were kidnapped by so-called "men-stealers" or "crimps" who operated generally undisturbed in such cities as London, Bristol and Liverpool.

It is true that in the early years of the Virginia Colony unlimited bondage did not exist. Even the first 20 Africans sold at Jamestown in 1619 by the captain of a Dutch frigate were fortunate enough to be set "free" after their indenture term had expired. But the ever growing demand for labor soon led to the statutory recognition of chattel slavery in 1661, legalizing what originated in the 1640s as contracts with Blacks specifying that they were "servants for life". With their color making it all but impossible to run for freedom, even after the shackles had been taken off, enslavement of Africans soon was to become a long-lasting solution of the labor problem, especially in agriculture.

With the rapid expansion of tobacco, rice, and indigo plantations in the South after the turn of the eighteenth century, the slave trade developed into a highly profitable enterprise. A poem entitled "The Slave Merchant" puts it this way:

What cares the merchant for that crowded hold,
The voyage pays, if half the slaves are sold.

With capital interests increasingly tied up in this trade, racism spread and sank deep and lasting roots into American society.

These short remarks regarding the status of large parts of the colonial workforce shall only serve to point out what had to be confronted and under which conditions the struggles of American labor originated.

But in any analysis of this period one must not overlook the emergence of a "free" laboring class, first evident in the seaport cities like Boston, Philadelphia and New York. Here shipbuilding and other bourgeoning industries required skilled craftsmen, which had to be attracted by working conditions not to be found anywhere in Europe.

Thus, with the exception of depression years, most of the skilled workers had a good chance of setting themselves up as independent masters at some point and those unskilled could easily move on or turn to farming with the abundance of cheap available land.

Nevertheless, white workers did not gain improvements without resorting to organized struggle. "Strikes of white journeymen", Richard B. Morris notes, "while rare and sporadic, can be found in almost all periods of colonial history." The first probably took place in Virginia in 1619, when German glass workers struck for higher wages. Of course, the indentured servants and slaves tried to better their lot by any number of means—many by running away from their masters, which always brought the risk of severe punishment or even death.

Enslaved workers rose up in revolt as well. In some of the more than 40 plots organized by slaves during the colonial period, white indentured servants had joined the revolt. These rebellions did not only take place in the South. One, for example, was crushed by "His Majesties Garrison" in New York, 1712, and as a result "some were burnt, others hanged, or broken on the wheel, and one hung alive in chains in the town, so that there has been the most exemplary punishment that could be possibly thought of", as the then Governor Hunter put it.

The Pictorial Record

Although this book does not contain any images of colonial workers and the conditions shaping their lives—a selection of which is included in the 331 page "Pictorial History of the American Labor Movement" in the original German edition of "The Other America"—it should be noted that a wealth of material exists. Unfortunately this substantial documentation has yet to be published.

Some of the earliest original plates depicting the subjugation of the Native American nations resisting exploitation and forced labor in the mines are included in a book by the Spanish Dominican missionary Bartolomé de Las Casas published in Sevilla in 1552. De Bry's "Americae", Part IV, 1594, contains scenes from the gold and silver mines operated by "Nigritten"—slaves from the Guinea coast brought over to replace the Natives who had been worked to death. Other plates include Blacks in sugar production.

Pictorial items related to the slave trade and the treatment of slaves in the colonies have to be pieced together from a multitude of sources, but all aspects starting with their capture in Africa and subsequent transport—often referred to as the "Middle Passage"—have been well documented.

The same is true with respect to European immigrant workers whether "indentured" or "free". The best single source for on the job images of craftsmen in the English colonies is Diderot's "Encyclopédie" (1762—77) from which Carl Bridenbaugh selected 17 plates for his book "The Colonial Craftsman". Again, all other works are scattered and many only exist as reprints and often without documentation.

Some will, of course, argue that these prints have little artistic value, which is true when compared to the works of the great masters of that period. There is no doubt that dramatic paintings and fine prints telling the worker's story would have existed, if they had been requested by those who traditionally commission and buy art, whether it be the rich aristocrat or merchant of the past or his counterpart, the refined, propertied gentleman in colonial New England. This also applies to 19th century art, with the exception of a few, almost heroic pieces dedicated to working people.

As Walter Crane, the well-known English illustrator and socialist, commented on the realities confronting the artist: "If he has cherished dreams of great and sincere works, he must put them away from him unless he can face starvation. Perhaps, in the end, he goes into some commercial mill of production, or sells his soul to the dealer, the modern high priest of Pallas Athene. Then he finds that the practice of serving Mammon has so hardened into habit as to make him forget the dreams and aspirations of his youth, and the so-called successful artist sinks into the cheerful and prosperous type of cynic, of which our modern society appears to produce such abundant specimens.

The choice presented to the modern artist is really pretty much narrowed to that of being either the flatterer and servant of the rich or a trade hack. Between this Scylla and Charybdis it is difficult indeed to steer a true course." ("Why Socialism Appeals to Artists", Atlantic Monthly, Jan. 1892)

Art and Labor in the 19th Century

A small selection is included here of well-made paintings, watercolors and lithographs showing working people in the period before the Civil War. But none of them could have offended the ideological make-up and the taste of those with plenty of leisure time to mingle among the crowd at events such as the annual spring exhibition of the National Academy of Design, founded in 1826. This was when and where reputations could be made, and to please the eye of a potential buyer the artists themselves came in for Varnishing Day prior to the openings.

One painting finished a few years before the Declaration of Independence should be mentioned, because, as Patricia Hills stated in "The Working American" it is "the first instance in America when an artist captured the informal moment of the craftsman's looking up from his work to engage the viewer." This is John Singleton Copley's painting of the silversmith and engraver Paul Revere, who himself in 1770 did the famous print showing the Bloody Massacre in Boston, where five workers participating in an anti-British demonstration were killed. The first to die that day was Crispus Attucks, a black seaman who had escaped from slavery. Revere's emotive engraving certainly was not lost on the local mechanics who immediately armed themselves for the inevitable conflict.

It followed in the visual arts for many years to come that conflict and repression of workers were off-limits. Even factory or other industrial scenes were extremely rare and generally only as prints, watercolors or lithographs. But a variety of early work-place images can be found illustrating the certificates of such organizations as the New York

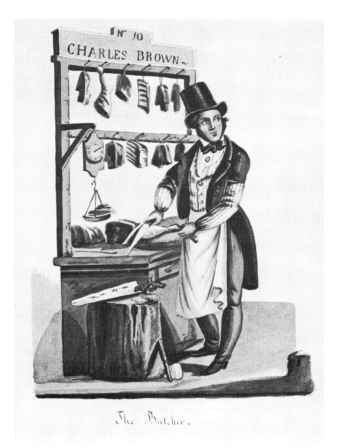

Nicolino Calyo. The Butcher, 1840—44. Watercolor, 30 x 25 cm
Museum of the City of New York

Eastman Johnson. Husking Corn, 1864
Oil on canvas
Toledo Museum of Art

Mechanick Society (1791), the Society of Master Sail-makers (1793), and the Bricklayers Company, Philadelphia, 1797. The Mechanick's etching is especially noteworthy for its top center detail showing an arm and a hand swinging a hammer above which is stated:
"By Hammer & Hand all Arts do stand".
This image has repeatedly been used in labor publications.
There are two artists both of whom produced a series of watercolors of tradesmen: Pavel Svinen in Philadelphia, 1811–13, and Nicolino Calyo in New York, 1840–44. These are not really working-class images, because their subjects are those fortunate enough to have set up their own shops, but who were still not in a position to withdraw from manual labor.
The same is true for Eastman Johnson's "Husking Corn", 1864, one of many paintings depicting aspects of work on the farm. Again, these images are not concerned with the realities of farm labor—even if they include workers, like William Sidney Mount's "Farmers' Nooning", 1836.
Basically they are contributions to a nostalgic body of work catering to the desire for rustic scenes, glorifying the good old days of communal life in the countryside. Very nice to reminisce about. Especially, if one could still find something coming close to it while travelling to the family's remote country seat.
This was exactly why critics, such as William Walton in 1906 praised Johnson's work as preaching "no ugly gospel of discontent, as does so much of the contemporary French and Flemish art of this genre."
The same could have been said about the lithographs produced by the publishing business of Nathaniel Currier from 1834 on. At that time the use of color illustrations was extremely rare and thus Currier's hand-colored prints pioneered a new and lucrative market. In 1857 Currier teamed up with James Merritt Ives to form the firm of Currier & Ives which gained an international reputation for its thousands of lithographs reproduced from original paintings by leading artists of the period. Although Currier & Ives were artists in their own right, it should be noted that their success was due more to their business acumen and shrewd insight into the public's taste than their artistic accomplishment. After all, the original black and white lithographs were then colored by women in an assembly-line fashion, who were occasionally directed by the same artists whose paintings they were reproducing.
Aside from those considerations Currier & Ives deserve credit for the production and distribution of unbiased historical scenes, such as "The Whale Fishery" or "The Life of a Fireman."
With respect to George Caleb Bingham's paintings of rivermen working Missouri flatboats, an overly poetic fascination with camaraderie and carefreeness has unfortunately diminished his otherwise naturalistic style. There is very little reference to the fact that these hardy boatmen were on duty 16 hours a day, subsisting on pay low enough to compete with large steamboats well into the 1870s.
The inherent romanticism is a pervasive feature of almost all paintings throughout the 19th century, even in the case of child labor. A good example for this is Wm. H. Burr's "The Scissors Grinder" as well as the later paintings of children working in the street by J.G. Brown. The latter are perfect counterparts to the more than 50 extremely popular books by Horatio Alger such as "Sink or Swim", the second volume of the "Lucky and Pluck Series". There is no need for philosophical interpretation of these rags-to-riches themes once you have digested a quote from one of Alger's straightforward prefaces like this:

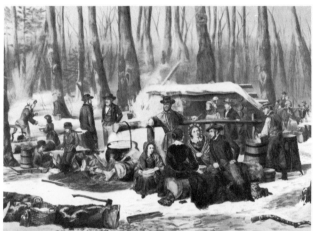

Currier & Ives. American Forest Scene: Maple Sugaring, 1856
Color lithograph. From a painting by A.F. Tait

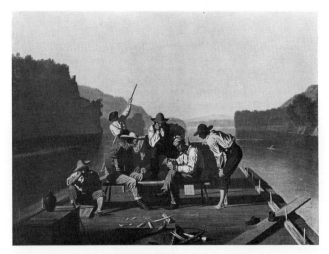

George Caleb Bingham. Raftmen Playing Cards, 1847
Oil on canvas, 71 x 91 cm
City Art Museum, St. Louis, Missouri

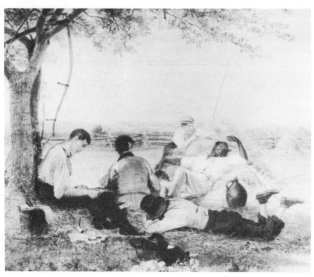

William Sidney Mount. Farmers' Nooning, 1836
Oil on canvas, 51 x 61 cm
Suffolk Museum and Carriage House, Stony Brook, Long Island

William Henry Burr. The Scissors Grinder, 1856
Oil on canvas, 65 x 55 cm
Coe Kerr Gallery, New York

"If there are any of my young readers who are disposed to envy Harry's final good fortune, let them remember that the best way to strive for success is to deserve it; and then, if it does not come, there will at least be a consciousness of well doing, which in itself is a rich reward."
("Sink or Swim", 1870)
In conclusion, it needs to be said that none of the great American painters of this period dared to concern themselves with the harsh realities of this early phase of American industrial society.
After all, at least in the Northern States where universal

suffrage albeit only for men swept away all property qualifications for voting after 1818, democratic institutions, unprecedented in history, had been established. The first labor party had been set up in the summer of 1828 and similar organizations were established in 61 cities and towns within the following six years. In that same period almost 50 labor weeklies were being published. The first one of those, the Mechanics' Free Press, demanded free libraries, museums and other institutions as early as May 1, 1830.
Why then, didn't at least some of the great visual artists catch the flavor of the vernacular, creating scenes of visual impact that could be hung next to Goya's "The Executions of May 3, 1808" or Delacroix's "Liberty Leading the People", 1830?
Only a few have attempted to provide an answer. According to Joshua C. Taylor, former director of the National Collection of Fine Arts, this failure resulted from the fact that "American painters and sculptors (were) brought up on the heady idealism of academic theory and taught to draw people by studying casts of antique statuary".
Patricia Hills in "The Working American" states: "The pastoral ideal of an agrarian America inevitably occupied the attention of many American painters during the second quarter of the 19th century. In turning to the American farmer as a subject, they satisfied private patrons and book publishers who desired paintings showing typical American scenes and activities."
As far as Stephen Hess and Milton Kaplan, authors of "The Ungentlemanly Art—A History of American Political Cartoons" are concerned with this issue, the simple answer is that "Americans were artistic laggards during the 18th and much of the 19th century" while at the same time "instinctively political" with an appreciation of the ridiculous especially as presented in widely distributed and easily accessible cartoons.
An evaluation Taylor obviously shared when he stated: "The visual impact was made thus rather through the elevated arts of painting and sculpture than through illustration and prints. These formes the real pictorial galleries for most Americans, and in their own way helped to formulate the point of view from which the more formal arts were likely to be seen."
Another scholar probably in agreement with this analysis was Francis O. Klingender, who stated in "Art and the Industrial Revolution" (1947): "Since the 15th century the development of wood cutting and of engraving . . . was greatly stimulated by the revival of learning. In turn, the wood cutters, engravers and printers provided both the scientist and the artist with an immense new public", while at the same time gaining their own through a mass medium allowing partisanship and causes to be espoused.
If all of the above statements contained at least part of the truth, it wouldn't be surprising to find that while the great painter was varnishing his piece for the money to walk into the National Academy of Design, a variety of graphic artists not to be dealt with extensively in art history books, were busy getting their message across.
While the painters of the young Republic rather went 200 miles into the countryside than get caught up with controversial subjects next door, political and social comment became the domain of graphic artists. Although high standards of excellence had been set by such cartoonists as Gillray in England, early prints like those used for the Workingmen's Party were crude with text-filled ballons containing slogans and general statements.
With the introduction of lithography, political caricature became more sophisticated, drawn with crayon, and single sheets were widely distributed. An outstanding example of such a print containing scenes of the workers plight is "The Times", blaming President Jackson for the panic of 1837, which left one-third of the working class unemployed and dealt trade unionism a devastating blow, from which it took many years to recover.
With the growth of the anti-slavery movement and especially after the outbreak of the Civil War, many cartoons were published depicting the plight of the black worker in the South.
The strongest images during the war and the following

Reconstruction period were presented by Thomas Nast, a German immigrant well acquainted with Daumier and other contemporary progressive European artists.

Nast was the first major political cartoonist, and his popular work did much to make Harper's Weekly the leading pictorial magazine. With respect to organized labor, Nast's position was unfortunately deeply affected by the anticommunist propaganda of his days. Pretending to side with the poor workingman, his labor leaders are either anarchist-type foreign agitators or appear as "Death", both occasionally draped with a sash inscribed "Communism".

An abundance of cartoons from Harper's and its competitor, Frank Leslie's weekly, show the development of industry and workers throughout the country whether in factories or driving cattle in Kansas. Almost all aspects of America's rapidly expanding industrial scenery have thus been documented. In paintings, even in the second part of the 19th century, only a few such images appeared. The first major works of this kind were John Ferguson Weir's "Gun Foundry" 1866, and the no less dramatic scene "Forging the Shaft", 1866, repainted in 1877, after it had been destroyed by fire. It took Weir almost two years to complete the "Gun Foundry" after the composition had been sketched, paying many visits to the workers which he studied as closely as Adolf von Menzel had done in his famous German counterpart, the "Iron Rolling Mill", 1875.

A few of America's great painters, such as Winslow Homer, also published wood engravings in Harper's, which today have become fairly rare collector's items. One of these, the "Morning Bell", 1873, shows workers approaching a small New England textile factory. In his painting of generally the same setting the men and boy on the ramp are left out, which may have caused the art historian Barbara Novak in 1969 to identify them as milkmaids, which they may very well have been an hour before the bell rang— usually 4:30 a.m.

Actually these so-called "factory girls", prior to the 1840s, usually came from nearby farms to which most of them returned later. In 1868 Homer had drawn another "Bell Time", showing thousands of women, children and men leaving a Lawrence mill at the end of a 13-hour shift. But he preferred to paint the textile mill in a pastoral setting which, at the time it was done, was nothing but a reference to a past without the brutal features of mass industry exploitation—the scene being dotted by sunlight. After all, even the young women from the farms considered the mill to be a "factory prison".

The same is true for "Cotton Pickers", 1876. Although it pays tribute to the beauty and dignity of these young black women, it has certain disturbing qualities. Cotton plantations required large numbers of blacks, almost mercilessly driven by overseers to harvest the crop before it could be damaged by inclement weather. The work had to be continued for hours after sunset, wearing out even the strongest. Homer certainly did not expose these realities. There is no sign of fatigue and the cotton picked is being carried almost without effort, evoking compassion only because of a certain sadness on the faces of the two women, obviously pausing.

The work break is also the theme of John George Brown's

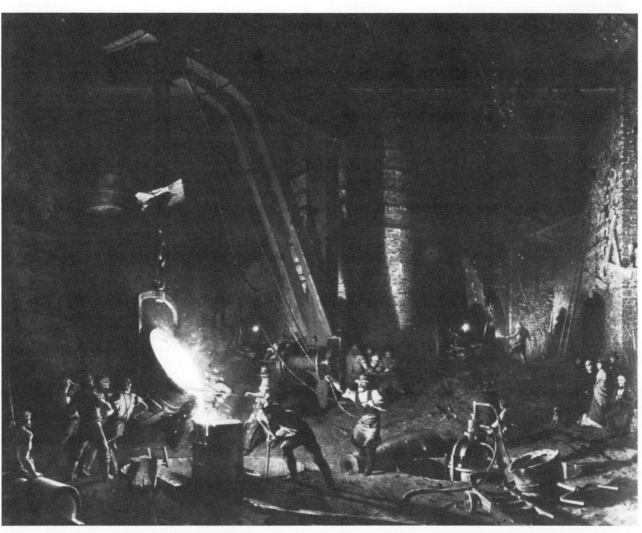

John Ferguson Weir. Gun Foundry, 1866. Oil on canvas, 1.18 x 1.57 m. Putnam County Historical Society, Pennsylvania

Winslow Homer. The Morning Bell, 1873
Wood engraving, 23 x 24 cm. Harper's Weekly

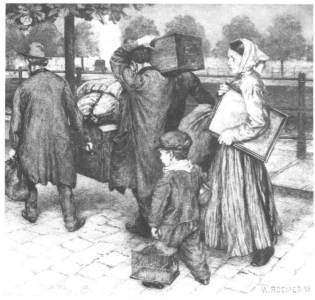

W. Roemer. Emigrants on Their Way to the U.S. in Hamburg, 1898
Etching, 26 x 29 cm. Collection Werner Schartel, Hamburg (FRG)

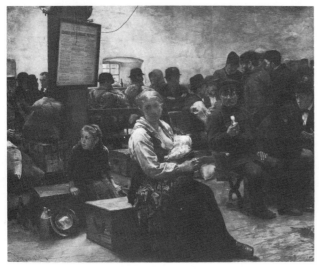

Charles Frederic Ulrich. In the Land of Promise, 1884
Oil on panel, 71 x 89 cm
Corcoran Gallery of Art, New York

"The Longshoremen's Noon", 1879 and Thomas Pollock Anshutz's "Ironworkers—Noontime", 1880—81. While Brown's painting simply shows dockworkers resting as a group, a familiar theme, "Ironworkers—Noontime" is a unique and outstanding study of industrial workers getting ready for lunch.

"Anshutz's painting . . . recognizes the workers simultaneously as individuals and as members of a class. Unlike the handful of earlier American paintings of industry, it neither stereotypes nor condescends. Rather it suggests a strength and capacity for autonomy (expressed through the independent movement of the figures) which is directly linked with the subject."
("anti-catalog" published 1977 by Artists Meeting for Cultural Change)

Anshutz was a student of Thomas Eakins, who once commented: "The working people, from their close contact with physical things, are apt to be more acute critics of pictures than the dilettanti themselves, and might justly resent patronage." His portraits, which include some of the most beautiful and individual faces ever realized in American art never made it big in the market during his lifetime.

The same is true with respect to Anshutz's "Ironworkers", today called his "masterpiece". When first displayed, no one cared to buy it and the frustrated artist almost painted it over. He never again painted an industrial scene. A few years later another German-American artist, Charles F. Ulrich, who had earlier painted various scenes of workers, gave expression to anxieties of immigrant workers "In the Land of Promise—Castle Garden", 1884.

Two years before the first general immigrant restriction had been passed by Congress, excluding undesirables and all Chinese. "The servile and degraded hordes of Southern and Eastern Europe, with their crime and disease-breeding adjuncts of poverty, filth, and slavish willingness to work for almost nothing", as one of the leaders of the A.F. of L. put it, also were on the target list of nativist racists, employer-sponsored organizations and organized labor.

While the "old" immigrants had been accepted by the A.F. of L. as "sturdy intelligent and liberty-loving races of Northern and Western Europe", the "new" immigrants were considered to be a "menace" to American institutions and a threat to "racial purity". As they had successfully excluded black workers from affiliated craft unions, Gompers and the rest of the A.F. of L. leadership also did everything in their power to keep potential immigrant "troublemakers" out, then pouring into the Lower East Side slums of New York.

This happened at a time when the Statue of Liberty had just been erected. In 1903 "The New Collossus" poem by Emma Lazarus was engraved and attached to an interior wall asking to "Give me your tired, your poor . . . The wretched refuse of your teeming shore."

Almost six months before the Statue of Liberty was officially dedicated in 1886, events took place in Chicago, which will always be remembered. For the first time in history, a national labor organization—which later that year, amongst others, became the A.F. of L.—had called on all workers to down their tools on May 1 and go on strike for the eight-hour day.

In Chicago alone 40,000 strikers paralysed transport and most of the industries. The official response was increased police interference at the McCormick Harvester plant where 1,400 workers had been locked out. On May 3 the police fired at the strikers killing at least 4. From this resulted the Haymarket Meeting at the end of which a bomb was thrown toward the police, ready to disperse the small crowd left.

This tragedy, which caused casualties on both sides, provided an excellent opportunity for repression of the entire movement. Eight labor leaders, not connected to the bomb attack, were put on trial and seven sentenced to death. The sentences of two men were later commuted to life in prison, one killed himself and four were hanged in 1887. Six of the Haymarket martyrs—all of whom were declared to have been innocent by Governor Altgeld in 1893—were German immigrants, one was born in England.

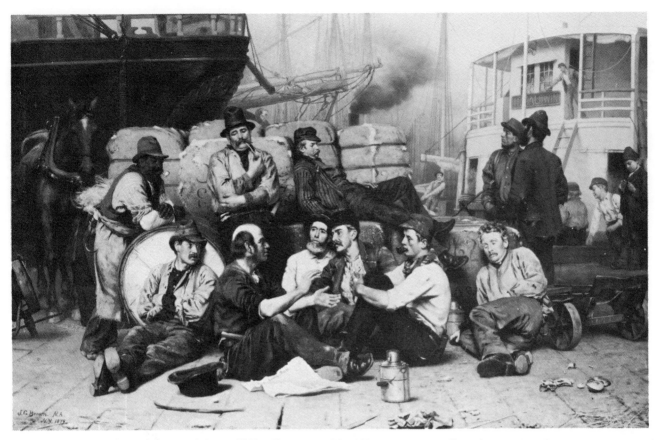

John George Brown. The Longshoremen's Noon, 1879. Oil on canvas, 84 x 128 cm. Corcoran Gallery of Art, New York

The week the first May Day took place, Harper's Weekly published a reproduction of Robert Koehler's painting "The Strike" which just had been presented at the National Academy of Design. Koehler, born in Hamburg in 1850, had come to the U.S. as a child and moved with his parents to Milwaukee, Wisconsin. He had witnessed the Great Labor Uprising of 1877, one of the most widespread and militant strikes in U.S. history. It had been provoked by wage reductions for railroad workers. The first casualties occurred in Pittsburgh where the militia killed 20 people before driven out of town by the aroused citizens. Koehler, who grew up in a socialist family, never forgot these events, as he stated in 1901:

,,The Strike was in my thoughts for years. It was suggested by the Pittsburgh strike. Its actual inception was in Munich and there the first sketches were made. I had always known the working man and with some I had been intimate. My father was a machinist and I was very much at home in the works where he was employed. Well, when the time was good and ready, I went from Munich over to England and in London and Birmingham, I made studies and sketches of the working man—his gestures, his clothes. The atmosphere and setting of the picture were done in England, as I wanted the smoke. The figures were studies from life, but were painted in Germany. Yes, I consider The Strike the best, that is the strongest and most individual work I have yet done.''

Because of May Day and the Haymarket tragedy, Koehler's painting was a sensation and was widely praised in progressive circles. The lengthy N.Y. Times review published April 4, 1886 stated:

"Mr. Koehler has done well to show the earnest group of sweating workmen, quite possibly with justice on their side, but ready, some of them, to take the law in their own hands.

He has contrasted with them fairly well the prim capitalist. But in trying to rouse our sympathies with a beggar woman his moral gets heavy . . .

All the same, 'The Strike' is the most significant work of this Spring exhibition."

After having been shown at various places in the U.S., "The Strike" was shipped to the Paris International Exposition in 1899. At that time reproductions had already been

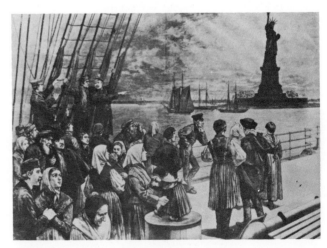

Immigrants' Shipboard View of Liberty, 1887
Wood engraving
Frank Leslie's Illustrated Newspaper

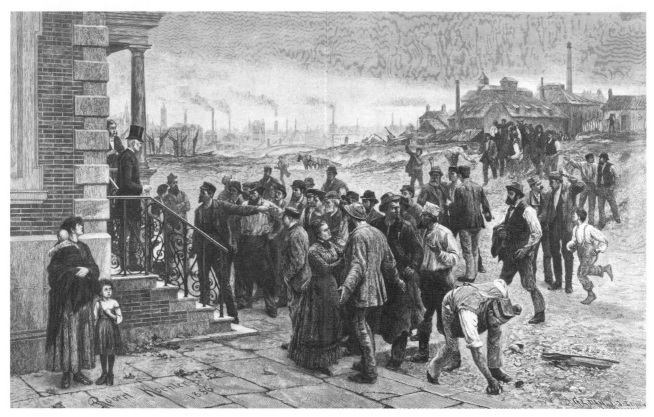

H. Gedan. Workers on Strike (in Belgium), 1886. Engraving, 30 x 49 cm. From the painting "The Strike" by Robert Koehler as reproduced in Harper's Weekly, May 1886

published like the one by Gedan in Leipzig, identifying the scene as a strike in Belgium. Another print of the same engraving appeared in a French magazine which it indicated took place in the Belgium County of Charleroi.

While other paintings by Koehler such as "Smithy in Bavarian Highland", "The Carpenter's Family" or even his powerful image of "The Socialist" remained virtually unknown, "The Strike" still struck people even after it was put into storage soon after Koehler's death in 1917.

In his recently published classic "Ästhetik des Widerstandes" (Aesthetics of Resistance) the German writer and painter Peter Weiss recalls that the Harper's Weekly print had been hanging in his family's kitchen when he was young.

But the painting, which today is generally considered to be the labor masterpiece of American painting, was never paid much attention to by U.S. art critics until its rediscovery in the 1970s. In fact, after Koehler had stepped down as the Director of the Minneapolis School of Art, the so-called curators storing "The Strike" managed to hide it so well, that for almost 50 years it was considered to have been lost. It took extensive research by its present owner to locate it. Covered with dirt and seriously damaged it was sold to him for less than what most used cars cost.

Since it has again returned to Europe in 1983 for the travelling "The Other America" exhibit, "The Strike" has been reproduced in many reviews and several books and also as a poster and a postcard.

In 1985 it was shown at the Germanic National Museum in Nuremberg, Bavaria not far from Munich where Koehler had made his first sketches for the painting—probably the first one ever to depict a scene of "labor unrest", or "riot" as such events were generally referred to in the press.

From the Turn-of-the-Century to the Great Depression

With the war of 1898 and the subsequent acquisition of Hawaii, Puerto Rico and the Philippines, the United States had become an imperialist power to be reckoned with. At home, industrial feudalism was on the rise. The trusts and monopolies of the 1880s and 90s gave way to giant corporations, controlling or even literally owning whole towns and communities. With the aim of crushing fast spreading unionism a national open-shop drive by employers' organizations was launched. But workers resisted, going on one of the greatest strikes in U.S. history which shut down the coal fields in 1902 and won the nine-hour day and a ten per cent increase in wages. Wm. Balfour Ker's "The Hand of Fate" symbolizes this struggle of the working class almost crushed by an exorbitant bourgeoisie. A popular image at the time, it was reprinted in "The Cry for Justice" an anthology edited by Upton Sinclair in 1915. With poverty rampant, child labor spreading and brutal exploitation, especially of unskilled immigrant workers in the textile, steel and other main industries showing its ugly face, progressive reform movements sprang up all over. Many artists supported these causes like Everett Shinn, George Luks and William Glackens and some, like John Sloan, joined the ranks of the Socialist Party. With the establishment of the periodicals Craftsmen and especially Comrade in 1901, the ideas of the great English poet and socialist William Morris had already gained influence among artists, who previously had confined themselves to reformist "muck-raking", which was so popular among intellectuals. Even though The Comrade had to be soon discontinued, it had a lasting influence on the art of drawing and illustration. This became obvious with the publication of The Masses (1911—17) and its short lived successors, Good Morning and Art Young's Quarterly, and again with its chief successor, The Liberator, founded in 1918. Many of the artists who had worked for The Masses, like Art Young, Saul Bellows, Boardman Robinson, and Robert Minor contributed to The Liberator. But it was a new generation that shaped it—represented by such outspoken radicals as Hugo Gellert and William Gropper.

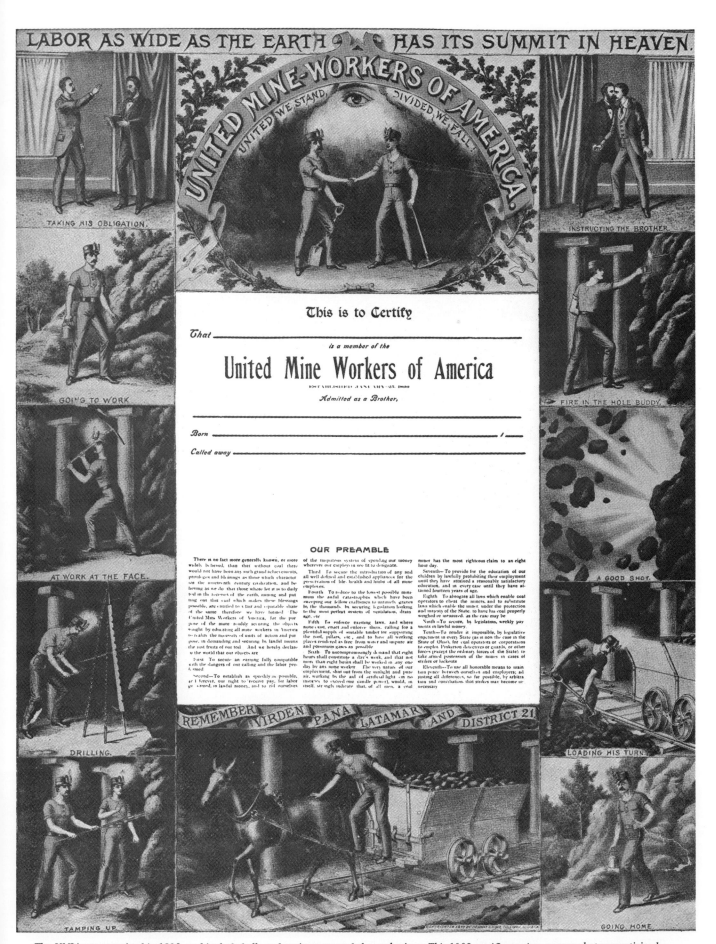

The UMW was organized in 1890, and included all workers in or around the coal mines. This 1902 certificate gives a somewhat romanticized view of the grim life of the miner. "Remember Virden . . . and District 21" refers to strikes in which several workers had been killed

William Balfour Ker. The Hand of Fate, 1906. Lithograph

The same forces supporting military expansionism under the guise of "preparedness", of course, loved seeing the split in labor's ranks, setting such "radical foreign elements" as the "Wobblies" of the IWW up for violent repression, which climaxed in the infamous Palmer Raids in 1920, when thousands of "suspects" were arrested. Of those identified as "aliens", many were deported. This was not the climate for artists to step forward and depict the heroic struggles of the working class in the way John Sloan had done in 1914 on his cover for The Masses, illustrating John Reed's report about the "Class War in Colorado". A war conducted by the Rockefeller "Fuel and Iron Co." against striking miners. After the Ludlow Massacre in which 32 people—mostly women and children—had been shot or burnt alive in their tent colony, Sloan did another image for The Masses showing Rockefeller, who according to an editorial by Joseph Pulitzer "has debauched an American commonwealth, and the blood of women and children is on the hands of his barbarous agents." In conclusion it can be said that most of the other artists who had concerned themselves with various aspects of workers' lives before World War I soon withdrew to draw and paint the more pleasant realities of the American scene. It was left to the contributors of The New Masses, established in 1926 to continue "radical art". People like Sloan, Art Young, William Gropper and Hugo Gellert, who in 1927 painted a series of murals, the first ever done in New York presenting images of labor. Another of these "radicals", Boardman Robinson also painted his first frescoes in 1927—another originator of this medium in the U.S. which became so popular in the 30s. But the great revival of mural painting had already started in 1922—24, initiated by a group of leading radical artists in Mexico including Siqueiros, Rivera and Orozco.

After decades of silence it has become fashionable to "rediscover" The Masses and to praise its achievements. If the analysis includes enough footnotes to prove scholarly research the student might earn an academic degree. If a statement, such as ". . . the Liberator, which succeeded The Masses but soon took a hand in stirring up the infantile disorders of communism . . ." (Irving Howe, "To the Masses—With Love and Envy") is included, a larger audience will even applaud. Especially if there is no reference to the "Lucky devils, happy comrades!" (Howe) being indicted under the Espionage Act—partly because of the antiwar drawings by Art Young and Henry J. Glintenkamp. This is what really finished the magazine from which the U.S. Postal Service had already withdrawn mailing privileges in August 1917.

Opposition against U.S. participation in World War I, had originally also been voiced by the A.F. of L. When the war broke out in Europe, August 14, 1914, Gompers immediately denounced it as "unnatural, unjustified and unholy", charging that it only served to divert attention from domestic problems and to demoralize organized labor. But with the leading capital interests preparing for intervention and preparedness propaganda sweeping the country, he soon abandoned his previous policy of strict neutrality and admitted that he had been "living in a fool's paradise". But not only did he proclaim a change of heart by the end of 1915 but also started to viciously denounce all those who continued their unwavering opposition against war like the supporters of Labor's National Peace Council, the Industrial Workers of the World (IWW) and the Socialists, led by Eugene Debs.

Francis Xavier Leyendecker. The Blacksmith, 1904
Gouache, 47 x 38 cm

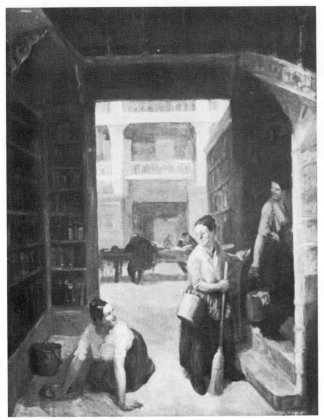

John Sloan. Scrub Women, Astor Library, 1910
Oil on canvas, 81 x 56 cm
Munson-Williams-Proctor-Institute, Utica, New York

Edward Hopper. Stevedores Unloading Ship, 1900–1910
Ink and wash on illustration board, 55 x 36 cm
Whitney Museum of American Art, New York

The Great Depression

"Prosperity is Just Around the Corner." (President Herbert C. Hoover, 1929)

Six months after the first successful businessman ever to be elected President, was inaugurated, the U.S. stock market crashed starting the worst depression in the country's history.

"To understand fully the meaning of the 'Great Depression' of the thirties, one must go beyond the statistics, as staggering as they are to a rational mind. Especially, if viewed at a distance of some forty years. To recall the 'Hoovervilles,' shanties built of cardboard, pieces of tin, wooden planks, etc. all along the Hudson, Harlem and East Rivers, housing thousands of ill-clad, half-starving people is to relive a nightmare. Especially, if you were one of them. Snow is forecast for tomorrow, you get on line with several hundred other men and wait all night for a snow shovelling job. To relate oneself to the depression in these terms, is to begin to understand that tremendous catastrophe in the terms of the humanity involved in it.

What about the artists? With the bulk of them living on the periphery of poverty even before the depression, they found themselves in exactly the same economic position as the millions of other working people, when it came. With one difference, though. They were artists and in spite of the desperate situation, they were determined to continue as such. Many spent a better part of the night in a cafeteria, no minimum charge, just to absorb some of the warmth before returning to the cold-water flats for some sleep to be able to work the next day. It was not romantic. Neither was it romantic to get a bowl of soup in a dairy restaurant and gobble up all the rolls and bread available without extra charge. Some artists were lucky enough to exchange their work for real artists' material, as they also did for clothing, rent, medical services, etc. And so they continued to work as artists. But they also began to discover their place among the rest of the working people, people who like themselves were unemployed and half-starving at the moment but already beginning to gather strength for the struggle against these degrading conditions."

(Norman Barr, New York City WPA Art, N.Y. 1977)

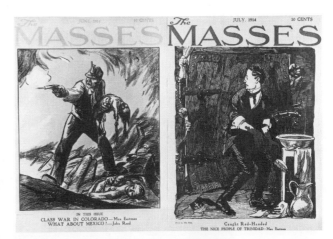

John Sloan. Class War in Colorado, 1914 (Left)
Caught Red-Handed, 1914 (Right)
The Masses

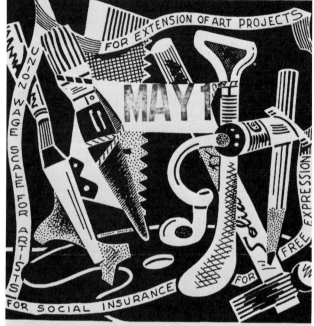

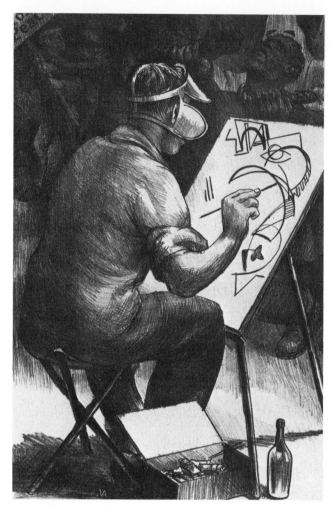

Stuart Davis. May 1, 1935. Art Front
(Magazine of the Artists' Union)

Victor Arnautoff. Pure Art, c. 1940
Lithograph, 45 x 30 cm
Collection Irving Fromer

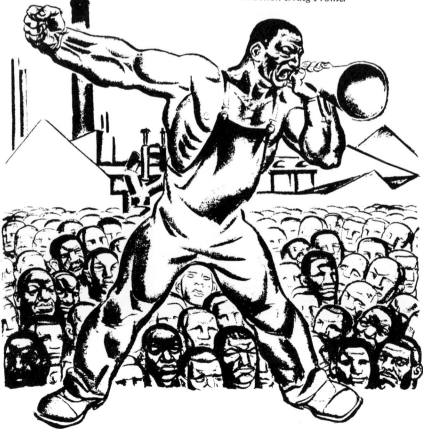

Hugo Gellert. Illustration for Primary Accumulation, Karl Marx' 'Capital' in Lithographs, New York, 1934

After the inauguration of President Franklin D. Roosevelt on March 4, 1933, Congress met in special sessions to pass legislation for recovery measures, usually referred to as New Deal programs. As soon as these "make-work" projects started, artists demanded jobs as well. In response, the pilot Public Works of Art Project (PWAP) was started in December 1933, employing 3,749 artists. Lump sums received as weekly salaries ranged from 26.50 dollars to 42.50 dollars. Within six months, 15,663 works of art were produced for or handed over to decorate public institutions. The PWAP was succeeded by programs sponsored by the Treasury Department, the Federal Works Agency, and the Works Progress Administration (WPA). By July 1, 1943, the WPA Art Program ended completely after having been turned over to the War Services Program in 1942.

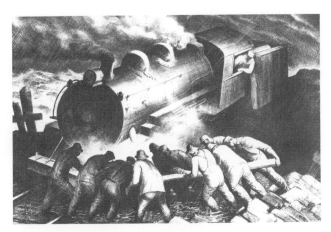

James E. Allen. Distress, 1938. Lithograph, 23 x 35 cm
Ben and Beatrice Goldstein Foundation, New York

"The practical matter of liquidating the project was entrusted to the now familiar Col. Somervell, who undoubtedly enjoyed this assignment. What happened to the hundreds, if not thousands of works of art still in the project storage rooms? We can only surmise. It is a fact, though, that hundreds of paintings, torn from their stretchers and baled with metal strips were found in a junk shop along Canal St. We must assume that the rest of the work had been destroyed altogether, for no trace of them has been found. It is also a fact that the project records being packed for shipment to Washington in the last days of liquidation had disappeared with no clue."
(Norman Barr, New York City WPA Art, N.Y. 1977)
Still today no one exactly knows how many have actually been produced altogether. WPA/FAP artists alone finished approximately 2,500 murals, 17,000 sculptures, 108,000 paintings, 11,000 designs for prints and 35,000 for silkscreens, of which 2 million posters were produced. And among these works were many commenting on labor history, industrial conditions etc. or just depicting working people and their life.
The New Deal art programs, it should be noted did not discriminate against artists, whatever their aesthetic medium. There were social realists like Philip Evergood, still working in the tradition of John Sloan and George Bellows; abstractionists of every variety, including Stuart Davis, the

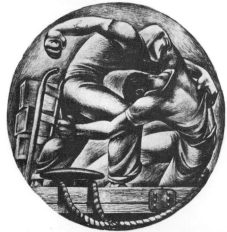

Fletcher Martin. Trouble in Frisco, 1938. Offset lithograph, 29 cm diameter

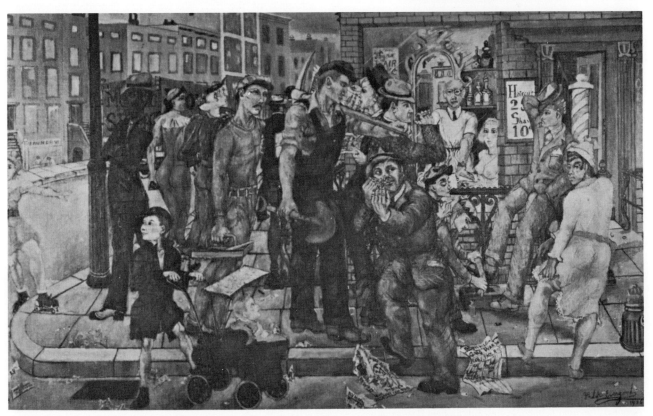

Philip Evergood. Street Corner, 1936. Oil on canvas, 75 x 128 cm. Fashion Institute of Technology, New York

23

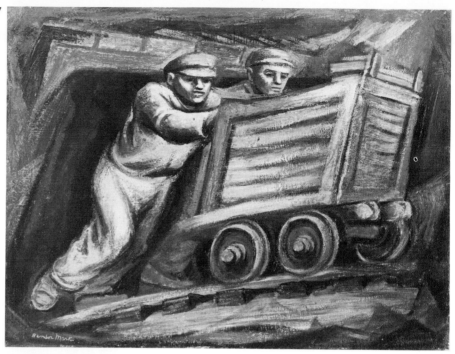

Bendor Mark. Two Men and Cart, c. 1937
Oil on canvas, 41 x 56 cm
National Museum of American Art,
Smithsonian Institution

first President of the Artists' Union and the great figure of later abstract expressionism, Jackson Pollock.

He was assigned as a stone carver and helper in 1935 and stayed with the WPA in New York until 1943. His highest monthly pay was 103.40 dollars.

About his years with the WPA, Anton Refregier wrote in 1977 for the New York City WPA Art Exhibition catalog: "There was a close comradeship among the artists, a respect for each other regardless of the direction each of us chose— the Realist painter along with the Abstract and Surrealists felt a common bond. Recognizing our obligations as citizens, we participated in all major social and economic struggles of the day. We were not degraded by personal opportunism, we were not manipulated by art entrepreneurs, critics nor museums. Our projects were administered by fellow artists taking turns away from their work and by sympathetic people in Washington. We jealously guarded our freedom of expression recognizing at the same time the necessary disciplines and obligations that go with freedom. Together, with writers, musicians, actors, dancers and poets, we were creating a people's art."

But there were, not to forget, constant attacks against all New Deal programs, with the far right denouncing them as "state communism".

This, of course, cautioned the administrators into seeing that artists wouldn't go so far as advocating sit-downs or strikes in the country. As Norman Barr states about the "cat and mouse game" regarding the WPA, "with Congress enjoying the role of the cat", political witch hunts resulted in constant harassment of the artists.

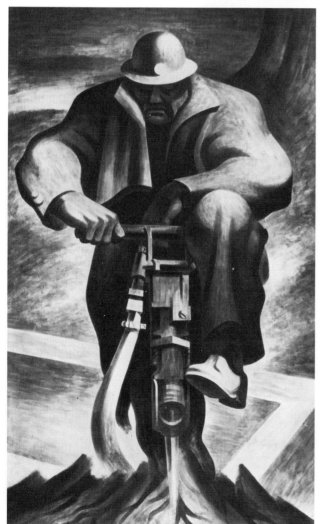

Harold Lehman. Driller, 1937
Tempera on fiberboard, 2.34 x 1.45 m
National Museum of American Art, Smithsonian Institution

Jackson Pollock. Miners
c. 1934–1938
Lithograph, 29 x 39 cm
National Museum of American
Art, Smithsonian Institution

"The Artists' Union, soon to become The United American Artists as part of the Congress of Industrial Organizations, met this onslaught with militancy and determination. Its well prepared and vigorously carried out demonstrations, protests and sit-ins helped to save the project from continual threats of destruction and to prolong its life for some years to come. Needless to say, the authorities responded with the same repressive measures as had been the custom throughout the depression. Beatings and arrests continued. The arrests of 219 artists at one of the demonstrations is still vividly remembered by the survivors of that period as the 'Case of The 219.' However, the artists battled on for their jobs and their rights as artists, and as the struggle continued they began to see themselves in a new dimension. They were not isolated any longer. The solidarity and camaraderie that developed among them as a direct result of the common struggle for survival, created unprecedented conditions for communication, interest in each other's work and in each other's well being. Having developed a great degree of political awareness, they realized that at last they had become respected members of society, that they had won the right to dignity and self-respect. They were proud of their being members of the C.I.O. and they held their heads high . . .

With the nearing of World War II the Congress increased its efforts to discontinue the W.P.A. and finally in January, 1943 the battered and decimated Art Project ceased to exist."

(Norman Barr, New York City WPA Art, N.Y. 1977)

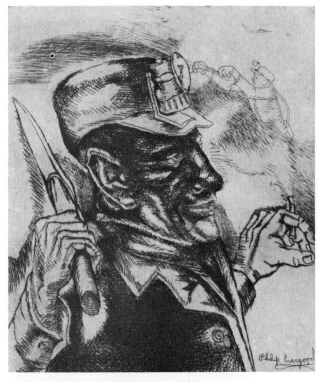

Philip Evergood. Portrait of a Miner, 1936
Etching on steel, 19 x 16 cm

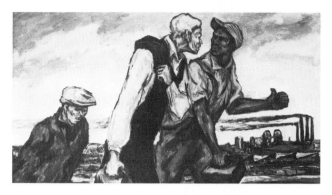

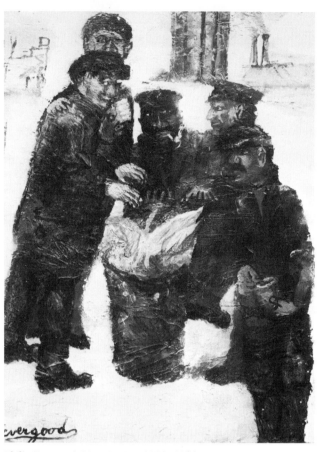

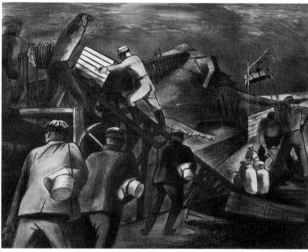

Top: Mervin Jules. The Common Man, 1943
Oil on fiberboard, 19 x 34 cm
Hirshhorn Museum and Sculpture Garden, Smithsonian Institution
Bottom: Harry Gottlieb. Bootleg Mining, c. 1936
Color lithograph, 35 x 45 cm

Philip Evergood. Warming Up, 1928–1938
Oil on paperboard, 24 x 22 cm
Hirshhorn Museum and Sculpture Garden, Smithsonian Institution

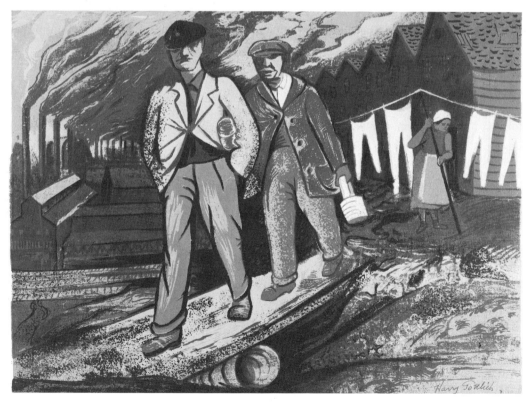

Harry Gottlieb. Going to Work, 1938. Silkscreen, 38 x 51 cm

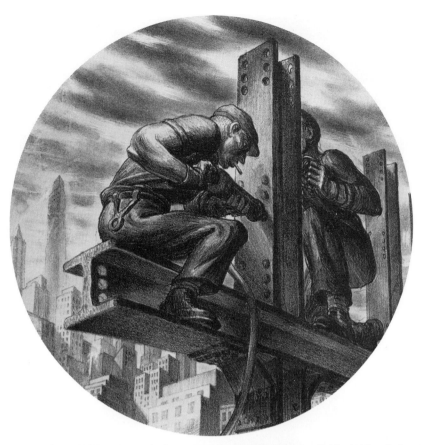

Harry Sternberg. Builders, 1935. Lithograph, 35 cm diameter. Ben and Beatrice Goldstein Foundation, New York

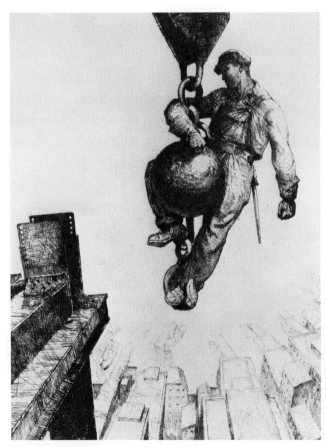

James E. Allen. The Sky Man, 1935
Etching, 32 x 23 cm
National Museum of American Art, Smithsonian Institution

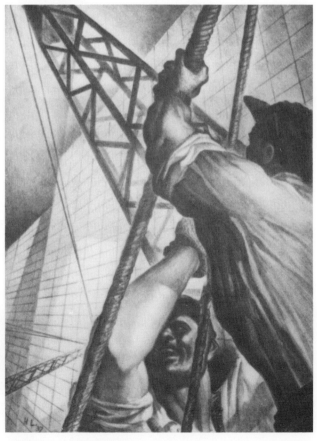

Hershell Levit. Builders, 1937
Lithograph, 31 x 24 cm
Collection Christopher DeNoon, New York

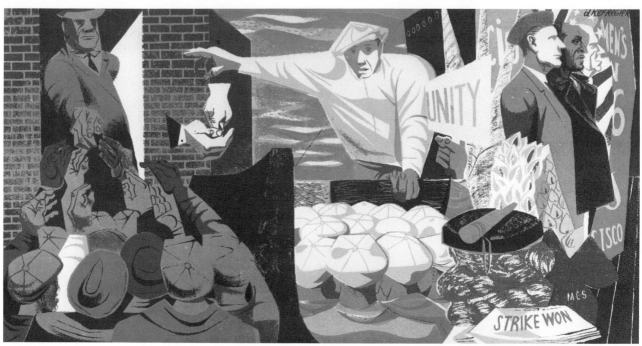

Anton Refregier. San Francisco Waterfront Strike, 1934. Silkscreen, 57 x 29 cm. Ben and Beatrice Goldstein Foundation, New York

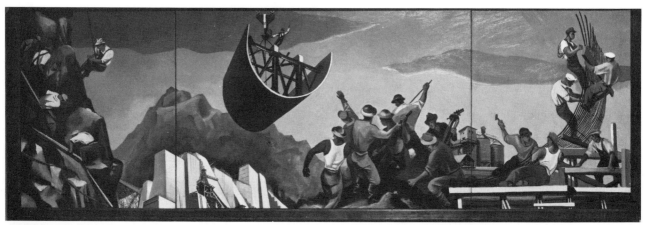

William Gropper. Construction of a Dam (Study for a mural), 1937. Oil on canvas, 76 x 231 cm. National Museum of American Art, Smithsonian Institution

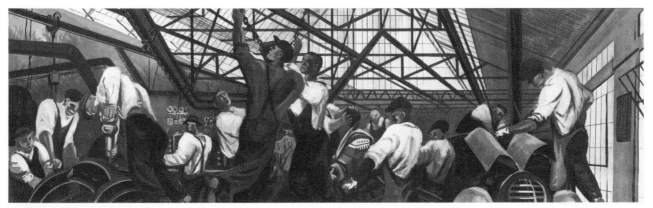

William Gropper. Automobile Industry (Study for a mural), 1941. Oil on fiberboard, 51 x 122 cm. National Museum of American Art, Smithsonian Institution

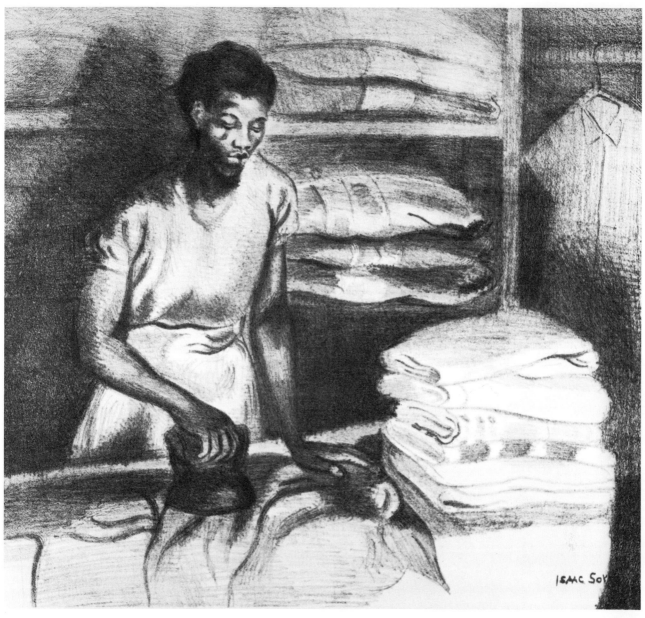

Isaac Soyer. Laundress, n.d. Etching, 141 x 57 cm. Art Institute of Chicago

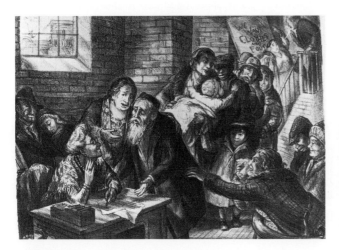

Don Fisherman. Home Relief, n.d.
Etching, 29 x 41 cm
Art Institute of Chicago

Louis O. Guglielmi. American Dream, 1935
Oil on canvas, 55 x 138 cm
Collection Robert Belsky

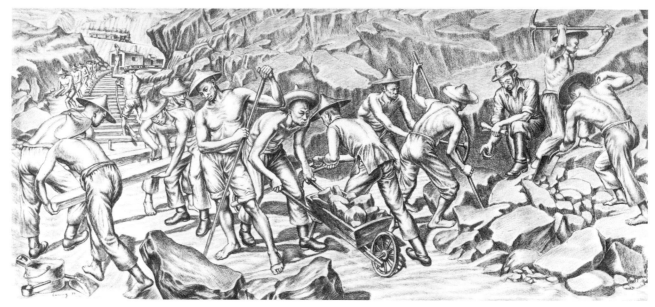

Edward Laning. Passage to India—Central Pacific, 1935. Ink and pencil on paper, 31 x 69 cm. Whitney Museum of American Art, New York

Philip Evergood. Toiling Hands, 1939/1957–1958
Oil on canvas, 61 x 76 cm
Collection Saul Rosen Family

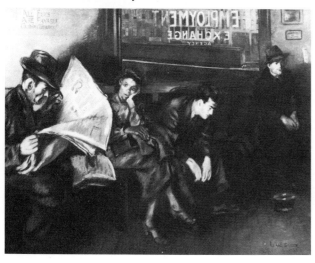

Isaac Soyer. Employment Agency, 1937
Oil on canvas, 87 x 114 cm
Whitney Museum of American Art, New York

San Francisco General Strike, 1934

''The Marine Workers' Industrial Union was a pioneer in the industrial union field; a new organization striving hard to organize the seamen.

On May 9 the boys walked out—all the boys in all the ports —and the maritime industry shut down as if somebody had turned off a faucet. . . .

About this time the Marine Workers' Industrial Union began going aboard the ships and pulling off the crews. They were organizing the seamen so fast that Scharrenberg and other International Seamen's Union officials began to recognize that if they didn't take some action the MWIU would freeze them out. Unable to stall any longer, the ISU began calling strikes. Soon the seamen were a part of the walkout with their own demands and their own representatives on the strike committee. It was now a full maritime strike. . . .

Finally came the major offensive to 'open the port'—one of the most violent assaults by police ever launched against organized labor—Bloody Thursday (July 5, 1934), in which scores were wounded and two men, Nicholas Bordois and Howard Sperry, were shot dead with bullets in their backs.

In the midst of the tense situation which prevailed between July 5th (Bloody Thursday) and the General Strike, the Knights Templar arrived in town by the hundreds for their convention. They strolled the streets in their extraordinary regalia, white plumed hats and shining swords, constituting an embarrassment to civic officials. Conservative midwestern businessmen dressed like 18th century generals, come to enact their fraternal pageantry amidst chaos. . . .

Early on the morning of July 9th, a living sea of people filled Steuart Street outside ILA headquarters and formed into the line of march. Approximately 40,000 men, women and children of every conceivable trade and profession stood silently with hats off in the hot sun, waiting for the services to end and the parade to begin.

The whole length of Market Street, from the Ferry Building to Valencia Street, was filled with mourners. Not a policeman was in sight. Longshoremen wearing blue armbands directed traffic. No police badge or whistle ever received such instant respect and obedience as the calm, authoritative voices of the dock workers.

Labor was burying its own. . . .''
(Mike Quin, On the Drumhead, S.F., 1948)

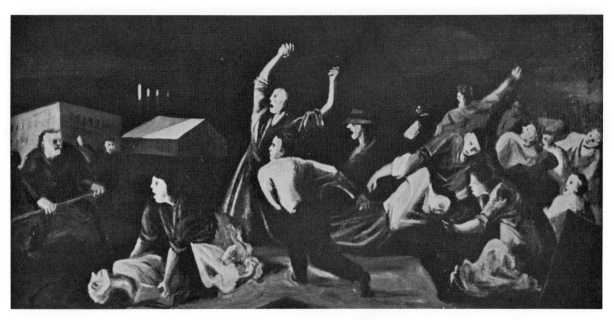

William Gropper. Youngstown Strike, 1937. Oil on canvas, 51 x 102 cm. Collection Mrs. Sophie Gropper, New York

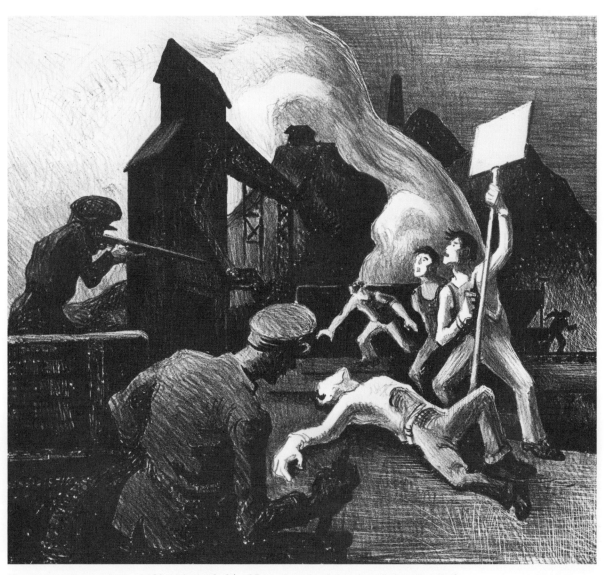

Thomas Hart Benton. Strike, 1933. Lithograph, 24 x 27 cm. Associated American Artists, New York

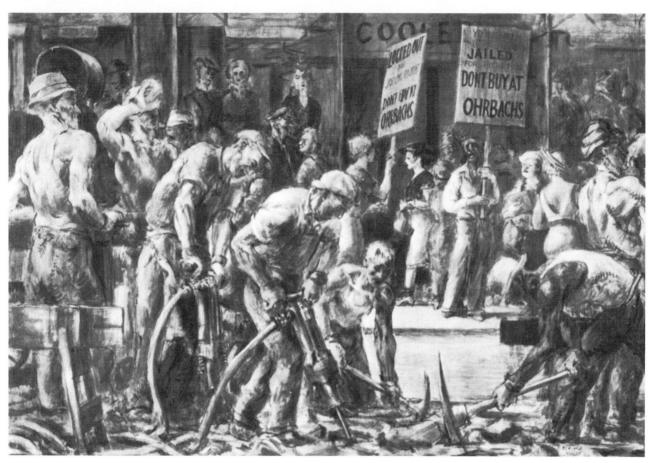

Thomas Hart Benton. Arts of the West. Tempera with oil glaze, 2.42 x 4.11 m. New Britain Museum of American Art, Connecticut

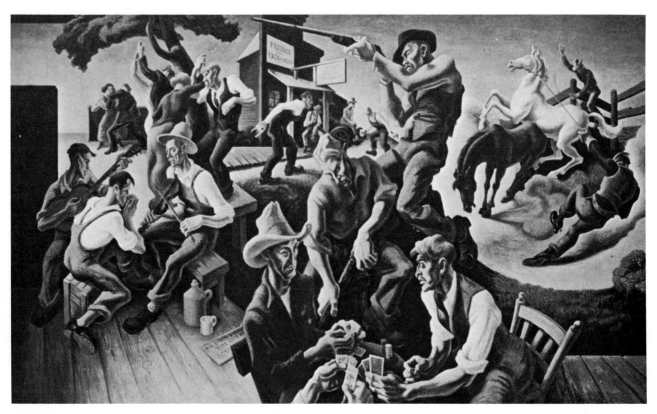

Reginald Marsh. End of the 14th Street Crosstown Line, 1936. Oil and tempera on board, 61 x 91 cm. Pennsylvania Academy of the Fine Arts, Philadelphia

These Are The Class War Dead

Stop in your tracks, you passer-by,
Uncover your doubting head;
The workingmen are on their way
To bury their murdered dead.

The men who sowed their strength in work
And reaped a crop of lies
Are marching by. Oppression's doom
Is written in their eyes.

Two coffins lead the grim parade
That stops you in your tracks;
Two workers lying stiff and dead
With bullets in their backs.

The blood they left upon the street
Was workers' blood and red;
They died to make a better world.
These are the class war dead!

Stand back, you greedy parasites,
With banks and bellies filled,
And tremble while the working class
Buries the men you killed.

This is our word to those who fell,
Shot down for bosses' gain;
We swear to fight until we win.
You did not die in vain!

(Mike Quin, On the Drumhead, S.F., 1948)

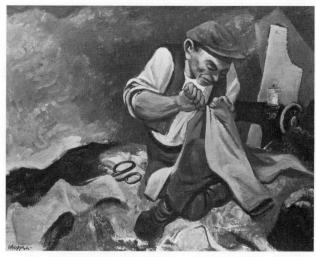

William Gropper. Tailor, 1940. Oil on canvas, 51 x 67 cm
Hirshhorn Museum and Sculpture Garden, Smithsonian Institution

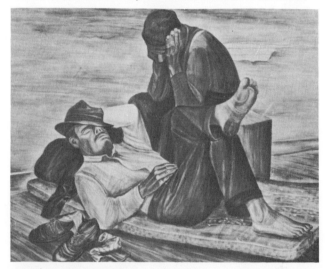

Edward Millman. Flop House, 1937
Tempera on fiberboard, 58 x 76 cm
National Museum of American Art, Smithsonian Institution

Louise Gilbert. The '34 Strike—Calling out the National Guard, 1934
Silkscreen, 22 x 37 cm
Collection Irving Fromer

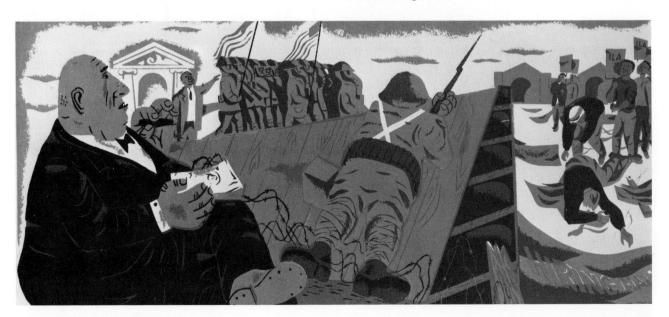

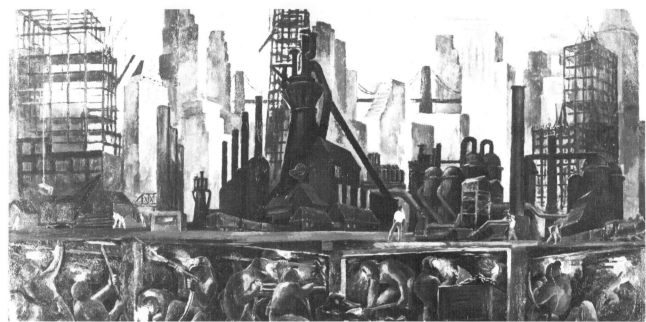

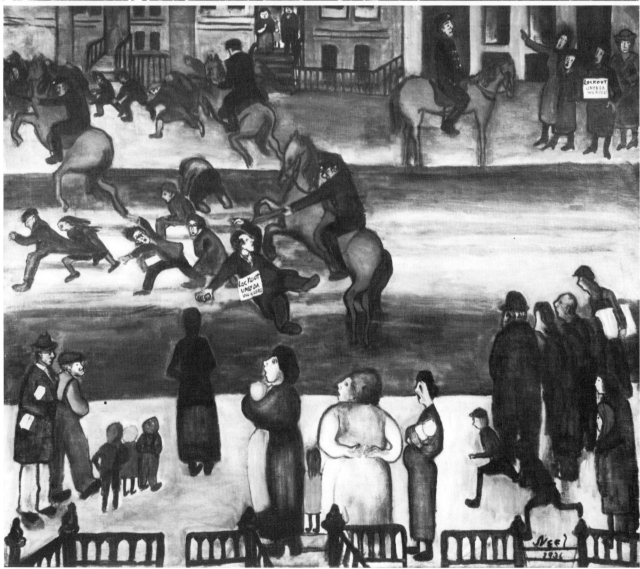

Top: Stuyvesant Van Veen. Foundation of the City, 1937. Oil on masonite, 56 x 104 cm
Collection Mr. and Mrs. Melvin Block, New York
Bottom: Alice Neel. Uneeda Bisquit Strike, 1936. Oil on canvas, 91 x 109 cm

"The Exhibition at Freedom House, New York, of documentary and pictorial material of Europe's Fighting Underground, arranged by the American Labor Archive and Research Institute, was an event of outstanding significance. For the first time the American people were presented with the tangible and visual proof of the seething underground movement in all the Nazi-dominated countries of Europe. Here the mysterious underground could be visualized in terms of men, women and children, not merely as helpless victims to arouse pity, but as implacable, heroic fighters to arouse admiration and respect.

Mrs. Eleanor Roosevelt, in opening the Exhibition to the public, pointed out its real function when she said: 'Here we see what labor and social conditions are like in Europe today. This is an attempt to show the forces of passive and aggressive resistance to the invader by European underground organizations, and by the representatives of free labor who are now in exile in other countries. This exhibition should be of great interest to us in this country, for it will serve as a valuable source of information to those who attempt to restore free government in the conquered countries after the war.'

Historical Significance of Exhibition

The historical significance of the Exhibition was pointed out by (. . .) Mr. Matthew Woll, Vice-President of the American Federation of Labor, (who) said: 'A century hence, our descendants will regard the underground movement of these terrible days with the same thankful admiration with which we now look upon the stubborn, embattled workers and farmers of the American Revolution.'"
(Europe's Fighting Underground, N.Y., n.d.)

NEW YORK DEMONSTRIERT GEGEN DIE HAKENKREUZ-FAHNE AUF DER „BREMEN". Die Fahne wurde von einigen Antifaschisten abgerissen. Am Ufer begrüßten Tausende das Fallen der blutigen Fahne. — Blick auf die Demonstration auf dem Hafenkai.

New York demonstrates against the Nazi-flag aboard the "Bremen"
Arbeiter-Illustrierte Zeitung, 1935. Werkbund Archiv Berlin

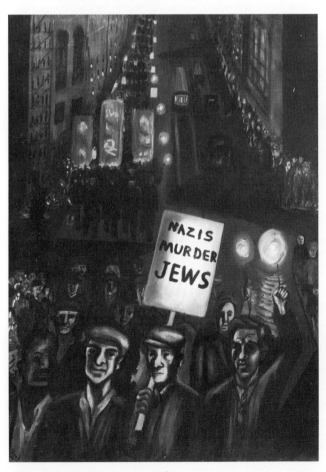

Alice Neel. Nazis Murder Jews, 1936
Oil on canvas, 107 x 76 cm

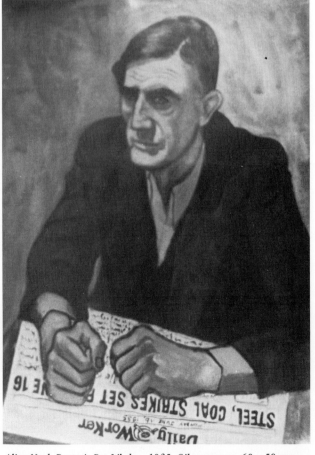

Alice Neel. Portrait Pat Whalen, 1935. Oil on canvas, 69 x 59 cm
Whitney Museum of American Art, New York

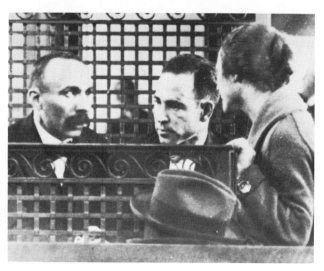

UPI. Sacco and Vanzetti in Court, 1921

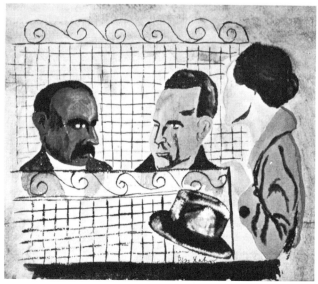

Ben Shahn. Sacco and Vanzetti: The Prisoner's Dock, 1931–32
Gouache, 22 x 26 cm

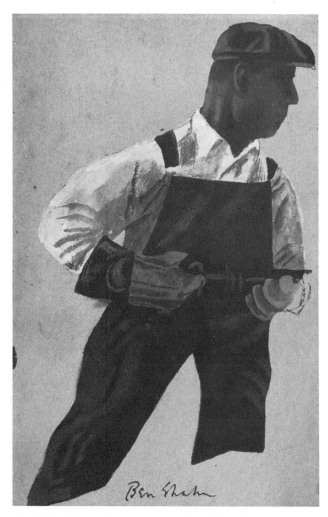

Ben Shahn. Riveter (Study for a mural), c. 1940–42
Gouache on board, 31 x 20 cm
Kennedy Galleries, New York

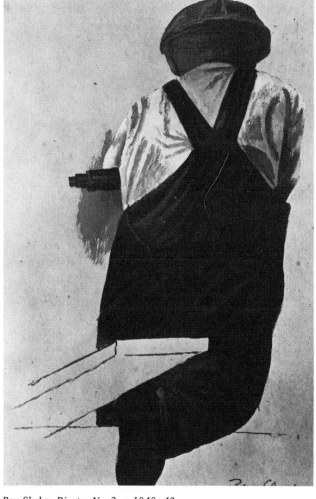

Ben Shahn. Riveter No. 2, c. 1940–42
Gouache on board, 31 x 20 cm
Kennedy Galleries, New York

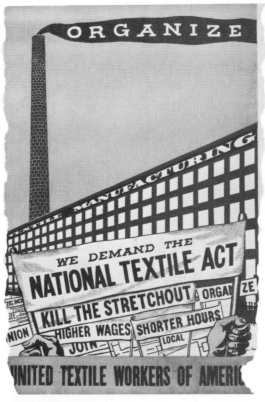

Ben Shahn. We Demand the National Textile Act, 1935
Poster, 106 x 70 cm
New Jersey State Museum, Trenton

Rockwell Kent. Title unknown, 1941
Lithograph, 30 x 23 cm
Associated American Artists, New York

Rockwell Kent. Title unknown, 1941
Lithograph, 31 x 23 cm

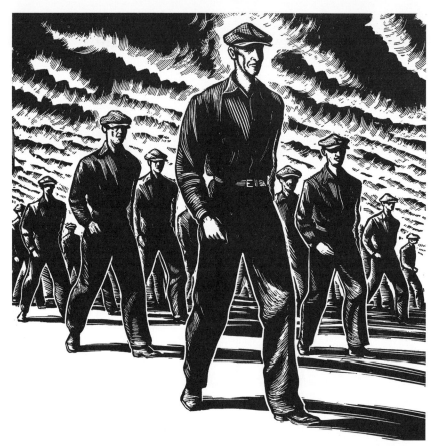

Giacomo Patri. Cover for "Storm over Bridges" by Leo Huberman, 1941. Linocut

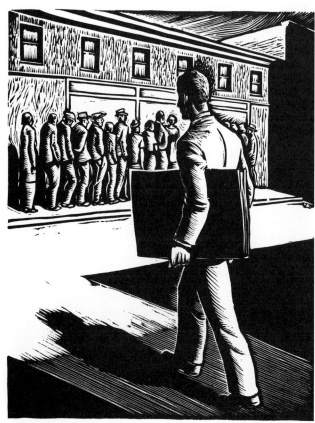

*Giacomo Patri. Image from
"White Collar—A Novel in Linocuts", 1940*

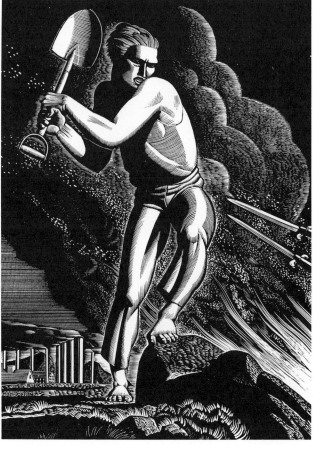

*Rockwell Kent. Workers of the World Unite!, 1937
Wood engraving, 20 x 15 cm*

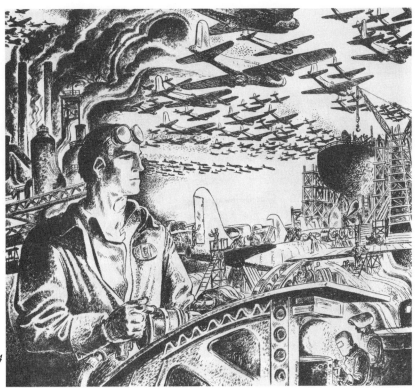

Lynd Ward. American Labor and Management, 1944
Lithograph, 41 x 46 cm
Ben and Beatrice Goldstein Foundation, New York

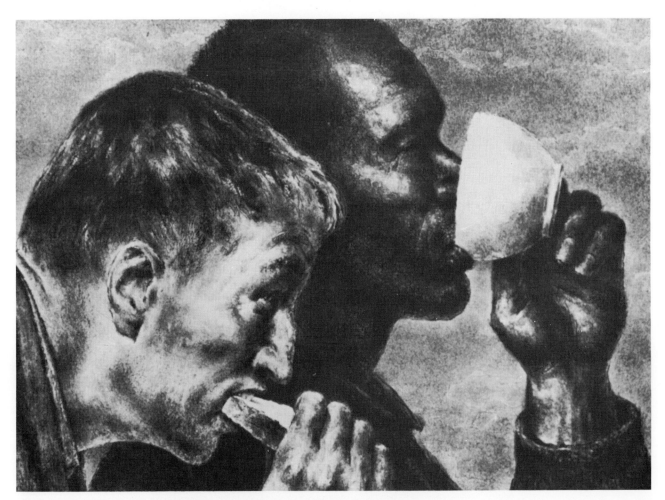

Joseph Hirsch. Banquet, 1945. Lithograph, 25 x 35 cm. Corcoran Gallery, New York

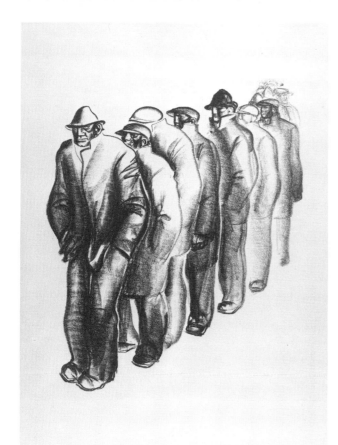

Top left: Hugo Gellert. Law of Capitalistic Accumulation. Lithograph for "Karl Marx' Capital in Lithographs", 1934. Top right: Law and Order. Lithograph for "Comrade Gulliver", 1935. Bottom: Patronage. Lithograph for "Comrade Gulliver", 1935

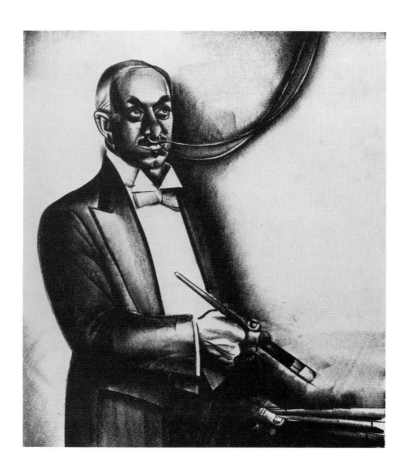

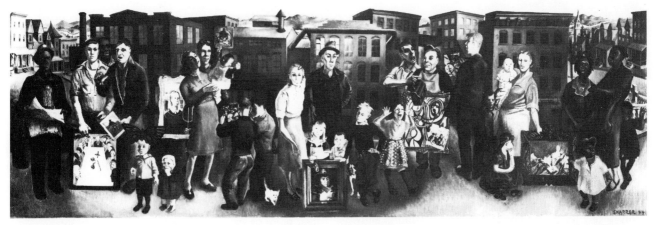

Honoré Sharrer. Workers and Paintings (Study for a mural), 1943. Oil on composition board, 30 x 94 cm. Museum of Modern Art, New York

From World War II to the 1980s

After the United States directly intervened in the war against fascism, many—especially younger—artists left for the front. As far as art and labor were concerned, there was basically only one theme still considered to be important—workers and war production. But only a few cared to illustrate it. Just as World War I had caused extensive migration of Blacks from the South to replace those gone to fight in Europe, Afro-Americans again were needed in industry—as were women.

It was not easy to break through the many barriers set up in a racist system, but substantial progress was eventually made. The human side of this is shown in a lithograph by Joseph Hirsch, 1945, an image which also implies the hardships endured by workers during the war.

After the anti-communism of the Cold War period began to sweep the country, it took extreme courage to comment on the realities of U.S. society like Philip Reisman did in his painting "The Trial". This was an exposure of the true nature of the witch hunts conducted by Wisconsin Senator McCarthy and his House Un-American Activities Committee.

One great artist, Ben Shahn, who had previously designed art work for labor union posters as early as 1935, continued to do such work for the Congress of Industrial Organizations (CIO) until 1946. In the San Francisco Bay Area, progressive artists and labor activists kept the California Labor School active until the late 1940s when being forced to close it down because of the constant hounding from McCarthyites. Yet the artists endeavored to continue under the name of the Graphic Art Workshop. One of them, Adelyn Cross Ericksson, left for Stockholm when her husband, a Swedish immigrant was deported.

Progressive artists suffered much in this period as did anyone active on the left. The great worker-painter Ralph Fasanella from New York who had exhibited widely in union halls suddenly found that there was no place anymore for his work. It took the art critics more than 20 years to rediscover this unique talent who at the time was still wiping windshields and pumping gas underneath the Cross-Bronx Expressway.

With the dramatic struggles of the Civil Rights, peace and other political movements since the 1960s a younger generation of artists stepped forward.

They have joined those of the older generation who are still active like Hugo Gellert. Born in Hungary in 1892, he began "to try his artistic wings" (Art Young, 1928) with painted sets for the Hungarian-American Workers Travelling Theatre.

"In the April 7, 1975 Arts and Leisure section, Hilton Kramer, referring to the 1934 artists' protest against Nelson Rockefeller's savaging of Diego Rivera's mural in Rockefeller Center, called Gellert a 'long forgotten painter.' Gellert and the ten other leaders of the protest had been described by the Herald Tribune that February 14, 1934 as 'eleven of New York's best known artists.'

Henry Koerner. Vanity Fair, 1946
Oil on composition board, 91 x 107 cm
Whitney Museum of American Art, New York

Philip Reisman. The Trial, 1955
Oil on masonite, 72 x 87 cm
Collection Mrs. Florence Lipman

41

Sometimes a 'best known' artist of one period can be a long forgotten painter in later years. But a review of Gellert's career indicates that Kramer's assessment is less than objective. 'He and Rockefeller would like to forget me,' Gellert said of Kramer's remark. 'They like to pretend that I never existed.' . . .

Unlike some modern American artists, Hugo Gellert has never accepted anti-social pseudo-theories of art. Nor has he sold out his understanding of the laws of history for the lawlessness of the market place.''
(Johnny Woods, Daily World, Aug. 14, 1975)

Also the younger artists today, commenting on the realities faced by the working people of the U.S., have had to button down the hatches especially in recent years. There are no WPA-like programs, only occasional small local projects to support them.

Little, if any, money is to be made in commercial galleries.

Only a few unions will employ them for cultural activity. The noteworthy exception was District 1199, National Union of Hospital and Health Care Employees in New York.

A review about its Working American exhibition which later travelled all over the U.S. states:

''Currently in the midst of their two-year 'Bread and Roses' cultural project, the union has—along with mounting a series of programs that includes drama, music, poetry readings, and symposiums—established Gallery 1199, the only permanent exhibition hall in the labor movement. According to 1199's executive secretary, Moe Foner, it attracts 'more than twelve thousand members each year, most of whom have never visited a gallery.' Last winter, many of them came to see 'The Working American,' an unusual gathering of two centuries of paintings from which this portfolio is drawn. The subjects are as varied as the nation itself, ranging from men driving iron into a whale on a heaving sea to Edgar Melville Ward's serene turn-of-the-century coppersmith . . .''
(American Heritage, No. 4, 1980)

There have been a few smaller projects such as the exhibitions sponsored by the United Automobile Workers, featuring works by UAW members, some of which have been reproduced in UAW local calendars recently.

There were also 1,500 pieces of art entered into a contest announced in the union's Solidarity magazine in 1980.

There is, of course, a network of small galleries, magazines and distributors kept alive by hard-working cultural activists. But generally they can only help with the presentation and not with providing an income to feed the artists. Most of them work all kinds of odd-jobs to survive. One of the first of those organizations was the La Raza Silk Screen Center, established in the early 1970s in the Mission District of San Francisco. Representative of other such outlets it stated in 1973:

''The work done at the center is a blend of cultural, commercial, and movement work. By cultural it is meant that a portion of the posters produced have a theme or message that convey aspects of the Latino culture and heritage. By commercial it is meant that the posters printed in this area are for community oriented groups and organizations who wish to advertise an event, function, or cause. By movement it is meant that posters and placards are printed for people, groups, and organizations who want to distribute their point of view or announce an upcoming rally.''

Its successor, La Raza Graphic Center, Inc., today services approximately 100 groups and organizations, including the United Farmworkers of America union and the San Francisco Mime Troupe, the internationally respected radical street theatre established in 1959.

Although this indicates some kind of progress, at least for the Center, the situation of artists has deteriorated considerably under Reaganomics.

As Csaba Polony, editor of the ''veteran'' Left Curve Magazine of Contemporary Cultural Work puts it:

''We're all in the same boat together, and not only do we have to patch up the holes through which the stench of the sewer-water of the system keeps seeping into our minds, but eventually a new boat has to be built.''

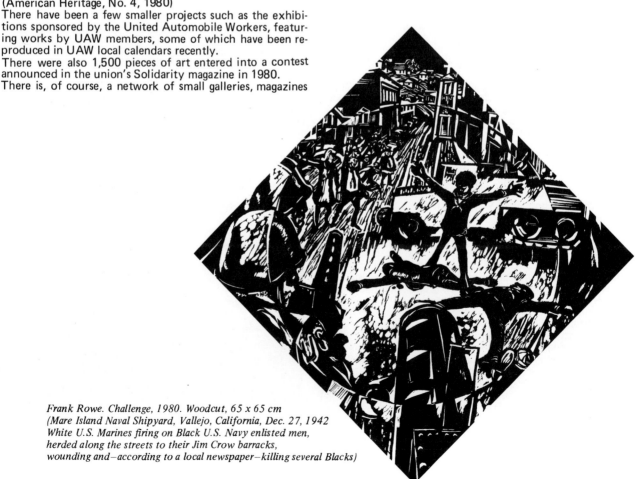

Frank Rowe. Challenge, 1980. Woodcut, 65 x 65 cm
(Mare Island Naval Shipyard, Vallejo, California, Dec. 27, 1942
White U.S. Marines firing on Black U.S. Navy enlisted men,
herded along the streets to their Jim Crow barracks,
wounding and—according to a local newspaper—killing several Blacks)

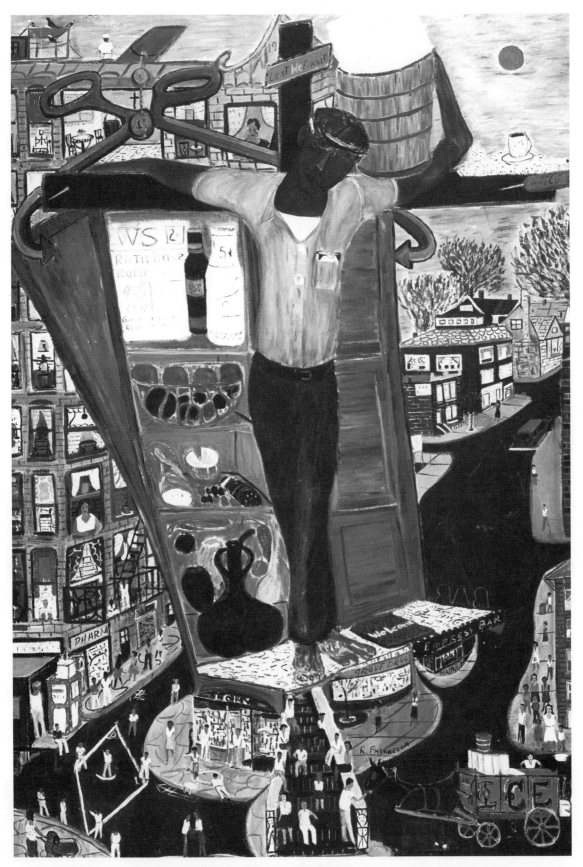

Ralph Fasanella. Iceman Crucified, 1958. Oil on canvas, 92 x 63 cm

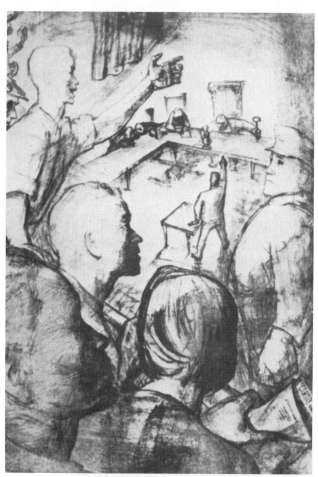

Tamara Patri. Giacomo Patri's Portrait Class of the California Labor School, San Francisco, August 14, 1944

Irving Fromer. Courage is Contagious, 1955 Lithograph, 70 x 50 cm

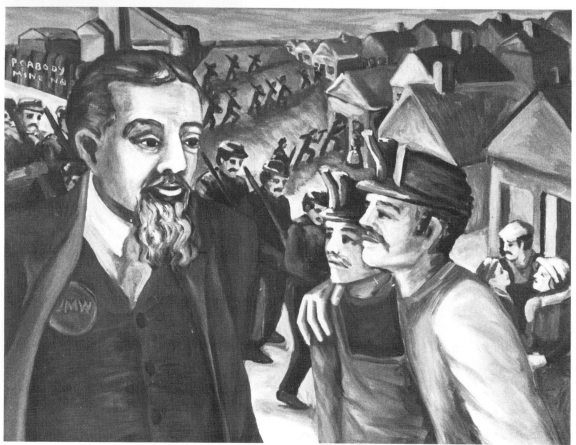

Kathleen Farrell-McSherry. Mc Laughlin Talking to the Miners (1877), 1981. Acrylic on canvas, 76 x 102 cm

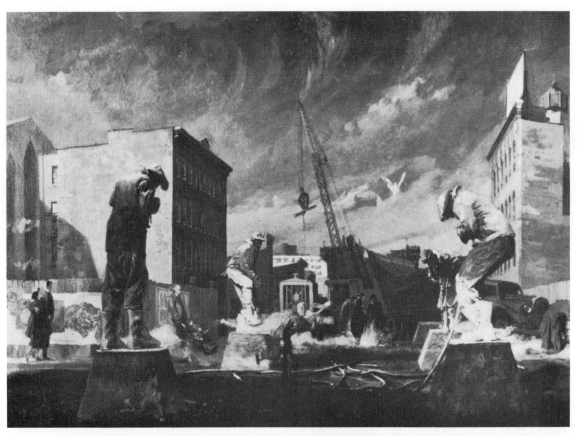

Stanley Meltzoff. Demolition of the Myrtle Avenue Elevated, 1951. Oil and tempera on panel, 66 x 97 cm

Left: Arnold Trachtman. Spirit of '76, 1979
(Bussing riots in Boston)
Acrylic on canvas, 193 x 153 cm
Right: R.B. Kitaj. Ramon, 1978. Crayon on paper, 56 x 38 cm
The American Can Company, Greenwich, Connecticut

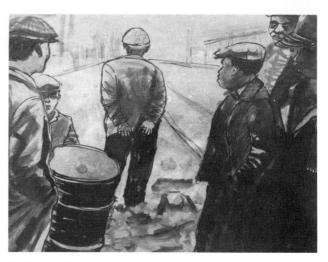

Frank P. Saso. Workbreak, 1981. Gouache, 50 x 65 cm

Fethi Meghelli. No Jobs, 1979. Ink on paper, 28 x 36 cm
Collection Robert E. King

Robert Rauschenberg. Labor's Centennial, AFL-CIO, 1881–1981
1981. Photo-offset in colors, 74 x 50 cm

Susan Ortega. The Immigrant Series. (Based on photos by Lewis Hine).
Top left: The Armenian. Right: The Italian
Center left: The English Girl. Right: The Gypsy
Bottom left: The Ukrainian. Right: The Pole
1979. All images: Charcoal on paper, 61 x 48 cm

Norman Rockwell. Indians and Dam, 1970. Mural. Department of the Interior Washington, D.C.

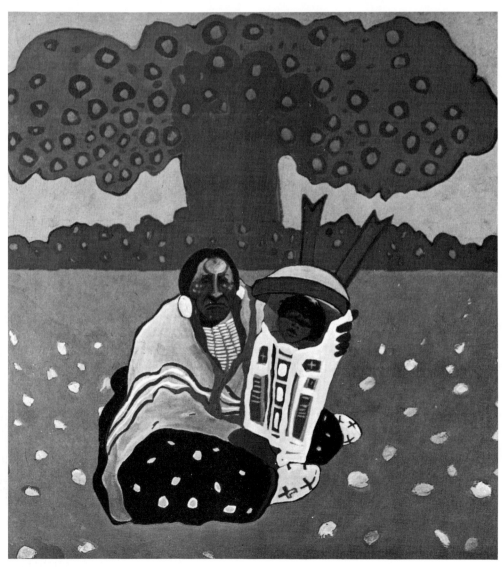

T.C. Cannon. Village with Bomb, 1972. Acrylic on canvas, 97 x 83 cm. Aberbach Fine Arts, New York

Jorge Soto Sanchez. Our Forgotten History, 1982. Lithograph, 66 x 102 cm

Marcos Quimos. Santiago Andrades—Sociedad de Amigos
del Bien Publico, 1846—1897, 1975
Silkscreen, 67 x 51 cm

Bruce Kaiper. Highway Robbery, 1974
Photo-silkscreen, 61 x 43 cm

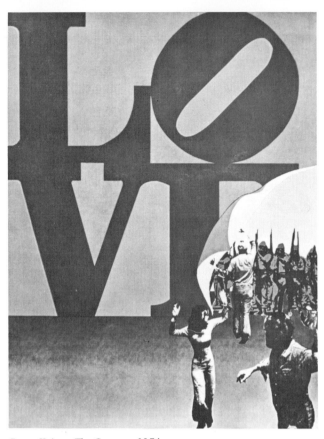

Bruce Kaiper. The Coverup, 1974
Photo-silkscreen, 56 x 46 cm
(A satire of the Robert Indiana painting that was selected by the
U.S. Postal Service during the Vietnam War to adorn a postage stamp)

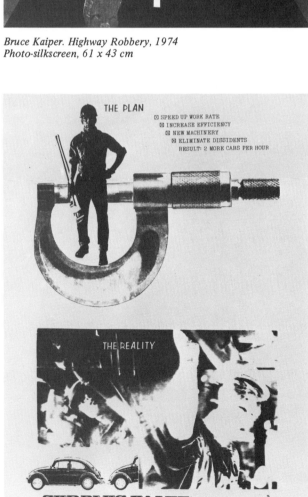

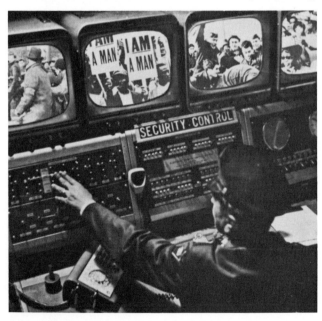

Bruce Kaiper. All Systems Out of Control, 1974
Collage, 25 x 23 cm

Bruce Kaiper. Surplus Value, 1973
Photo-silkscreen, 63 x 41 cm

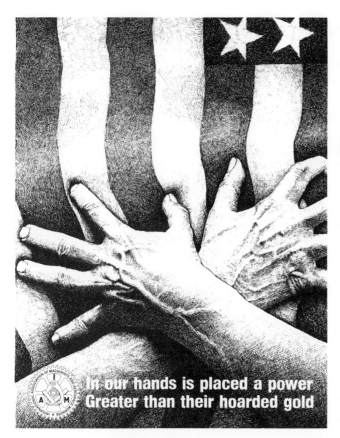

Unknown. IAM poster, 1982
Offset, 71 x 55 cm

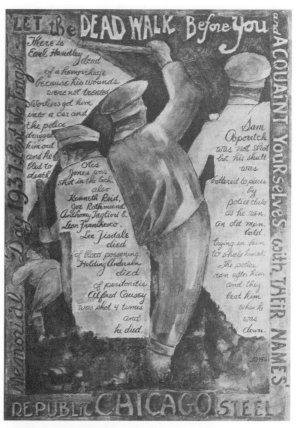

CAC. Memorial Day, 1937. Lest We Forget, 1975
Photo-offset in colors, 71 x 52 cm
Poster for the National Steelworkers Rank and File Committee, Ohio

Doug Minkler. We Don't Want a Bigger Piece, We Want the Whole Thing, 1979. Silkscreen, 28 x 35 cm

Images of the Afro-American Experience

Unknown. The Old Plantation, c. 1800. Watercolor
Rockefeller Collection, Williamsburg, Virginia

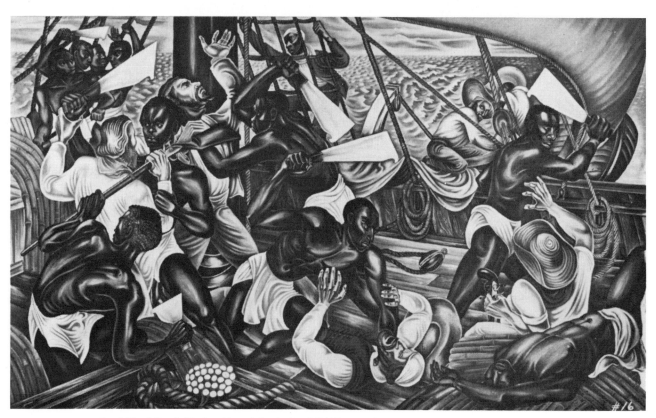

Hale Woodruff. Amistad Mural No. 1: Mutiny Aboard the Amistad (1839), c. 1938. Savery Library of Tallandega College, Alabama

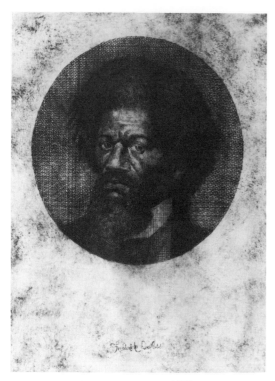

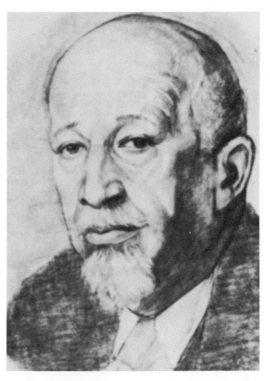

Charles White. Frederick Douglass, 1973
Etching, 59 x 45 cm
Heritage Gallery, Los Angeles

Charles White. W.E.B. Du Bois, 1974–75
Charcoal on paper

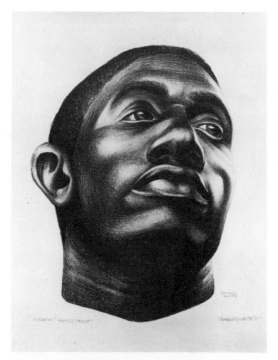

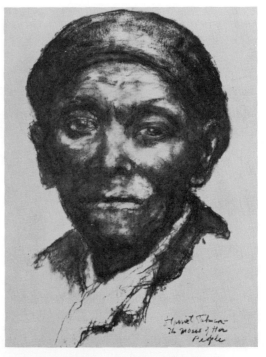

Charles White. Gideon, 1951
Lithograph, 55 x 37 cm
Heritage Gallery, Los Angeles

Tecla. Harriet Tubman–The Moses of Her People
1820–1913, c. 1970. Charcoal on paper

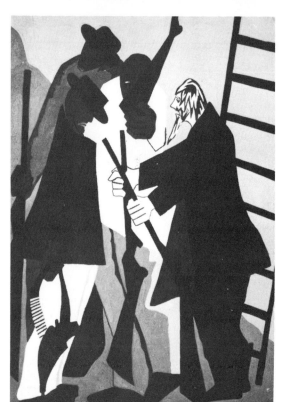

Jacob Lawrence. John Brown. No. 6 of "John Brown Series", 1941
Gouache, 50 x 35 cm. Detroit Institute of Arts

Jacob Lawrence

Jacob Lawrence, born in 1917 in Atlantic City, New Jersey, created a number of paintings relating to Black history dealing with: Toussaint L'Ouverture (1937—38); Frederick Douglass (1938—39); Harriet Tubman (1939—40); Migration (1940—41); John Brown (1941); Harlem (1942—43); War (1946—47); and, Struggle (1955—56). In 1978 he was nominated by President Carter and confirmed by the U.S. Senate to serve as a commissioner on the National Council of the Arts.

"Seven years ago, in its November, 1941, issue, Fortune reproduced twenty-six paintings by Jacob Lawrence. They were pictures of Negro migration from South to North in the U.S. They were daring pictures, done with a deliberately shocking economy of artistic method. Lawrence, a northern-city Negro, painted strident yet somehow calm scenes of things that took place among that mass of people suddenly moving from work on the cotton land into the world of oiled-metal assembly lines, really tough labor warfare, and crushing, dirty weather.

Milder—but not mild. The great hurt group of people that is Jacob Lawrence's subject still forces him to leave all the small, pleasing tricks of painting alone. Ol' Man River as a song has a certain prettiness; but there is never anything scaled to prettiness in the songs you may sometimes hear from the lungs of cotton-field Negroes when they let go in their tones, for their own relief. That is not for squeamish eardrums nor for fanciers of cheery folklore.

Nor do Jacob Lawrence's pictures come from such European or American culture as has arrived at academic gentility. That is why this note has called them daring."
(Walker Evans, Fortune, Aug. 1948)

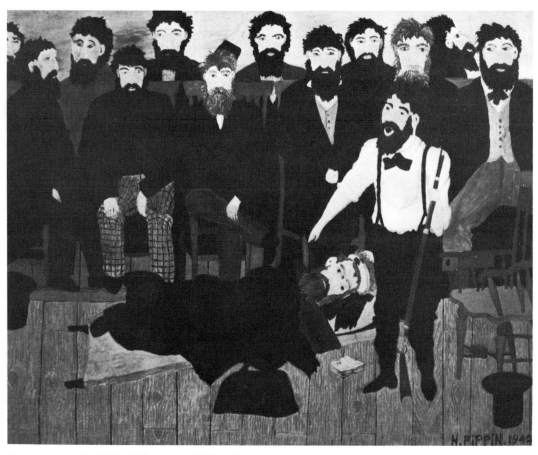

Horace Pippin. The Trial of John Brown, 1942. Oil on canvas, 41 x 51 cm
Collection Dr. and Mrs. Marvin Radoff

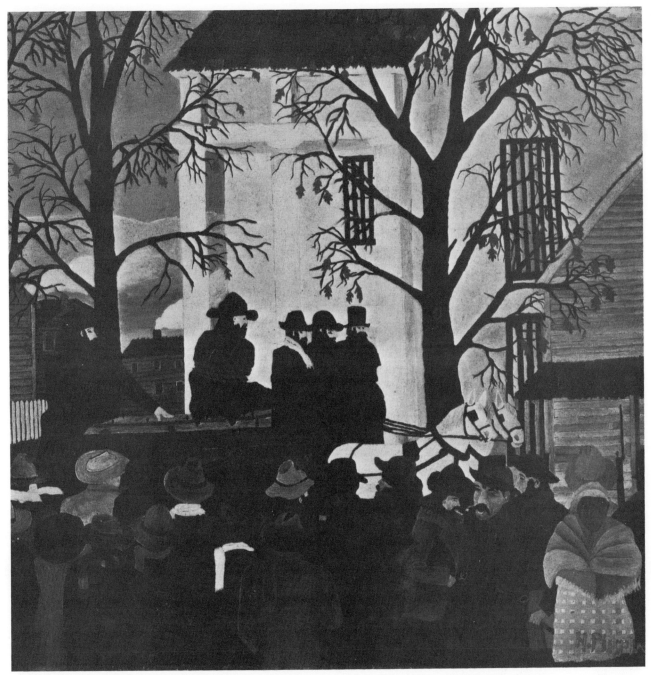

Horace Pippin. John Brown Going to His Hanging, c. 1942. Oil on canvas, 61 x 76 cm. Pennsylvania Academy of the Fine Arts, Philadelphia

Horace Pippin

Horace Pippin, born in 1888 in Pennsylvania, worked as an iron molder before enlisting in the Army in 1917. He returned with his right arm crippled. In 1925 he began to experiment with burnt-wood panels in maneuvering the panels with his left hand against a "white-hot poker" balanced on his knees.

Pippin started to paint in 1930 with "End of the War: Starting Home" and continued with other war scenes. In 1942 he painted three pictures of John Brown, the great abolitionist who helped slaves to escape from Missouri on the Underground Railroad and battled with pro-slavery forces moving around Kansas. In 1859 he and a small band of less than 50 men seized the federal arsenal at Harper's Ferry in Virginia to secure ammunition for an attack on the slaveholders. Before he was hanged on December 2, 1859 he told a reporter of the New York Herald:

"I pity the poor in bondage that have none to help them;

that is why I am here; not to gratify any personal animosity, revenge or vindictive spirit. It is my sympathy with the oppressed and wronged, that are as good as you and as precious in the sight of God. . . . You may dispose of me easily, but this question is still to be settled—the negro question—the end of that is not yet."

Upon hearing his sentence he calmly said:

"Now, if it is deemed necessary that I should forfeit my life for the furtherance of the ends of justice, and mingle my blood further with the blood of my children and with the blood of millions in this slave country whose rights are disregarded by wicked, cruel, and unjust enactments, I say, let it be done."

In a 1976 essay, Romare Beardon shared his reflections on Horace Pippin:

"On the one hand, Pippin was concerned with incidents of his childhood, historical events, and his experiences as an

55

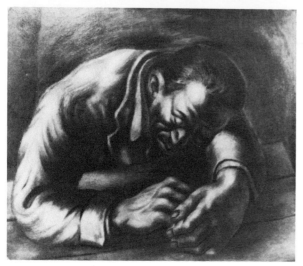

Charles White. Exhausted Worker, 1935
Oil on canvas, 71 x 81 cm

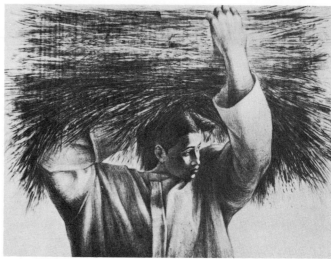

Charles White. Harvest, 1965. Lithograph
Staatliche Kunstsammlungen Dresden (GDR)

infantryman in World War I, but even so he developed these concerns out of the sensibilities contingent with art, not out of just a description of the actual world. To the extent that he was able to realize this conception, Pippin must have felt he had achieved a favorable accuracy in his work. When he first began to paint as a man in his forties, Pippin depicted what was then uppermost in his mind, his war experiences, the grim details of which he knew at first hand. He next did a remarkable series of works where the focus was almost entirely based on recollections of his childhood and they tell us of Pippin's early life as well as that of many Afro-American families, at the turn of the century.

Pippin's paintings of Abraham Lincoln and John Brown, and his still life paintings (that have a certain similarity to the fruit and flower chromo prints of the late 19th century) were done in approximately the same period of the early 1940's. Lincoln and John Brown were as much a part of the actuality of the Afro-American experience, as were the domino games and the hoe cakes for Sunday morning breakfast. I vividly recall the yearly commemorations for John Brown and see my grandfather reading Brown's last speech to the court, which was a regular part of the ceremony at Pittsburgh's Shiloh Baptist Church.''

Pippin died on July 4, 1946, shortly after being awarded the Purple Heart for his services in World War I.

Charles White

Charles White, born in Chicago in 1918, participated in the formation of the Arts & Craft Guild at the age of 14 and entered art competitions at the Chicago Academy of Fine Arts and another academy two years later where each time he won scholarships. When he went to these·respective schools to start his studies he was denied registration. Later, when he was included in an exhibition at the Delgado Museum, he was not allowed to enter because this institution—like many others—only catered to "white folks".

In the foreword to the catalog for the Image of Dignity retrospective at the Studio Museum in Harlem in 1982, the Executive Director Dr. Mary Schmidt Campbell wrote:
"In many regards, Charles White is the quintessential Black artist. He came to national attention during the WPA years, an era that witnessed for the first time in American history a large number of Black artists, supported by the government, who were able to produce significant bodies of work. Like many Black artists of the period—Elizabeth Catlett, Hale Woodruff, Romare Beardon, Charles Alston—White was inspired by the revolutionary images of the Mexican muralists, Diego Rivera, Jose Orozco and David Siqueiros. Although White's early works were very often pointedly political, represented in the exhibition by Can a Negro Study Law in Texas, or Freeport, his use of alle-

gory (influenced no doubt by his stay at the Taller de Grafica in Mexico), is evident in his early paintings as well.

. . . Like many Black artists whose careers blossomed during the WPA years, White began to interpret the Black experience in mythic, symbolic terms. Like Aaron Douglas, Eldzier Cortor and Hughie Lee-Smith, White found it necessary to abandon a straightforward realism in order to penetrate the meaning of the African American heritage. The hallmarks of his mature style have, by now, become familiar: the use of black and white medium almost exclusively in his mature works of the 1960s, the anatomical distortions, especially enlarged hands, deeply-expressive prism of light and dark, enigmatic gestures, all combine to create human figures freighted with poetry and wisdom. Whether they are individual pieces, such as Mayibuye Africa, 1961, or General Moses, 1965, or from one of his many series, such as I Have Seen Black Hands, 1969, the Wanted Poster Series, 1969, or the Love Letters, 1977, they are united in that all focus on the human figure. Sometimes the person is a specific historical figure: Harriet Tubman, Frederick Douglass, Sojourner Truth, Bessie Smith are among White's heroes. More often however, the heroism and the dignity are embodied in anonymous Black people. Though anonymous, their features are always clearly defined. White has etched their mood or attitude into their face, pose, gesture, clothes and, in some cases, their abstract emblematic settings. They have become symbolic fragments of the historical experience of Black America.''

In 1980 the National Union of Hospital and Health Care Employees presented his work at Gallery 1199, and in its Progress Report stated:
"The paintings of Charles White about the struggles, strengths and dreams of black people won him recognition as a major American artist with a universal appeal.
They will be on display from Sept. 10 through Dec. 6 at Gallery 1199 in union headquarters in Manhattan.
Noting that White grew up in the Black ghetto in Chicago, author Lorraine Hansberry wrote that 'memories of that crucible, the Chicago South Side, must live deep within the breast of this artist. . . . The humanity of a vision has utterly taken command and, wedded as it is to the drawing tools of a master craftsman, the result is that beauty of statement, that totality, which in art defines man everywhere and the indomitable nobility of his potential.'
White died last Oct. 3 in Los Angeles, where he lived since 1956. The 1199 exhibit, presented by the 1199 Bread and Roses cultural program, is the first exhibit of his work in New York since his death.
In connection with the exhibit, Freedomways magazine will hold a book party Oct. 23 at Gallery 1199 in honor of its special issue devoted to White's work.''

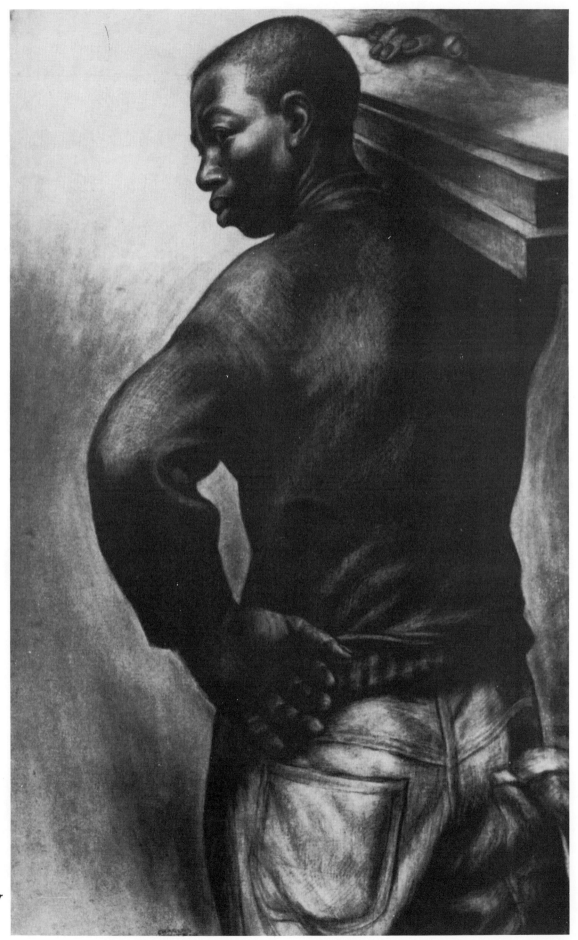

Charles White
Young Worker
1954
Wolff crayon
102 x 76 cm

Robert Blackburn. The Toiler, n.d. Lithograph

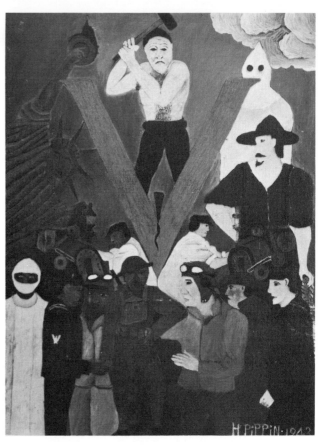

Horace Pippin. Mr. Prejudice, 1943. Oil on canvas, 46 x 36 cm
Collection Dr. and Mrs. Matthew T. Moore

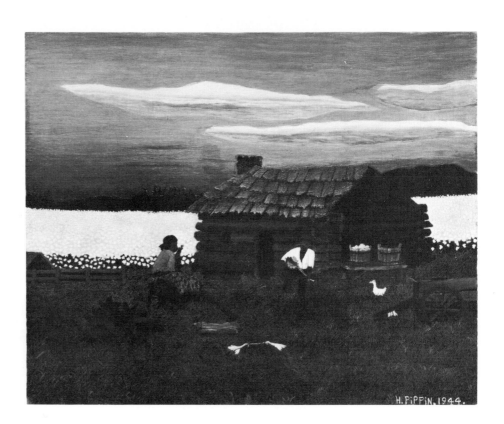

Horace Pippin. Cabin in
the Cotton III, 1944
Oil on canvas, 58 x 74 cm
Collection Roy R. Neuberger

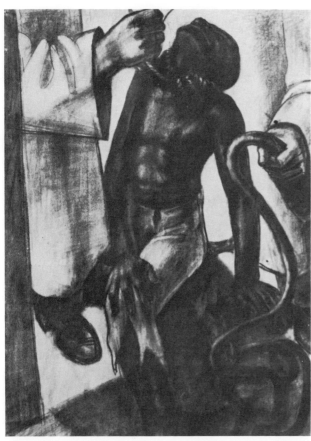

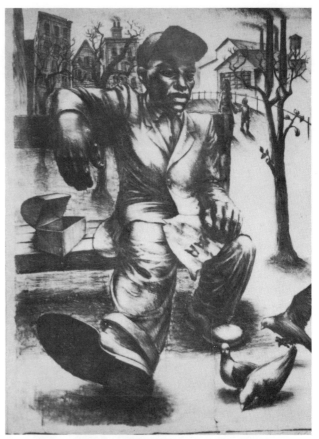

John Wilson. The Incident, 1952. Conté crayon

John Wilson. Breadwinner, 1942. Lithograph, 48 x 36 cm

Vincent D. Smith. Sharecropper, 1967
Oil on canvas, 48 x 65 cm

Samuel J. Brown. Scrub Woman, 1937. Watercolor

Romare Beardon. Roots Odyssey, 1978. Silkscreen, 69 x 53 cm
Ben and Beatrice Goldstein Foundation, New York

Aaron Douglas. Building More Stately Mansions, 1944
Oil on canvas, 122 x 92 cm
Department of Art, Fisk University, Nashville

Jacob Lawrence. Workshop, 1972
Lithograph, 56 x 46 cm
Ben and Beatrice Goldstein Foundation, New York

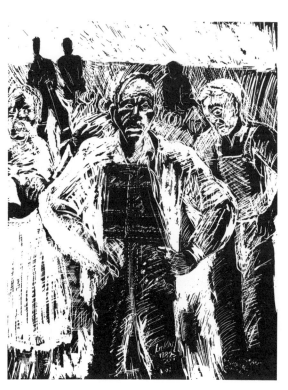

Ann Dolly Wallace. Migrant Workers' Children in the Field
1982. Scratch board, 46 x 40 cm

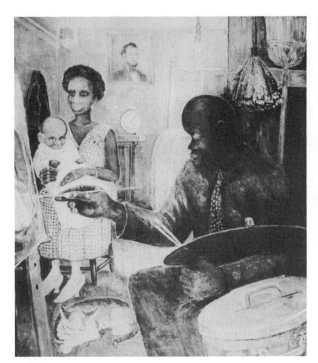

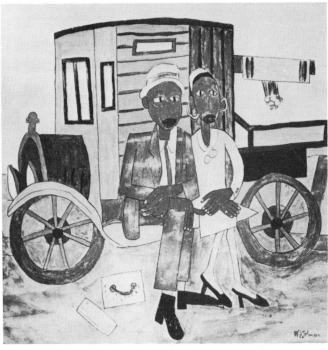

Palmer Hayden. *The Janitor Who Paints, 1937*
Oil on canvas

William H. Johnson. *The Honeymooners, n.d.*
Watercolor, 36 x 43 cm
Department of Art, Fisk University, Nashville

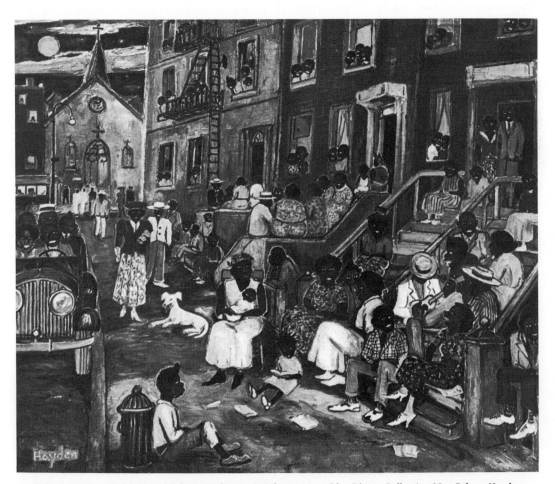

Palmer Hayden. Midsummer Night in Harlem, n.d. Oil on canvas, 64 x 76 cm. Collection Mrs. Palmer Hayden

Ollie Harrington. Goodness, gracious, Baby Doll, how did I know it would be like this? I just told the real estate man to rent us a place for the Labor day week-end, where we wouldn't have to worry about no race problems!, n.d.

Ollie Harrington. Oh Brother Bootsie, you scared the lif out'a me. I couldn't see nothin but your legs hangin' over the keyhole. You know that would'a been real awful seeing as how you still owes seven weeks' back rent!, n.d.
Both drawings from "Bootsie and Others—The Cartoons of Ollie Harrington", 1958

Ollie Harrington. Gentlemen, Please, Women and Children First 1982. Drawing

Ollie Harrington

After the war was over in 1945, Ollie Harrington decided to stay in Europe. He spent a couple of years in Paris and then moved to Berlin (East) where he still lives today. He has returned to the U.S. only once for a short visit but his cartoons are being published every week in the Daily World (N.Y.) as well as the People's World (Berkeley, Calif.). The great Afro-American writer Langston Hughes introduced Bootsie, the first book of Harrington's cartoons in 1958:

"Ollie Harrington was born on February 14, 1912, in New York City. Harlem soon became his stomping ground. Out of Harlem evolved a cartoon character called Bootsie, who has appeared for some twenty years now in the Pittsburgh Courier, America's largest Negro newspaper. With its various regional editions, the Courier has a big national circulation, so Bootsie's rather rugged adventures are widely known from coast to coast. Harrington has long been Negro America's favorite cartoonist . . .

As a social satirist in the field of race relations, Ollie Harrington is unsurpassed. Visually funny almost always, situation-wise, his pictures frequently have the quality of the blues. Behind their humor often lurks the sadness of 'When you see me laughin', I'm laughin' to keep from cryin'.' . . . Shortly after the Detroit race riots of World War II, there appeared a Harrington cartoon which many whites found too bitter for laughter. It depicted a little white boy showing a small friend his father's hunting trophies. Mounted on display on the wall of the den among the moose, tiger, and walrus heads, hung the head of a Negro. The caption read, 'Dad got that one in Detroit last week.' . . .

A careful craftsman, an excellent artist, with a little of Daumier and a lot of Hogarth—although not really very much like either, being too full of laughter—Ollie Harrington is uniquely Harrington, and Bootsie of Harlem is out of this world."
(Bootsie and Others, N.Y., 1958)

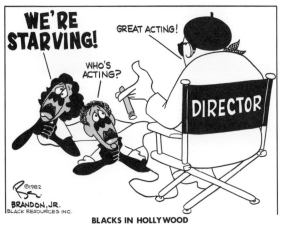

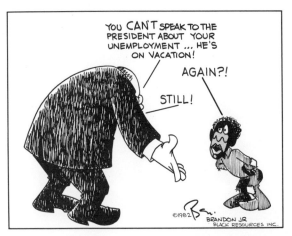

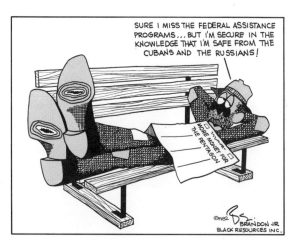

Brumsic Brandon, Jr. Cartoons, 1982. Ink on paper. Black Resources Inc.

Brumsic Brandon, Jr. Luther, 1974. Ink on paper. Los Angeles Times

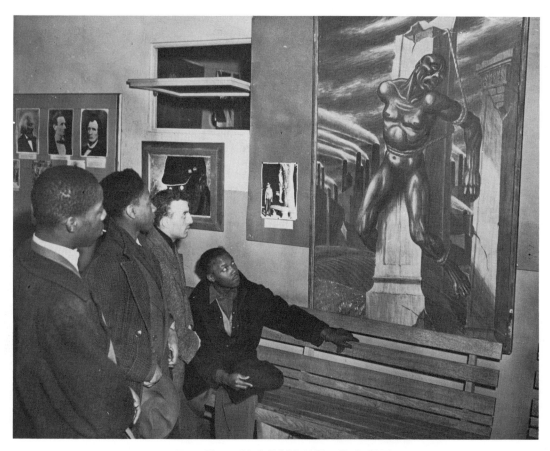

Negro History Week Exhibit in New York, 1954

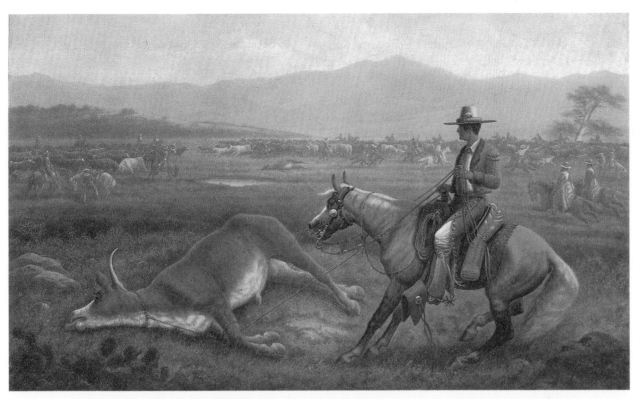

James Walker. Vaqueros at the Roundup, 1877. Oil on canvas, 78 x 129 cm. Collection Dr. Carl S. Dentzel

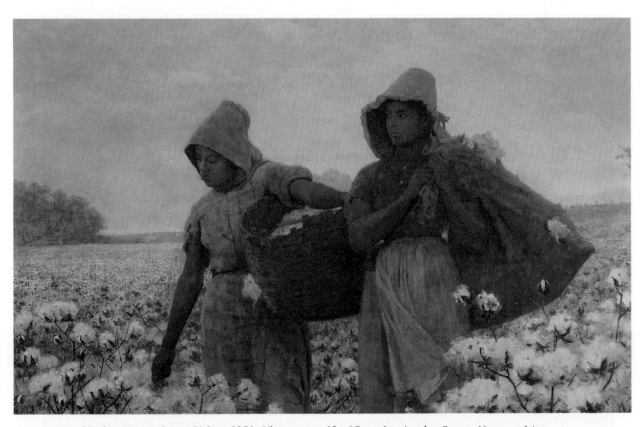

Winslow Homer. Cotton Pickers, 1876. Oil on canvas, 63 x 97 cm. Los Angeles. County Museum of Art

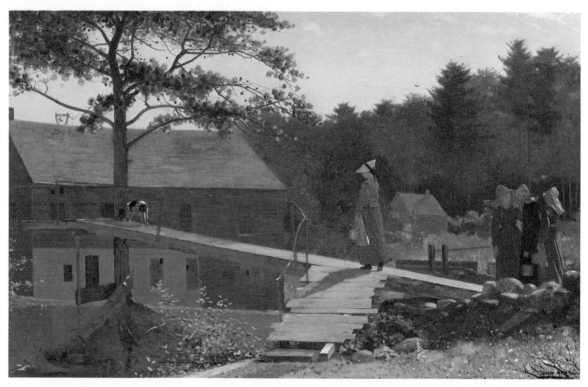

Winslow Homer. Morning Bell, c. 1873. Oil on canvas, 61 x 97 cm. Yale University Art Gallery, New Haven, Conn.

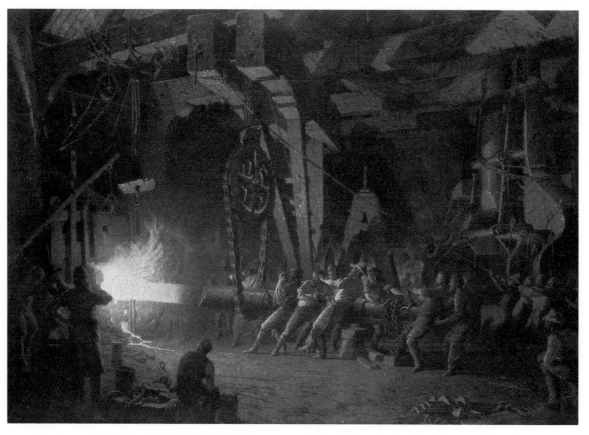

John Ferguson Weir. Forging the Shaft, 1877. Oil on canvas, 1.32 x 1.86 m. Metropolitan Museum of Art, New York

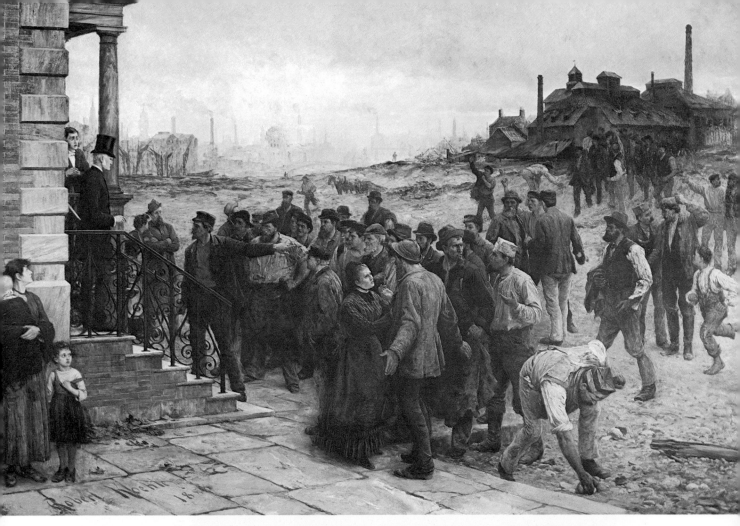

Robert Koehler. The Strike, 1886. Oil on canvas, 1.82 x 2.76 m. Collection Lee Baxandall

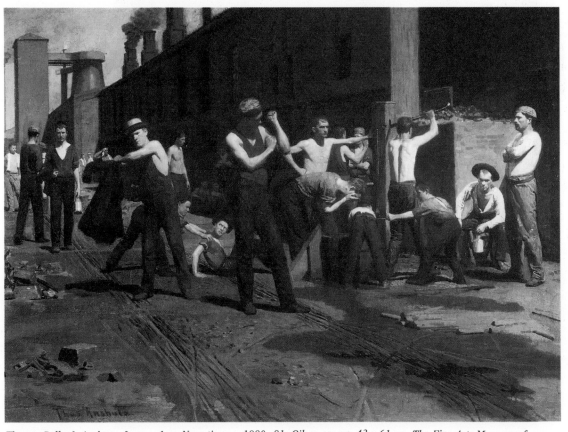

Thomas Pollock Anshutz. Ironworkers-Noontime, c. 1880–81. Oil on canvas, 43 x 61 cm. The Fine Arts Museum of San Francisco

Edward Hopper
Workmen with Picks
c. 1916–18
Watercolor and pencil
on illustration board
50 x 38 cm
Whitney Museum of American Art
New York

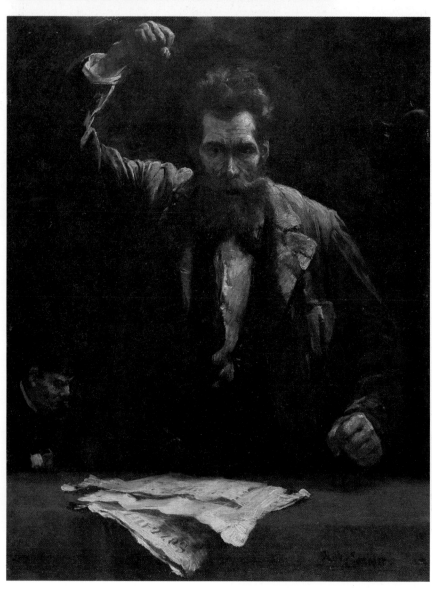

Robert Koehler. The Socialist, 1885. Oil on panel, 39 x 31 cm. Collection Lee Baxandall

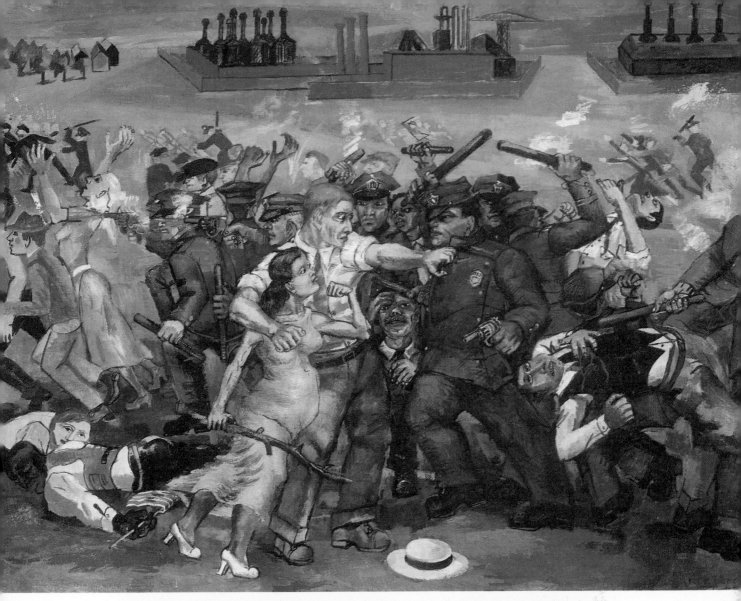

Philip Evergood. American Tragedy, 1937. Oil on canvas, 75 x 100 cm. Collection Mrs. Van de Bovenkamp

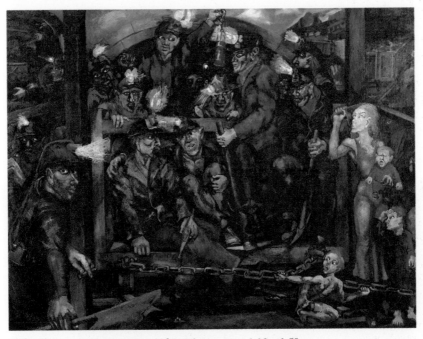

Philip Evergood. Mine Disaster, 1937. Oil on canvas, 1.02 x 1.78 m
Fashion Institute of Technology, New York

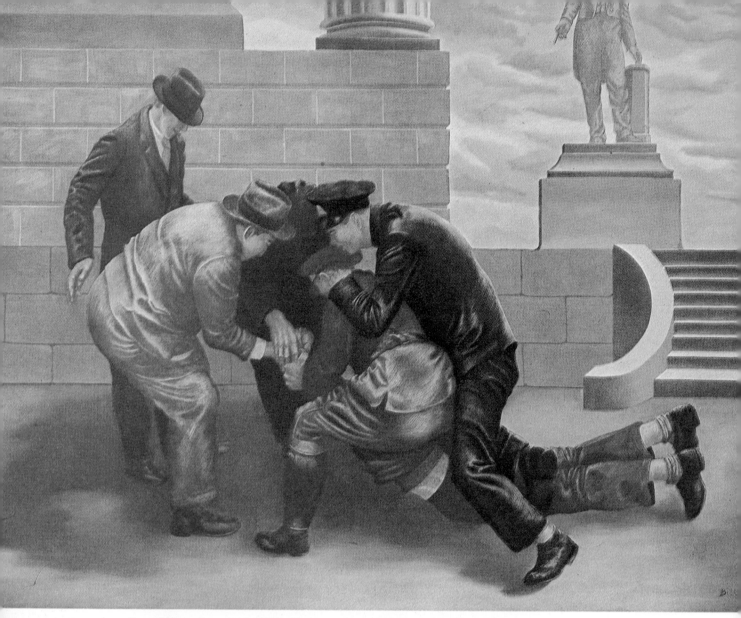

Henry Billings. Arrest No. 2, 1937. Oil and tempera on gesso panel, 46 x 66 cm. Collection Dr. Irwin Schoen

Robert Gwathmey
Sowing, 1949
Oil on canvas
91 x 102 cm
Whitney Museum of American Art
New York

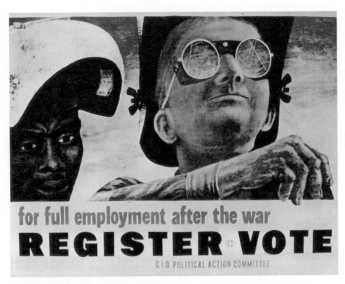

Ben Shahn. Welders, 1944. Lithograph in colors (poster), 70 x 85 cm
New Jersey State Museum, Trenton

Clarence H. Carter. Jane Reed and Dora Hunt, 1941. Oil on canvas, 91 x 114 cm. Museum of Modern Art, New York

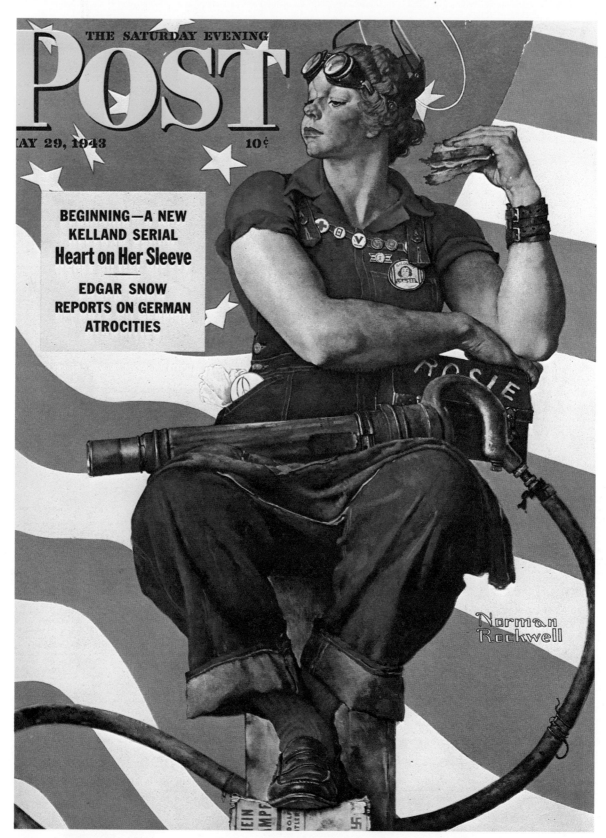

Norman Rockwell. Rosie the Riveter, 1943. Saturday Evening Post. Collection Ellen Kaiper

With "Rosie the Riveter" Norman Rockwell created what soon became the symbol of women in the U.S. war industries. Rosie's feet are resting on a worn-out copy of Hitler's "Mein Kampf"–a visual comment, which in one of the many newspaper advertisements read: "Hitler forgot about these Girls". It took a concerted effort and cooperation between the big publishers and the administration in Washington to motivate American women to become industrial workers, building ships, planes etc. But when the war was over, another concerted effort was made to convince women to "Give them Back their Jobs" and to exchange the overall for a nice dress–to leave the shipyard and to return to their traditional place in society, the family home.

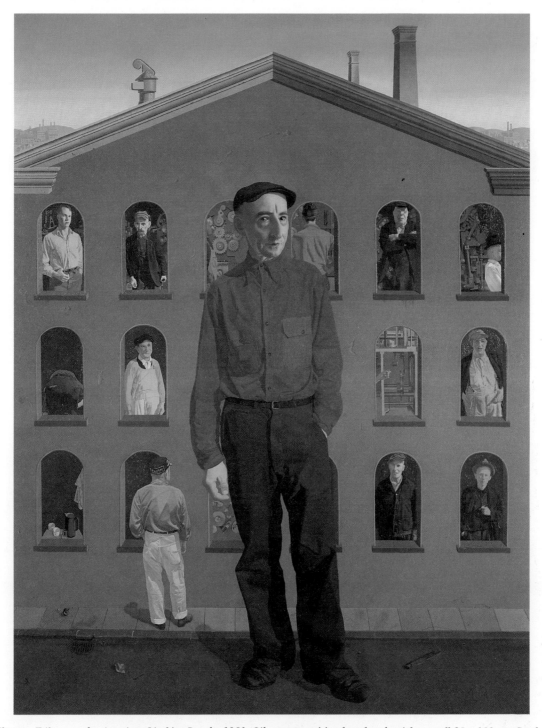

Honoré Sharrer. Tribute to the American Working People, 1951. Oil on composition board, polyptich, overall 85 x 152 cm. Sarah Roby Foundation

Rupert Garcia. Julius Rosenberg, 1980
Pastel on paper, 102 x 77 cm

Rupert Garcia. Ethel Rosenberg, 1980
Pastel on paper, 102 x 77 cm

Ralph Fasanella. McCarthy Period, 1963. Oil on canvas, 1 x 1.75 m

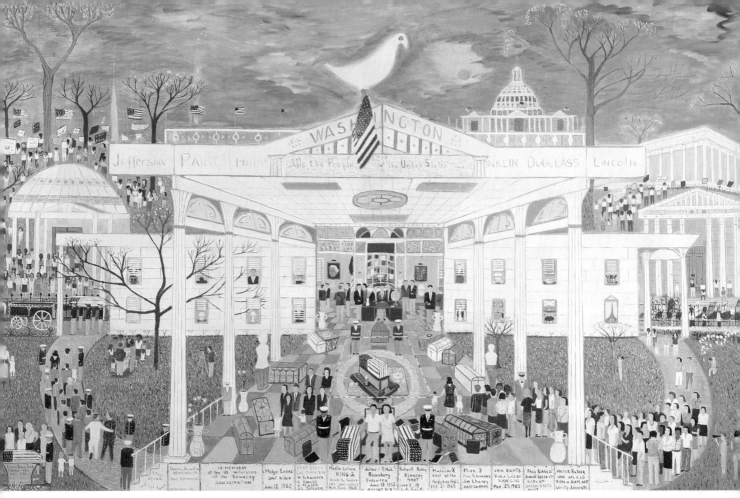

Ralph Fasanella. American Heritage, 1975. Oil on canvas, 1.02 x 1.80 m

Ralph Fasanella. Lawrence Strike, 1977. Oil on canvas, 2.29 x 2.41 m

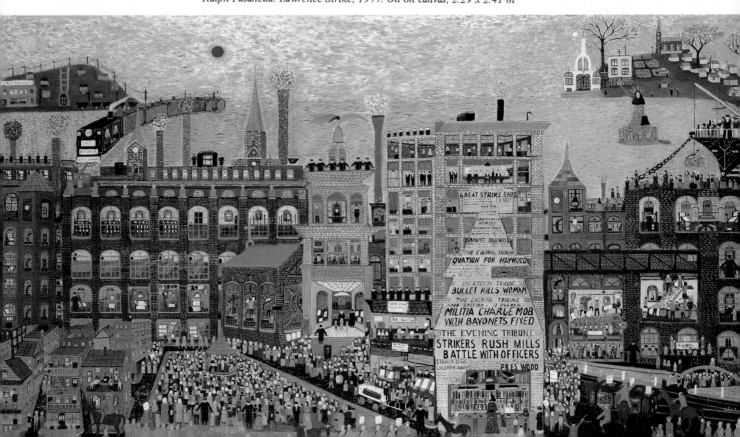

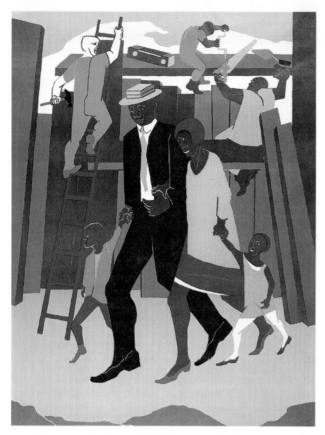

Jacob Lawrence. Builders, 1977. Silkscreen, 64 x 54 cm
Terry Dintenfass Gallery, New York

Bruce Kaiper. Oppression Breeds Violence, 1974
Photo-silkscreen, 70 x 55 cm

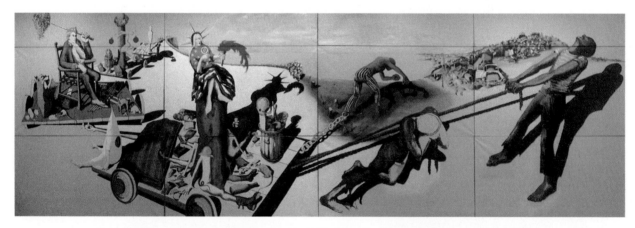

Benny Andrews. One of twelve parts of Trash, 1971. Oil and collage on cotton, overall 31. x 8.68 m

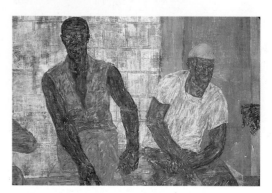

Tim Rollins and K.O.S. Dracula, c. 1983

Leon Golub. Four Black Men (detail), 1985
Acrylic on linen, 3.14 x 2.91 m

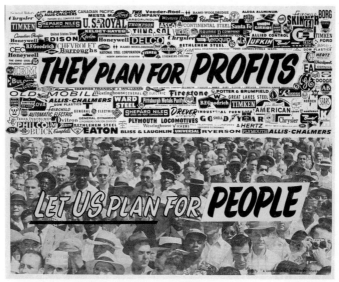

Artist unknown. 1982. Silkscreen, 55 x 69 cm
Poster for the United Automobile Workers (UAW)

Bruce Kaiper. Can't Wipe Those Blues Away, 1974. Photo silkscreen, 46 x 37 cm

Malaquias Montoya. Undocumented, 1981
Silkscreen, 89 x 58 cm

T.C. Cannon. Waiting Indians in Hospital, 1970
Acrylic on canvas, 102 x 92 cm. Aberbach Fine Arts, New York

Diego Rivera
Top: The Rockefeller Center mural (as revised for the Palace of Fine
Arts in Mexico City).
The original painting (1933) was destroyed in February 1934 on
orders from Nelson A. Rockefeller, because it included a portrait of
Lenin. The revised mural shows Lenin more clearly and in addition
pictures a bespectacled John D. Rockefeller, Jr. among the revelers
in a night club (center left).

Diego Rivera
Bottom: The Belt Conveyor, 1932–33
Detail from 27 panels commissioned by Edsel Ford, president of the
Ford Motor Co., for the Italianate garden court in Detroit

May Stevens. Lucy Parsons (1853–1942), 1980
Mixed media, 60 x 73 cm

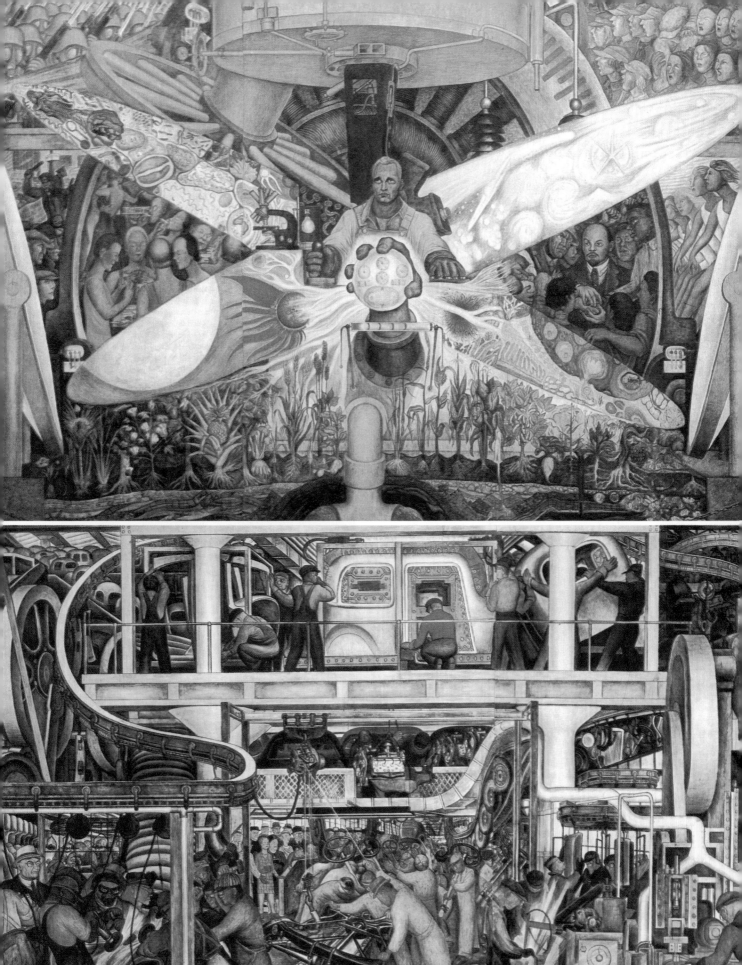

Nancy Spero. Nicaragua, 1985
Handprinting and painting collage on paper, 89 x 63 cm

Hans Haacke. Reaganomics, 1982–3

Charles White. Technique to Serve the Struggle, 1939–40. Mural for the Chicago Public Library, artist in foreground

Patronage

Ever since I arrived in New York I had a hankering for a ride on top of one of those double-decked busses in which passengers ride about-town in the open air. One sunny Spring afternoon I was seated atop of one. A very beautiful girl was seated in front of me. A young fellow tipped his hat very gallantly and bent over towards her: 'Pardon, but haven't we met before?' She looked up at him. 'Don't I know you from Boston?' She did not answer. 'Didn't I meet you at the Brown game?' Still she would not answer. 'Oh, but I'm certain we met somewhere! No?' 'No,' said she, 'I'm positive we have not!' 'Well, well,' said he, 'where have you been all my life?' Quite unexpectedly the girl slapped his face so you could hear it. As the gallant retired, I laughed so loud the girl turned on me indignantly. 'Oh no, we never met!' I hastened to tell her. She burst into laughter. Then I sat beside her. She told me she was on her way to Rockefeller Center. We went together.

It was a group of buildings large enough to house the population of an entire city. I wasn't much impressed by the decorative details, but I liked the simple lines and massing of the buildings.

We entered the tallest one in the center of the group. A large white wall faced us. On either side of it long corridors were decorated with pictures. 'How strange,' I remarked, 'they put pictures where you can't see them and this big space, in the light, remains blank.'

'That too had a picture—a fresco. Didn't you hear about it?' the girl said. I shook my head. 'Yes, a picture of a countryman of yours—Lenin.'

'A picture of Lenin, what happened to it?' I asked in amazement.

'It was destroyed.'

'Why, wasn't it any good?'

'It must have been good; they paid twenty thousand dollars for it.'

'Why was it destroyed then?'

'Oh, Mr. Rockefeller didn't like it.'

'Who is Mr. Rockefeller?'

'He's the richest man in the world. He's an art patron.'

'Did you ever hear of our great art patron of the good old days—Czar Ivan the Terrible?' I asked.

'Yes, what about him?'

'Well, he put out the eyes of his favorite architect to prevent him from creating other buildings that might rival the beauty of the Basilica built for him.'

'Oh, but we're living in a civilized country. Here we only destroy the work of the artist,' the girl slowly remarked.''

(Hugo Gellert. Text for the lithograph on page 40 from Comrade Gulliver, 1935)

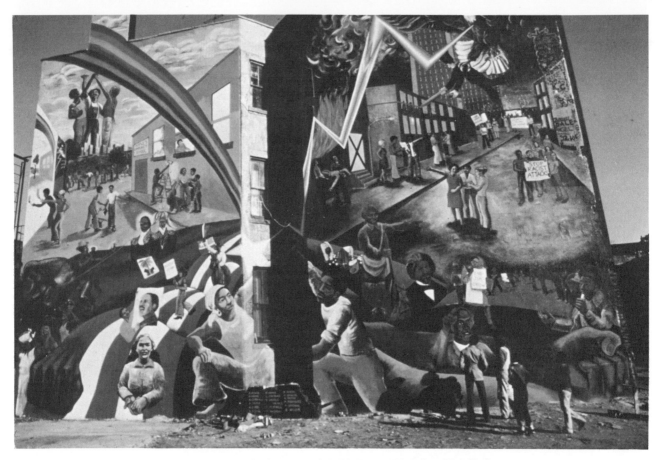

M. Patton. Douglas Street Mural, 1976. Cityarts Workshop, New York

Images of Labor in United States Community Murals

Tim Drescher and Jim Prigoff

Since only about 20 percent of the United States working class is unionized, it is not surprising that unions have not sponsored many murals. The major union leadership has largely made its peace with the ruling class of the country, and has not made control of the means of production—industrial or cultural—a priority. Nevertheless, the few murals painted with direct union sponsorship are powerful, and in the body of non union-supported community murals, images of the dignity, struggle and celebration of workers persist, often at the center of a mural's meaning.

Sometimes these visual statements show concern for workers in terms of the quality of their working lives, sometimes through concern for the special burdens of women and ethnic groups. Overall, images of labor in United States murals tend to depend more on individual consciousness than on any widespread, shared historical or economic analysis or union inspiration. While there has been recent awareness of the dangers of pesticides and corporate pollution, such workplace-oriented problems as black lung disease, mining dangers, occupational safety, etc., are rarely

mentioned. Murals with labor images tend to proclaim a future vision rather than point fingers at culprits, and the emphasis, for workers of all sorts, is on the goals of honest, dignified work with a decent wage and adequate benefits.

So we can distinguish, for purposes of organization, among murals painted with direct union support, murals supporting unionism, and murals supporting/celebrating workers in one way or another although not supported by unions. In these latter cases, ethnic concerns or the women's movement are often primary sources of inspiration. But murals about workers did not begin suddenly in the late 1960s. Important forerunners of the contemporary community mural movement were painted in the New Deal-Depression period by both U.S. artists and by the great Mexican muralist, Diego Rivera.

For nine years, from the midst of the Great Depression in 1932 until World War II "lifted" the country's economy in 1943, the U.S. Government paid people to paint murals in public places. There were various official programs, but they are usually referred to as New Deal or WPA murals

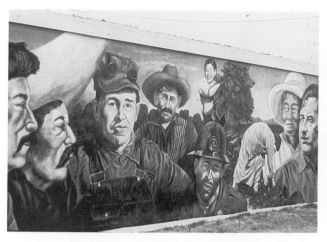

Emigdio Vasquez. For the Chicano Workers (detail), Cypress Street, Orange, 1979

Henry Varnum Poor. New Deal Mural, Chicago, 1943
Photo: Jim Prigoff

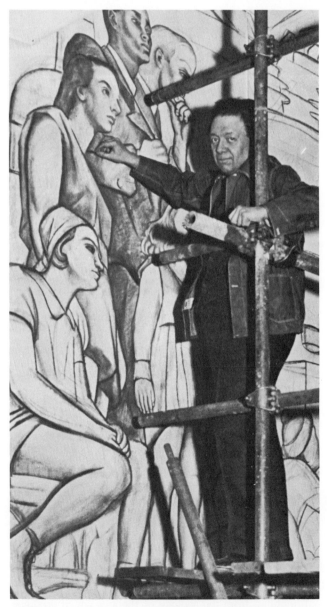

Diego Rivera working on the Rockefeller Center mural, 1933

Victor Arnautoff. Life of Washington (detail)
San Francisco, 1935. Photo: Tim Drescher

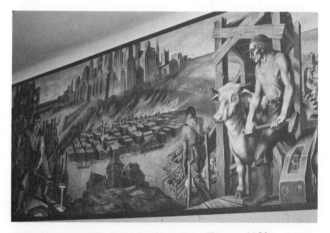

Harry Sternberg. The Epic of a Great City, Chicago, 1938
Photo: Jim Prigoff

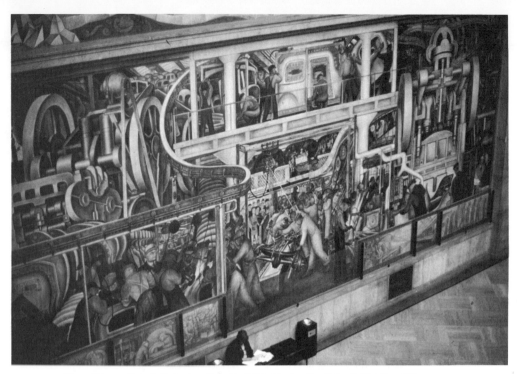

Diego Rivera. Detroit Industry, Detroit, 1932. Photo: Jim Prigoff (detail p. 81)

(Works Progress Administration, one of the main agencies of New Deal programs). Today, the murals painted in this period stand as reminders of what an association of artists and government can produce to enhance the lives of the general population. The murals were painted in post offices, schools, libraries, court houses, state buildings, etc., often as part of a law that said one per cent of the funds used to construct a building must be applied toward artistic enhancement of that building. All told, thousands of artists were thus employed, and hundreds of murals painted throughout the country.

Although there was some censorship of nudity, political and religious subjects, the murals proclaimed an optimism about the country and its people that seems a startling expression for a period of mass unemployment. Many of the murals depicted tranquil rural scenes, or vignettes of sports, games, and even fashion. Some showed the sciences, others fairy tales. But the best remembered proclaimed the dignity of labor, pride in the role of working people in building the country, forging its industries and transportation lines. The artists viewed themselves as workers too, and with the general encouragement of the New Deal arts programs to produce arts for public benefit, the paintings naturally combined the wide variety of stylistic variations of the artists in depicting the accomplishments of working people.

Unions were not major participants in this artistic flowering, even though it was the period of the greatest union organizing in the nation's history. Still, the themes of collective life and work were incorporated by the artists, who sometimes picketed their own offices on days off to protest elitist attitudes on the part of administrators.

It appears that women and minorities found somewhat greater opportunity in the WPA programs than in society in general, judging by the names of artists listed in documents of the period. Some murals dealt with themes of racism, such as Victor Arnautoff's 1935 frescoes painted in San Francisco's George Washington High School. Included is a panel showing George Washington, the "father of our country," pointing the way west to the mountain men and others who will go forth and develop the richness of the land. Politically sophisticated, Arnautoff has the mountain men stepping over the body of a slain Native American on their way to the new country, a symbol of the government genocidal policies toward Native Americans.

Another wall representative of New Deal treatment of workers is Chicago: The Epic of a Great City, painted by

Harry Sternberg in 1938 at the Lakeview Post Office. This mural has in its foreground workers of many disciplines, among them welders and iron workers and a large, stripped-to-the-waist figure holding a sledge hammer. From their labor rises the city in the rear of the mural.

Also in San Francisco is the remarkable Coit Tower, where some two dozen artists covered almost 4,000 square feet of the inner hall with scenes from the state including unemployed workers, state industries, transportation, meat packing, a steel worker's portrait, and so forth. An indication of the subtle level of comment made in some of the WPA murals can be seen in the appearance of Marx's Capital as one book on the shelves of a library in the mural.

Some of the artists who painted in Coit Tower and who worked on other WPA murals around the country had studied with the great Mexican revolutionary muralists, Rivera, Orozco and Siqueiros, each of whom had not only painted extraordinarily influential monumental murals in Mexico, but had worked in the U.S. when forced out of their homeland by reactionary administrations. Perhaps the most influential of these artists for WPA painters was Diego Rivera, because he painted from New York to California, and because wherever he worked his paintings were surrounded with publicity, if not controversy.

In 1932, Diego Rivera was invited to do a fresco in Detroit. The resulting work, viewed within its contexts of location, content, and process, stands as a remarkable example of many of the most important issues affecting workers and the arts in the United States. It is notable, for instance, that in the midst of the Great Depression, the Ford family and the Detroit Institute of Fine Arts could find over 20,000 dollars to pay a world famous artist. Rivera chose to depict a kaleidescope of manufacturing processes in a massive, multi-paneled fresco entitled Detroit Industry. His fascination with machines was given full reign, and he studied Ford's huge River Rouge plant for months before beginning work in the Institute. When he did, he fully utilized both his knowledge of Renaissance murals and his own background in cubism and other avant-garde styles studied in Europe before he returned to this continent. Modern industry is represented by showing the process of making automobiles, from the geology of the area which produces iron, to the multiracial workforce in the factory. Rivera combined panels depicting allegorical figures of agriculture (which opponents called "pornographic"), geological stratigraphic charts, and scenes representing aviation, trans-

portation, electrical power generation, smelting, stamping, and the interdependence of U.S. industry with agrarian Latin America, specifically shown in a scene at Henry Ford's Brazilian rubber plantation. All this leaves the two main panels, the north and south walls, to show the intricate and massive assembly processes of the 1932 Ford V-8 motor and the 1932 Ford body. In these frescoes, Rivera presented the Ford assembly as a symbol of the massive productive potential of U.S. industry and its workers.

The Detroit mural was allowed to stand, although Rivera's mural for the Rockefeller Center in New York was too strong in imagery for Nelson Rockefeller because of the presence of a portrait of Lenin, something not to be tolerated in a "bourgeois hall". Rockefeller ordered the wall smashed after paying Rivera. In 1972, Marcos Raya took to the streets of Chicago and painted Homenaje a Diego Rivera at 18th and May Streets which recreated Rivera's mural and its messages of class struggle. Interestingly, when he "updated" the mural in 1979, Raya changed general images of war to specific contemporary images, such as MX missiles, and included a fallen Central American dictator, adding specificity to the same general themes he and Rivera had used earlier.

Reasons for the dearth of mural painting during WW II are obvious, and extend until the late 1960s. The country was either at war or in the process of building an industrial economy of unprecedented scope and power. There were, to be sure, murals painted in these years, but they tended to be incidental or commercial, such as walls painted in Italian restaurants or in the tradition of meat markets and pulquerias in Latino communities. With the advent of open civil rights struggles in the 1960s, all this changed, and disenfranchised people, working class and ethnic minorities, turned to the walls of their communities to express in monumental wall paintings their hopes, aspirations, and anger. Included in these murals, collectively known as the Contemporary Mural Renaissance, are a number of murals dealing with workers, although relatively few are directly associated with organized unions.

Still, there are connections to be noted. The traditional labor demonstrations and picket lines became one tool of protest in the 1960s and early 70s, both in civil rights struggles and in protests against U.S. involvement in the Vietnam War. So, often an image of protesters from the 1960s has a strong visual resemblence to labor demonstrations of the 30s, as in the Haight Ashbury Muralists' Our History Is No Mystery of 1976.

Also, the existence of WPA murals throughout the United States cannot help but have influenced the contemporary muralists. They saw the walls of their schools, post offices, libraries, etc., painted, and many today remark on how that public art has impressed them. A major difference between the two movements was that in the 30s, the art had been government sponsored, while in the 60s, the murals were more truly community murals, painted by or with members of neighborhoods, women's centers, schools, and unions.

In 1972, the Amalgamated Meatcutters and Butcher Workmen of North America published a booklet entitled Cry for Justice in which they chronicled the Chicago mural movement's commitment to the struggle for civil rights. Two years later, the union commissioned William Walker to paint the History of the Packinghouse Workers on the outside wall of their Chicago headquarters. In the meantime, another union with a history of progressive activism, the United Electrical Workers, commissioned John Pitman Weber and Jose Guerrero to paint a complex mural, Solidarity, in the stairwell and upper floor of its offices also in Chicago. Weber and Guerrero's mural shows workers struggling against oppressive workplace conditions and smashing their way through the floor above them which holds up bosses, dictators, generals, etc. It is an epic of struggle, where also three union leaders carry a red banner saying "Organize". It is rather a picture of what unionism is supposed to be, than a picture relating to this specific union. It is also quite sophisticated in its use of complex space and its winding up the stairwell.

Walker's equally sophisticated wall is quite different. It depicts on the right side the tasks of the packinghouse

Top: Charles White
Booker T. Washington (center) and Frederick Douglass (right)
Not shown: Harriet Tubman, Mahalia Jackson and George Washington Carver
Bottom: Haight Ashbury Muralists
Our History is No Mystery (detail), San Francisco, 1976
Photo: Tim Drescher

workers, and on the left, in a chessboard format, the struggle between union workers and the bosses and their allies—judges, police, company finks, etc.

There are other post WW II murals in the United States directly supported by unions. One is Kathleen Farrell's mural painted for the Amalgamated Clothing Workers Daycare Center in Chicago in 1976. In Joliet, Illinois in 1980 she painted a mural showing workers operating heavy machinery. In 1975, Holly Highfill and Barbara Peterson painted a mural for the United Mine Workers called Dark as a Dungeon: The Story of Coal Mining, which is located at Truman College in Chicago. This interior mural, painted on panels, shows a history of both coal mining and the union's struggles on behalf of the miners, and it is appropriately placed in the basement hall of the school.

Two murals deal with longshoremen. The first was painted by John Biggers in Houston, Texas, in 1956, inside the hiring hall of Local 872. The other was commissioned for the hiring hall of the International Longshoremen's and Ware-

John Biggers. Longshoremen, Houston, 1956. Photo: Alan Barnett

housemen's Union (ILWU) in Coos Bay, Oregon and is of particular interest because it was painted by the Brigada Orlando Letelier, a group of Chilean refugees which has painted throughout the U.S. and in Nicaragua since the military coup forced them into exile from Chile in 1973. The mural celebrates the solidarity between workers of the two countries, and was offered by the Brigade after the Oregon longshoremen had refused to handle cargo bound to or from Chile. Also District 1199 of the Hospital Workers in New York commissioned Anton Refregier to do a mural about their struggle.

The western United States is the location of most of the organizing done by the United Farm Workers (UFW) Union, lead by Cesar Chavez, and the union is represented in several western murals although it did not directly sponsor these murals. Still, the symbols of Chavez' portrait and the UFW black eagle on a red background are virtually ubiquitous in Latino murals where they represent not only the union per se, but also the spirit of Latino peoples throughout the

Brigada Orlando Letelier. Longshoremen, Coos Bay, Oregon, c. 1976
Photo: Tim Drescher
(Mural for the ILWU hiring hall, painted after the Union had refused to load freight for Chile)

John Pitman Weber and Jose Guerrero. Solidarity (detail), Chicago 1973. Photo: John Weber

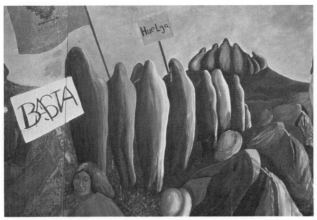

Irene Perez. Farm Worker Symbol, Fresno, 1976
Photo: Irene Perez

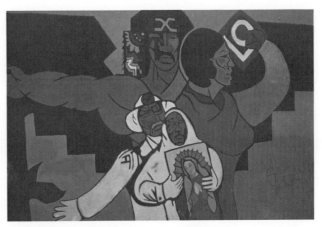

Artist unknown. Estrada Courts, Los Angeles, n.d.
Photo: Jim Prigoff

country who are finding their own voices and are beginning to recognize their potential political power—after the example of the UFW and its leader. The eagle symbol and the Virgen de Guadelupe, who has become something of the patron saint of Mexican and Chicano political struggles since the 19th century, thus become linked in several western murals. Two of these are Ernesto Palomino's 1971 untitled mural at Tulare and F Streets in Fresno, California. Palomino shows a madonna in a migrant worker's truck which in turn is seen against the eagle background. In History of Mexican American Workers, painted in Blue Island, Illinois in 1974–5 by Ray Patlan, Vicente Mendoza, and Jose Nario, the symbols of the UFW and the Virgen are placed side by side, as if to emphasize the role of each in the struggle for rights, both civil and labor, of Chicanos. These images were not easy for the community's officials to accept, but were strongly supported by the local trade unions. After a court case, the muralists won their right for their images to stay on the wall.

There are far too many murals with the UFW symbol to mention here, but it is the single case we know of where a union emblem has come to represent the general struggles of an entire people.

Other murals of recent vintage may be classified into general groups simply to give an idea of the different ways in which images of workers, and a sense of solidarity with working people of various kinds, has found its way into United States murals. There are, for example, a number of walls presenting images of workers engaged in struggles of several sorts, some more broadly phrased than others, but all with a strong feeling of respect for working people as the builders of the country. One example is Chicago's I am the People, directed by Caryl Yasko in 1974. The basic image of this wall has workers on the right side, literally making the world go around, while to the left a colossus, imagistically identified with the corporate headquarter buildings of downtown Chicago, tries to stop the people's work. The wall shows a struggle of (class) interests. In a similar vein, Gilberto Ramirez' 1976 LULAC mural in San Francisco depicts a symbolic man and woman rising above 'a literal depiction of nightmarish industrialism which oppresses workers in the lower portion of the wall. Although out of place in San Francisco, (it was designed in the industrial Midwest), the contending forces are nevertheless clear, as is the hopefulness of the larger central figures. Painted about the same time, Art Zarate's Worker's Mural in Los Angeles shows a worker trying to tear himself away from the machine to which he is chained.

But, just as the relation of workers to unions has not been simple, neither has the depiction of worker relationships in murals. In Chi Lai, Arriba, Rise Up!, for example, painted by New York's Cityarts Workshop in 1974, the central image of an apartment house with the walls removed to show is multi-racial, multi-national tenants, also shows as one of the several forces threatening them a group of hardhat construction workers who represent those who oppos-

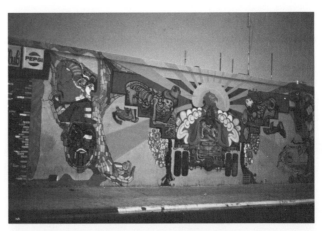

Ernesto Palomino. Tulare and F. Street Mural, Fresno, 1971
Photo: Ernesto Palomino

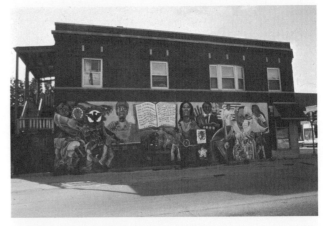

Ray Patlan, Vicente Mendoza and Jose Nario. History of
Mexican-American Workers
Blue Island, Illinois, 1974–75
Photo: Jim Prigoff

James Dong and Kearney St. Workshop, International Hotel Mural (destroyed), San Francisco, 1974–75
Photo: Tim Drescher

Art Zarate. Workers' Mural, Los Angeles, 1972
Photo: Tim Drescher

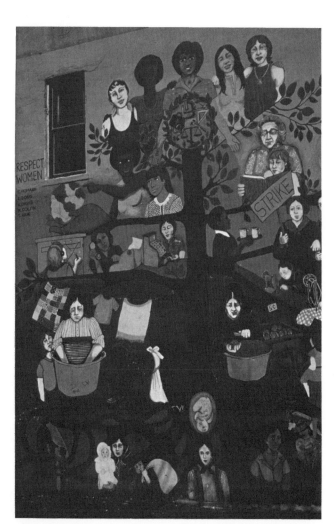

Cityarts Workshop. Wall of Respect for Women, New York, 1974
Photo: Jim Prigoff

ed anti-war and civil rights demonstrations in the late 1960s and early 1970s. It is also a reference to the occasionally racist policies of unions in refusing admission to people of color. The triumphant group of men and women of different races at the top of the six-story building represents the goal of all workers, i.e. dignity and self-determination.
Murals denoting struggles also often have a positive outlook perhaps culminating in a celebratory image, such as Chi Lai . . . just described, or a similar image at the top of Cityarts' 1976 wall, Work, Education, Struggle: Seeds of Progressive Change. As a group, murals depicting Third World workers have naturally stressed the extra-oppressive conditions of their ethnic histories. One example is Alan Okada's History of Chinese Immigration which shows the Chinese building the transcontinental railroad in the 1860s and also includes, appropriately for its New York location, women employed in sweatshops as seamstresses. Similarly, James Dong and the Kearny Street Workshop's International Hotel mural of 1974—75 in San Francisco presents not only industries, but on the right side two workers carrying a basket of tomatoes and another field worker with massive hands outstretched around two boarded-up windows. The original plan was to put angled mirrors in these windows so that viewers from the street would appear to be in the hands of the field worker. Unfortunately, funds could not be raised to purchase the mirrors, and the International Hotel itself, home to aged, mostly Philippino retired merchant sailors, was razed for . . . well, nothing so far after several years.
Allied with ethnic murals are those dealing with the issues of women's liberation, such as Astrid Fuller's 1975 Chicago mural, Women's Struggles, and Bary Bruner's mural, Women's Equality, painted with Caryl Yasko and Cynthia Weiss in Chicago in 1979.
The historical roots of oppression and discrimination are shown in Cityarts Workshop's 1974 Wall of Respect for Women, on New York's Lower East Side. Using a simple tree motif, it shows the different sorts of work to which women have been restricted throughout the country's history. Significantly, it presents a vision of a future society in which women have full access to professional careers as doctors, lawyers, architects, etc. Cynthia Weiss and Miriam Socoloff, in a mosaic mural of 1979 in Chicago, The Fabric of Our Lives, depicted the struggles of Jewish women for voting rights, equal wages, and the brutal reality of sweatshop work in a sewing factory. This mosaic had strong trade union support from the Amalgamated Clothing Workers, the Teachers Union and others who helped in the planning and fundraising. Another historical view of women is Astrid Fuller's 1976 Chicago Pioneers of Social Work, which shows obstacles to progress overcome by social workers of both sexes.
The Haight Ashbury Muralists' Our History Is No Mystery was dedicated to the birthday of Malcolm X and Ho Chi Minh in 1976. Its initial goal was to present images related to San Francisco labor history and was painted on the re-

Astrid Fuller. Pioneers of Social Work, Chicago, 1975
Photo: Jim Prigoff

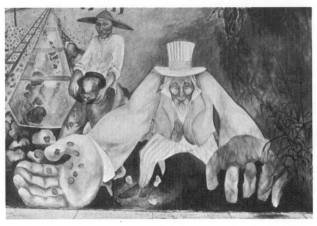

Haight Ashbury Muralists. Our History is No Mystery
San Francisco, 1976. Photo: Jim Prigoff

taining wall of a local technical school attended by many
students who work full time trying to continue their educa-
tion at night. It also includes Native Americans, the original
inhabitors of the Bay Area and continues with a selected
series of historical scenes and all races working produc-
tively together. This final vision shows women, for instance,
working at jobs traditionally taken by men, with an earlier
panel of a demonstration in which the demand for women's
rights is being raised. There are also panels of breadlines and
demonstrations of the unemployed from the 1930s as well.
as civil rights- and anti-war demonstrations from the 1960s.
One panel focuses on Uncle Sam greedily taking California
gold mined by Chinese laborers and another shows Japanese-
Americans locked up in concentration camps during World
War II. There are images of proud San Francisco workers
rebuilding the city after the devastating earthquake and fire
of 1906; earlier scenes of the Great White Fleet that con-
quered Puerto Rico and the Philippines in 1898; and later
scenes with shipyard workers striking against working
conditions in the wartime 1940s. Perhaps the strongest
impression the mural leaves, however, is that the city—and
by extension the entire country—has and continues to be
built by working people, people who work with their hands
and muscles as well as with their minds. They are too often
ignored or denigrated in the "fine" arts, and so find expres-
sion in people's community walls.

Another mural nearby is Selma Brown's Masters of Metal,
now installed in a tool and die shop. The central image of
five workers facing molten metal, shaping it by their work,
is wholly appropriate to the mural's location, but Brown
has commented that part of her motivation for the design
was based on alchemical principles as well as a desire to
present the workers positively.

In Los Angeles' Tujunga Wash, Judith Baca, working with
local youth and other artists each summer, completed over
2,000 ft. of murals unfolding the story of California. Stand-
ing 13 1/2 feet high, the sections depicting recent decades
consistently depict the injustices committed against oppress-
ed groups. We witness the railroads built on the backs of
Chinese labor and the subsequent anti-Chinese riots by local
labor organizations. We see Depression breadlines and strik-
ing workers carrying "We Can't Live—Striking" signs.
350,000 Mexican-Americans are hurled back across the
border in mass deportations, only to be reimported as
braceros in the following decade. Luisa Moneno, labor
organizer, appears wrapped in a banner, and trains carry
braceros back to work. It is these workers that Cesar Cha-
vez later organized into the UFW.

The entire wall is about people's struggles and their courage
in overcoming obstacles placed before them. Early sections
(both the beginnings of the mural and the history of Califor-
nia), show Native Americans as laborers and the wall moves
through different groups brought into the state as workers,
and the racist reactions against them. The wall also presents
the contributions of workers and people of color in agri-
culture, the sciences, education, and struggles for social

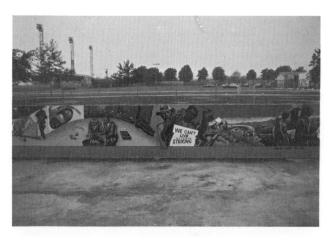

Judith Baca and students. Tujunga Wash (detail), Van Nuys,
California
Length 620 m, heigh 4 m. Completed in 1980, the mural illustrates
the history of California. Photo: Jim Prigoff

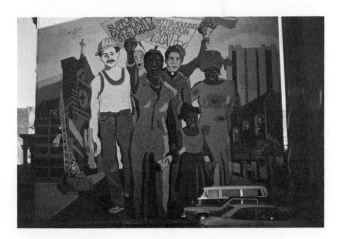

Cityarts Workshop. People's Right, New York, 1978
Photo: Jim Prigoff

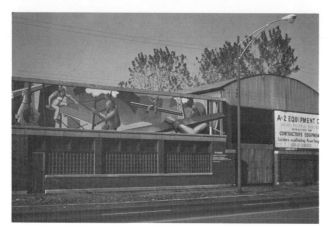

John Pitman Weber and Celia Radek. The Builders, Chicago, 1976
Photo: Jim Prigoff

Guerrero, Celia Radek and Cynthia Weiss shows a group of workers and citizens at the bottom while from their labor spring forth giant roots forming branches and foliage. In the upper left people are dancing in celebration. No longer extant, today the building has given way to a McDonald's hamburger franchise.

In a mural in Lamont, Illinois, painted in 1975 for the town's bicentennial, Caryl Yasko depicted the local quarry industry which employed some ten to twenty thousand workers at one time. Many of Chicago's churches and the Lamont water tower were constructed with the yellow limestone from Lamont, and while the mural celebrates these events, it leaves out any reference to labor struggles in the industry.

In a small town mural in Wisconsin, Caryl Yasko with Niki Glen, Frenchy Le Tendre and Steve England chose as the central theme a large waterwheel. Surrounding symbols represent agriculture, manufacturing, education, recreation and heavy industry. The figures to the right of the wheel represent the past and the present, the "water" that turns the wheel. The figures to the left are taking what is already built into the future. Embedded into concrete at the base of the mural are rusted machine parts used by earlier settlers in building the town, thereby making tools of the past part of the present's recognition of its own history.

CONCLUSION

The quick sketch presented in this essay is inadequate because each of the murals mentioned has its own story, and each exists within a group of complex interactions which at best could only be hinted at here. What is more, there are surely murals with labor themes of which we are unaware; news of new projects reaches us almost daily. But it is obvious that images of labor in United States community murals offer a rich and vital support for workers' struggles, and demonstrate joy and pride in our victories. If the 'community murals' vision of a future where working people have control of their own lives is correct, then the production of these walls themselves is an early sign that a key factor in that fight is the amalgamation of cultural with economic and political tendencies in the labor movement.

justice. The Great Wall project continues, and will document the decades since the 1940s in the next several years.

Elsewhere, other murals also celebrate workers in the United States. In Harlem at 132nd Street four workers of different races, arms locked and heads held high, march forth from a four story building. The mural size is equal to its important message—there is strength in workers' unity.

In 1975, A & Z Construction Company commissioned John Pitman Weber and Celia Radeck to paint a mural on their Chicago building on Ashland Avenue. Still there for all to see it is titled, The Builders, with workers, men and women, carrying steel beams, working on a scaffold, sitting on a beam and hauling on ropes. McDonald's may own this site by 1984, and so another mural may be destroyed. Almost in anticipation of this, Weber did a similar version with three figures in La Rochelle, France, in 1982.

Fruits of Our Labor, a fine mural done in 1976 by Jose

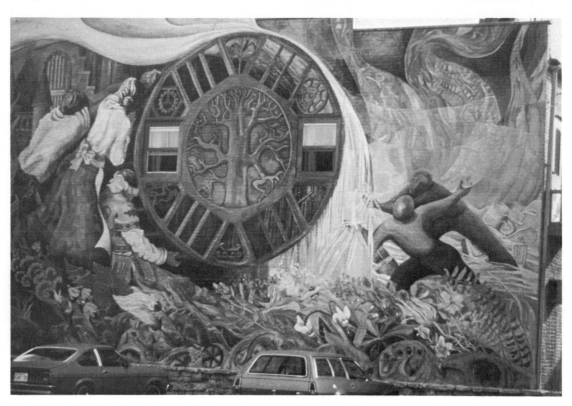

Caryl Yasko, Niki Glen, Frenchy Le Tendre and Steve England. Whitewater Mural, Whitewater, Wisconsin
Photo: Jim Prigoff

Message to the National Mural Conference—1976

by Anton Refregier

Public art is the antithesis of the private, subjective, art fostered today by society and its art operators. There is no room on the city wall for clowns and artists on ego trips. The street mural demands that it carries a message meaningful and vital to people oppressed by racism; by the inhumanity of our city existence. Street murals should speak of Brotherhood and Peace.

The vitality and energy of the recently emerged public art throughout the United States is but another evidence of the energy and basic humanism so typical of progressive America. And in a way, it is also a continuation, even if unplanned and unconscious, of the spirit of public commitment to the artist of the Depression areas of the Thirties.

In its militant aspects, in murals against racism, against war, it is a continuation of other periods where the artist and intellectual fought against the values and programs of the establishment of their time: as it was during the period of the First World War, the Depression years, and the Vietnamese War. Artists have made use of whatever channels were available to them, be it in graphics; the press; or on the walls of the streets of our cities. Historically, we can admire and learn from the experience of Mexico: their powerful and meaningful wall paintings of the late twenties and thirties and the work of their graphic workshops which pasted the streets with urgent messages.

I am aware that today, mural painting is practiced in diverse ways—some making use of the wall as a focal point for urgent messages; some concerned with pure design; some embellish the walls with ornamentation giving the people a sense of pleasure and joy; each contributing to the environment.

I think most artists have the capacity and the interest in both a search for a profound statement of concern and meaning to the people and a lighter gesture of pleasant sensation and a sense of play. And both these areas are needed by the people. (Only the artist, I feel, has the responsibility not to camouflage the ugly even if indirectly in the interest of the real estate operators.)

I have been a mural painter for most of my professional life and I firmly believe that with integrity and a firm belief in the capacity of the people for appreciation and understanding, one can paint or produce an art form in any area limited only by such possible commissions as the KKK or the super-patriots. With this belief, I have created tapestries for a bank, producing art forms that in no way glorify the profit system. I think they could easily be taken out of the bank and successfully installed in a school auditorium.

On the other hand, in my mosaic at 1199 (Martin Luther King Memorial Center of the Hospital Workers Union) I deal specifically with the building of a union. It was designed to function both as an identifying symbol and as an environment for the entrance and as it is an outdoor mural, I had a responsibility to the surrounding cityscape.

The Agit-Prop (agitation propaganda) phase of public art has reason and the need to continue in its obvious simple and direct statement. But at the same time, I believe the movement should enter the permanent phase of monumental art—in schools, hospitals, and universities. And with this, attention should be given to the disciplines of composition, the various forms developed by the Greeks and used in the Renaissance and the recent re-discovery by the Cubists and by Cezanne. It was indispensible to Rivera, Siqueiros, and Orozco.

Demand space in all public buildings. Tell Washington that the people of America deserve all the cultural richness that our economy can provide. Demand permanent enactment of a percentage for each Federal, State and Municipal building for art forms. See to it that large Federal, State and Municipal funds be available. That a sympathetic administration be in charge. And this brings the artist, of necessity, into the political area, the elections of sympathetic progressive people into the various areas of government, conscious of the cultural needs of the people.

Learn the lessons of the WPA—and what is more important to us now—the Section of Fine Arts. Demand that the Public Service Administration, which still hands out fat commissions to a few top name artists, for art in new Federal construction, returns to the former practice of OPEN national and regional competitions which gave the young, unknown artist an equal chance with the established artist to win a mural competition. A practice which brought fresh talent and vitality to the American community.

Raise the question of the Art Departments in universities to include the study of monumental art. Demand that the art press pages give attention to public art. See that the State Department makes use of photographs of the best public art in its international exhibits.

Be always ready for the struggle to maintain professional integrity, struggle against censorship.

We need to promote educational programs around mural production, utilizing the mass communications media. People have to be educated to appreciate works of art. This was known during the WPA days. And to this end, an educational program was established.

Today we are rich with past experiences. At the time of the liquidation of the government's art projects, at the beginning of the last war, the younger generation of American mural painters were on the verge of creating a movement of world significance. Now the public art movement is picking up the threads connecting us to the rich past.

There is a big talent in our country. There is a skill that must be fully utilized to continue after the long interruption—the movement of a peoples' art.

I have a few proposals for your attention. First, we have to know the history of monumental art, and we need to know what is happening in the area of the so called "professional" mural painter. For instance—the huge mural in the lobby of the American Federation of Labor in Washington. It is a banal academic performance completely void of any reference to the struggle in building a trade union. It could just as well, without any alteration, be placed in the lobby of the Chamber of Commerce. This is an example of an artist conforming to the needs of the establishment.

It is not enough to make use of street walls. Go inside.

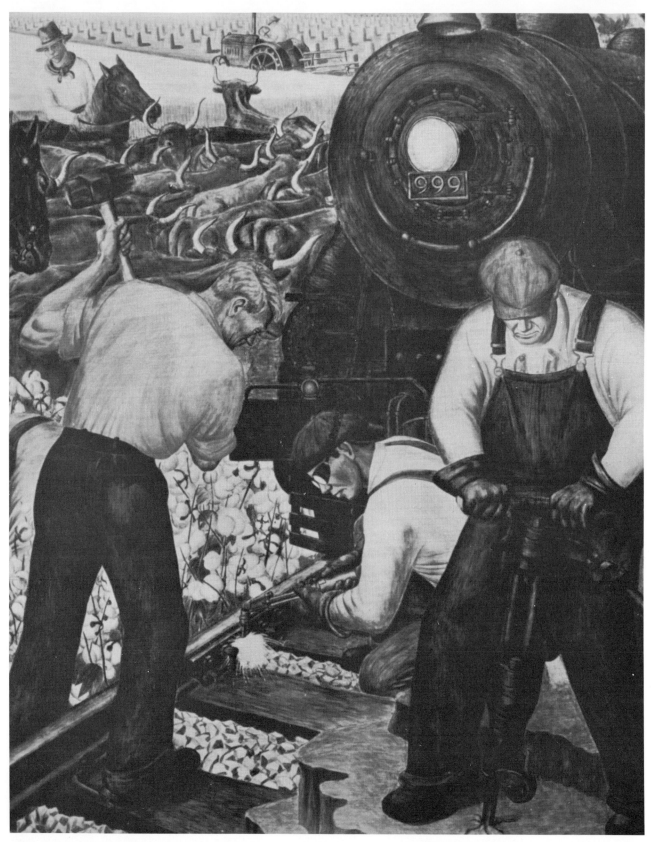

James Michael Newell. Evolution of Western Civilization (detail), 1938. Library of Evander High School, N.Y.

The Artists' Union in America

David and Cecile Shapiro

During the Depression of the 1930s most American painters and sculptors, never financially secure, lost their basic means of livelihood: galleries and dealers closed their doors, museums ceased their purchases, and private patronage dried up. While most artists were as a result going hungry, a few managed to find work among the 100 professionals employed by the Emergency Work Bureau, which represented the first attempt in the early 1930s to assist fine artists. When this private philanthropy seemed about to founder, some of the artists organized themselves into a group in order to work for government-sponsored employment programs for artists. (1)

Thus it was that these American artists, 25 in all, on September 24, 1933, organized themselves into the Emergency Work Bureau Group, the tiny seed that eventually grew into the first American trade union for artists. (2) Some of the EWB Group also belonged to the John Reed Club, whose founders were members of the Communist Party. (3) They were concerned about the thousands of painters, sculptors, and printmakers throughout the country who were in acute need, yet were not eligible for any existing job program. To increase their numbers and to state their constituency clearly, they soon named themselves the Unemployed Artists Group, called for militant action, and set about recruiting new members.

By December 1933, the newborn Unemployed Artists Group petitioned the Administrator of the New York State Temporary Emergency Relief Administration (TERA), whose infusion of money temporarily saved ERB, for jobs for artists. Their immediate reward was an increase in the number of artists employed from 100 under ERB to 393 by TERA. They presented plans for employing art teachers, mural and easel painters, commercial and applied artists, portions of which were later incorporated into the federal Public Works of Art Project (PWAP), the first national art project. During the seven months of its existence in 1933–1934, PWAP hired almost 4,000 artists nationally. Although the boost in employment could in part be attributed to the Unemployed Artists, these militants were far from satisfied with their achievement. They called for a further increase in the numbers hired, and demanded an end to the so-called merit system, whereby artists who had made some reputation were favored over unknowns, to the disadvantage of those in greatest need.

To promote their aims the Unemployed Artists Group led a demonstration in front of the Whitney Museum of American Art, the first of eight times artists marched on the museum during the period. (Juliana Force who was Administrator of PWAP in New York also headed the Whitney and had her offices there.) They demanded that she speed up the registration and employment of artists and end her practice of personally inviting favored established artists to join PWAP. Instead, they wanted artists to be called up in turn as regulations provided. (4)

Considerations of both individual and national needs—for the survival of artists and of a living culture—led to the establishment, by President Franklin Roosevelt's New Deal programs, of several nationwide art projects. Thousands of artists working on one or another of the projects had a single employer, the federal government. The employed artists, receiving regular paychecks, came to think of themselves as workers, "cultural workers."

In time, members of the Unemployed Artists and their friends began increasingly to find work on the projects. While the UAG was still concerned about those artists with no means of support, they gave their main attention to the cultural workers employed by the projects. Hence they changed their name from the Unemployed Artists Group to the Artists' Union. Their interests were parallel to the everyday concerns of other trade unions: wages, working conditions, and steady employment. By 1934 local artists unions, emulating the New York group, had sprung up in 16 cities.

The Artists's Union in New York published a journal, Art Front, generally conceded to have been the best art periodical of its time. The first issue, in November 1934, stated the Union's goals, which included the aim of "uniting all artists engaged in the practice of graphic and plastic art in their struggle for economic security and to encourage a wider distribution and understanding of art." They believed that private patronage could not provide for artists during the economic crisis and that, therefore, it was up to the government, to "fulfill its responsibility toward unemployed artists" as it was obliged to do "for all unemployed workers." The Artists' Union from its beginnings called for "the widest possible distribution of art to the general public." They also went on record as opposing the pauper's oath required for registration on relief rolls and thus for employment on an art project.

By May 1936, the Artists' Union had grown strong enough to hold a convention that some 1,200 delegates and friends from the East attended. They demanded expansion of existing art projects, a permanent Federal Art Project, and a uniform wage scale on artists' projects. They also took a position against "the forces of reaction, fascism, and war," a stance they underlined by voting to boycott the Olympic Art Exhibition that was to run concurrently with the Olympic Games of 1936 in Berlin. After the program was endorsed by the Midwestern convention, a national Artists' Union was inaugurated in January 1937. (5)

Friction between project administrators and supervisors (themselves usually artists) was constant and often bitter despite the fact that they and the artists usually had common goals for the projects. Much of the conflict stemmed

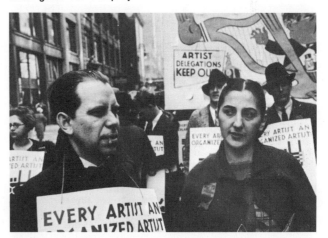

May Day Demonstration, Artists' Contingent, New York, 1935
Left: Ben Shahn

from the basic condition for employment set up by the Congress rather than from philosophical differences. (6) To be considered for WPA/FAP an individual had first to qualify for Home Relief. In order to do so, one artist recalls, "you had to show five months non-payment of rent, show them your larder . . . how many kids . . . and then your case was brought up to committees and investigations to make certain you didn't have a hoard under the mattress . . ." (7)

The actual rules for acceptance on Home Relief, the prerequisite for application for work on the Federal Art Project, were even more stringent than the artist quoted remembered. Only after an investigating social worker was satisfied that the applicant was destitute could a recommendation be made for Home Relief, and only after placement on the rolls could the artist apply for work on the Fine Art Project of WPA. Once artists had qualified, they were classified into one of four levels of skill.

One group of artists alone in New York were exempted from the inflexible rules. Because so many artists lived in New York, the demand for supervisors exceeded the supply, so for a time 25% of the artists in New York City and 10% in the State were relieved of the onus of declaring them-

selves paupers. On the other hand, by 1939 all artists working for WPA were limited to a maximum of 18 months employment.

Although pay scales for artists on WPA varied according to classification and hours worked, most artists seem to recall wages of 23.86 dollars weekly, at one point in the thirties the median wage in the United States. But actual salaries varied tremendously from one part of the country to another, between cities and rural areas, and according to hours worked. Such differences were, of course, another source of concern to the Union.

Easel painters, most of whom worked in their own studios, were required to submit completed paintings and sculpture of specified dimensions at stated intervals. But since acceptance of work by supervisors was subject to personal evaluation and taste, the entire concept of production norms inevitably led to discord. Such issues—means tests, classification by skill, salary differentials, the disposition of art, work schedules and the acceptance of work by supervisors, the 18-month limit—were sources of trouble between the artists and administrators in which the Artists' Union was often called to intervene.

But the single most pervasive ongoing cause of protest was the fight for the reinstatement of artists dismissed from the Project because of cuts in funds. The demonstrations, sit-ins, picketing were noisy and they sometimes became violent when administrators, frightened by the militancy of the artists, called in the police to disperse them. Resistance at times was followed by police brutality, and in at least one instance an Artists' Union member, a woman, was killed by the police on a picket line in Boston. The "219 Sit-in Strike" in 1936 in New York (so called because 219 artists participated) had begun as yet another demonstration against layoffs. It resulted in a melee in which "the cracks and thuds of fists and nightsticks" ended with "12 artists and policemen under medical care" and the arrest of all 219 artists, who were released the next day with warnings. (8)

Elements in the U.S. Congress (such as the Dies Committee, which later became the House Un-American Activities Committee) were opposed to the Art Projects. They viewed them as dominated by Communists or as havens for lazy "hobohemians," as the Hearst-owned newspaper chain dubbed them. Thus they consistently prevented Congress from allocating sufficient money and constantly undermined programs by cutting back on funds. (9)

One way the artists fought back was via the sort of demonstrations mentioned. Another was by affiliating with the powerful Congress of Industrial Organizations (CIO). In December 1937 the Artists' Union became Local 60 of the United Office and Professional Workers of America (UOPWA), changing its name to the United American Artists. The UAA also strengthened itself by bringing into the fold the Commercial Artists' and Designers' Union and the Cartoonists' Guild. In all, some 2,500 artists belonged to the United American Artists at its peak. (10)

The demise of the union for artists reversed its growth pattern. It arose when artists in large numbers had a common employer and common economic needs. It waned as the Depression eased, and by the time the United States had entered World War II in 1941, art projects, as such, were to all effects finished. With its members dispersed into the armed services, industry, or private life, and with its symbiotic relationship with the Federal Art Projects destroyed, the United American Artists was left with so few dues-paying members that it was unable to continue as a local of UOPWA. Some of the artists who had been in UAA formed the Artists League of America (ALA) during the war years, an organization with many of the same aims as UAA, although it never attracted more than a few hundred artists. (11) Members of ALA, however, were among the initiators of Artists' Equity in 1945. Modeled in many ways after Actors' Equity, the successful American union for actors, Artists' Equity was open only to artists with professional credentials. The large and prestigious membership it attracted during the 1940s has dwindled, so that today it has no significant impact on the American art world. Although other art organizations have come and gone, no

trade union for artists in the United States has ever again been attempted.

Notes

1 The Emergency Work Bureau (EWB), later the Emergency Relief Bureau (ERB), 1932—1935, was initiated by the College Art Association in New York City only. Funded by the Gibson Committee, a private relief agency, it eventually received funds from the Temporary Emergency Relief Administration (TERA), a New York State agency, 1931—1935. In 1935 it was absorbed into the Works Progress Administration's Federal Art Project. (WPA/FAP), 1935—1943, the largest and most active art project.
2 Art Front, November 1934, p. 2. Much of the information about the Artists' Unions beginning can be found in this issue.
3 Gerald Monroe, "Artists on the Barricades: the Militant Artists' Union Treats with the New Deal," Journal of the Archives of American Art, 18, No. 3 (1978), p. 20.
4 Richard D. McKinzie, The New Deal for Artists (Princeton: Princeton University Press, 1973), pp. 4—16.
5 Art Front, June 1936, p. 5, and January 1937, p. 6.
6 Audrey McMahon. "A General View of the WPA Federal Art Project in New York City and State," The New Deal Art Projects: An Anthology of Memoirs, Francis V. O'Connor, ed., (Washington D.C.: Smithsonian Institution Press, 1971), p. 66.
7 Marlene Park and Gerald E. Markowitz, New Deal for Art (Hamilton, N.Y.: Gallery Associates of New York State, 1977). We have drawn from pp. 15—19 of this invaluable study.
8 McKinzie, p. 96.
9 McKinzie, pp. 154—160.
10 Francis V. O'Connor, ed. Art for the Millions (Boston: New York Graphic Society, 1973), note p. 238.
11 Telephone interview, 28 December 1982, with Norman Barr, Vice-President of the United American Artists at the time it was dissolved.

Artists Must Organize

I want to talk of the undoubted fact—of the vital fact—that the artists and writers of America must organize, and organize along trade union lines and principles. It is good to have meetings in which the artist gets up and states his opposition to Fascism. To make that opposition good, he must make good through organization; and I see no other way except the organization through labor lines. I think it is enough to say that the future of art in America must come through a closer contact with labor.

I would not say that there had not been certain notable things done in art by Americans, but I am disappointed on the whole. I wrote a column the other day in which I stated, perhaps erroneously, that as soon as you cross the border in Mexico, you find wherever there is a broad wall four or five Mexican artists to paint on it. I thought perhaps that was due to a certain native genius in the Mexican artist. I am probably wrong about that. The reason seems to be in the unity of purpose art has with labor in Mexico. This statement is probably true because Mexican art exemplifies the life and thought of the Mexican people as a whole.

I wonder whether American art might not begin to step with labor. The highest prize given to an artist this year was a prize given to him by the United Mine Workers of America. As labor moves along the economic and the political front, it moves along the cultural front at the same time. There is the goal of the American artist.

What is the American artist fed on today? He is fed on what is called taste—the taste of the American people. I think we must get back to something better, greater than taste, and that is emotion; and where do you get emotion except out of the masses? So I say as a fellow artist, get together with labor. Get to know the aspirations, the ideals of the masses, and then art will be put back on earth. Then art will go ahead, lickety split, buckety bucket, here in America!

(Heywood Broun, statement at the American Artists' Congress, 1936)

Visual Artists:
A Part of the Labor Force

Susan Ortega

Visual artists in the United States are not considered part of the labor force. One is hard put to find official artist employment statistics at either the state or federal level. The U.S. Census Bureau does question the status of employment when it takes the census but the U.S. Department of Labor equates "artist" with self-employment. Thus an unemployed artist becomes a contradiction of terms.

Unlike performing artists and craftspeople within the film industry, visual artists have no union or advocacy group that keeps track of its members' working status. However, unofficial reports put artist unemployment in the double digit range.

The continuing inability of artists to earn their living from their art work is a serious problem for the development of art in this country. Certainly today's economic depression with its high unemployment and inflation severely affects visual artists as it does people of other walks of life. But even in the best of times, artists' ability to survive by the work they create is extremely limited.

This is attested by a national survey of artists who had won McDowell fellowships in the boom year of 1968. The questionnaire sent to relatively established artists, revealed that 62% had incomes of less than 5,000 dollars and only 4% earned more than 10,000 dollars from their art. Only one-half of those sent surveys responded. The complete poll would have probably shown even worse economic straits for artists. (1)

A 1977 survey of 1460 Massachusett's visual artists showed a median personal income (including sale of artwork, other employment income, investments, unemployment compensation, trust funds and grants) to be 6,200 dollars with 42% earning less than 5,000 dollars.(2)

Most artists are forced to seek part-time and often low paying jobs in order to support their art and their families. As the economic crisis continues it becomes more difficult for artists to find and to then give up whatever odd job they might have in order to meet the demands of their art.

While artists' grants offered by the National Endowment for the Arts and various state and local arts councils may bail artists out for a few months to a year, they hardly begin to deal with the annual problem of earning a living.

Besides, grants are highly competitive and are getting more difficult to obtain as budget cuts make less money available.

Most people outside the intellectual community can't quite understand what artists actually do and how to measure it as work. This lack of understanding perpetuates the mystification of the creative act and the continued alienation of artists from society. The myth of the magically inspired, "struggling artist" still survives in America. Some argue that since artists "choose" their profession, they have no right to claim the right to be able to earn a living at it. If artists wanted to have a decent income, they should do something else. Others assign a penance to those who choose to do creative work saying that "dues" must be "paid" in order to gain the right to "make it."

Artists will quickly affirm that they don't create better in financial deprivation. They have as much right to work as those who "choose" to be teachers, auto mechanics or bank tellers. The truth, as shown by the previous mentioned surveys, is that most artists never "make it" and spend their whole professional career "paying their dues". In fact, one even questions what is a successful artist when one learns that prominent American sculptor David Smith only sold 75 major pieces during his lifetime. His total receipts for the last five years of his life were 207,846 dollars of which 19,747 dollars was profit. That comes to 4,000 dollars annually (3), hardly what one would call "making it." Success for visual artists all too often, if it comes at all, comes after death with the dealers and collectors the only ones making a living from the art work.

There have been only two times in U.S. history when an effort was made to deal with this problem of artist employment: The Works Projects Administration (WPA) in 1937–43 and the Comprehensive Employment and Training Act (CETA) in 1974–80. Both programs occurred when the country as a whole, grappling with massive unemployment, enacted national jobs programs. Through the organizing efforts of artists themselves, artists took their rightful place by the side of other workers as integrated members of the labor force.

Attention here will be given to CETA as the WPA is dealt with in another article in this book. CETA was developed in the mid 1970s as a temporary program for the hard-core unemployed. It differed from the WPA in that people did not directly work for the federal government but federal money was made available to state, county and municipal governments and non-profit community organizations to run job programs. Emphasis was placed on training new skills with the hopes that these skills would enable the unemployed to find work.

Realizing that artists were part of the chronically unemployed a clever Californian successfully got San Francisco to hire artists under CETA's public service employment program in 1974. 3,500 artists picked up applications for the 113 positions available. Few of the applicants had ever held a full time artist job and most were receiving foodstamps or other public assistance.

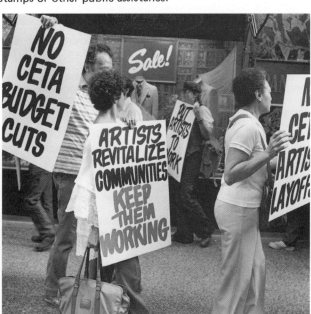

Stanley Banos. CETA Artists' Organization to Save CETA Artists' Projects, New York, 1979

CETA and the arts caught on and by the late seventies CETA was the largest public funding source for the arts employing over 10,000 artists nationwide with an annual budget (1978) of 75 million dollars going to fund 600 projects in 200 localities. For the first time since the 1930s artists received a weekly salary for their work.

In the mecca of the art world, New York City, the CETA Artists' Projects started in 1978 under the initiative of several art organizations including the Cultural Council Foundation which eventually employed 312 of the total 612 New York artists (115 of them visual artists). It was the largest single artist project in the country.

Despite the fact that CETA only dealt with the tip of the iceberg of New York City's artist employment (there are several thousand visual artists in New York City alone), it had great impact. Employed under CETA, artists became valuable community workers providing over 150 free weekly performances, workshops, classes and exhibitions. As cultural workers, CETA artists played an integrated part in stimulating and revitalizing neighborhoods both economically and spiritually. CETA helped support the growing mur-

al movement and kept alive many small cultural organizations serving Black, Hispanic, Asian, Native American and other ethnic groups which would have otherwise had to close. (As a matter of fact, many did go under or severely had to cut back their programing after the CETA projects ended.)

Shortly after the formation of the New York projects the CETA Artists Organization (CAO) was formed. While it never was recognized as an official bargaining agent for the artists it served as the unifying force to fight for an increase of artists' jobs for the unemployed, for the continuation of the CETA projects, and for a more permanent program of artist employment.

With an organization, artists began to find out what people in the trade union movement had known for a long time: working together could secure more than working as individuals. The CAO helped avert salary cuts, provided direct information to artists about CETA regulations and insured no blanket lay-offs of any particular artist discipline.

The CAO worked in conjunction with organizations representing the 15,000 other New York CETA workers including District 37 Municipal Labor Union. Collectively artists and other workers fought lay-offs with jointly sponsored petition campaigns, legal suits and job rallies. At the rallies artists provided songs, posters, and presented a play specifically dealing with the importance of CETA in keeping New York City functioning. The joint demonstrations showed artists the need for unity with all workers for the right of a job and strengthened artists' own struggle for the right to work as artists. It showed that artists were not in competition with hospital workers or daycare workers for jobs but that together they could fight for a better city for everyone.

The CAO also staged demonstrations to save the artists' projects including a 2-day cultural rally/demonstration in front of City Hall. CAO representatives met with the CETA Undersecretary of Labor in Washington D.C. in order to try to save the projects.

Despite nationwide recognition and public support by elected officials, the artists' projects along with most of the CETA public service jobs ended in 1980 as part of sweeping national budget cuts and a tide of conservatism that elected Ronald Reagan president.

Though short-lived, CETA, like the WPA, 40 years ago its predecessor, proved the viability of artists employed as public service cultural workers. Receiving a salary from their art gave artists a sense of dignity and allowed them to feel part of a community. By having artists work directly in neighborhoods, CETA helped demystify the artistic process and provided for a great democratization of the arts by giving everyone, regardless of economic status, the right to enjoy a cultural life. Many received classes and saw quality art, theater and dance for the first time. United with other workers in the common struggle against unemployment, artists began to feel linked with the people and people in turn began to see artists as fellow workers.

However, CETA proved to be no more than a bumpy roller coaster ride that took artists off unemployment and welfare lines for a spell only to throw them right back where they had started from.

Despite a tradition among artists to be involved in the progressive movement of people for peace, civil rights and more recently for nuclear disarmament, there has been little energy devoted by artists towards organizing around the basic issue of earning a living. Based on the experience of CETA and the WPA, the possibilities of visual artists working together with labor unions certainly need to be explored. There are programs in some unions throughout the country to bring the arts to members; most notable is the Bread and Roses Project run by Hospital Workers Union 1199 in New York City. It would be a welcomed addition if the unions also addressed the problems of artists as workers and the need to organize and incorporate them into the work force.

The current national "Jobs with Peace" movement, the momentum that came out of the AFL-CIO Solidarity Day (1981), and the massive New York June 12th Peace Rally (1982) along with other efforts to establish economic priorities that serve human needs rather than the military budget provide artists with another opportunity to link up with other working people. It is through artists aligning themselves with the labor movement that progress could be made towards artist employment and towards, as painter Stuart Davis said, ". . . a government administration that will regard the arts, along with proper housing, health services, social security legislation and educational facilities for all, as part of the basic obligation of a democratic government of all the people toward the welfare of its citizens." (Stuart Davis, National Secretary, President of the Artists' Union and American Artists' Congress, 1936.)

Notes

1 Art Workers Newsletter, January 1971. New York
2 "Career Development: A profile of Massachusetts Visual Artists" by Rita K. Roosevelt. The Artists Foundation. Boston. 1979
3 Art Workers Newsletter. Vol. 1, No. 4, New York

Susan Ortega, muralist and graphic artist was a CETA artist from the start of the New York city projects and President of the CETA Artists' Organization. She also was one of the organizers of Artists for Nuclear Disarmament for the June 12th Peace Rally in New York, 1982.

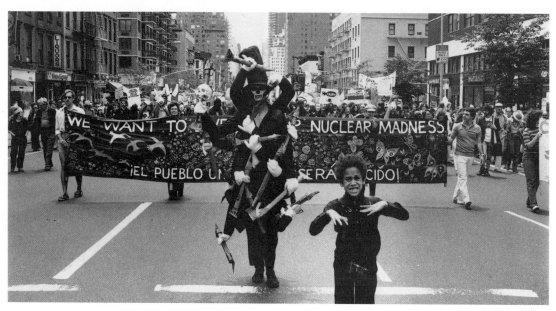

Gary Schoichet. Artists' Contingent of 2000. June 12th March for Disarmament, New York, 1982

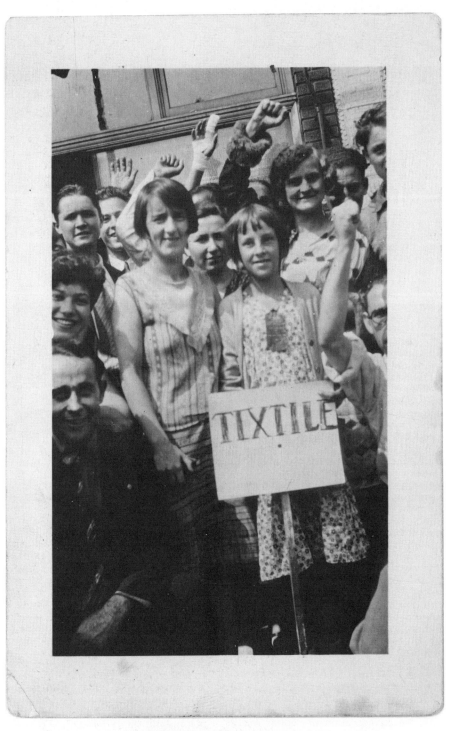

*Joe Rapoport. Textile Workers from New York
Going to a Demonstration, c. 1937*

Camera Images of Labor — Past and Present

Camera Images of Labor — Past and Present

Naomi and Walter Rosenblum

"Material assets don't just happen as a product of . . . impersonal machines." This observation, made by the American photographer Lewis Hine in 1933, might be taken as the theme of this volume whose purpose is to present a pictorial history of American labor. As Hine went on to note, machines are run not by robots but by men and women whose labor in factories, farms, mills and construction sites has provided the material prosperity of the United States. In a similar sense, the photographs included in this book were made by "machines" which, employing physical and optical phenomena, also have required a human hand and eye to produce the image. Unlike the factory worker, however, the person behind the camera lens has been in a position to select the purpose and design of the product, making the photograph a mechanically produced artifact which distills a personal sensibility.

Camera images of work have varying goals. The photographer may intend only an informational record of what transpires before the lens, seeking out the most suitable lighting and arrangement for this relatively simple purpose. Or, photographs may be regarded as a means of emphasizing physical structures—machinery, tools and industrial sites—rather than the people who work with these objects and in these environments. Of more significance are photographs of working people which have been conceived as a way to inform and arouse individuals about exploitive aspects of the work place or to awaken human compassion for the suffering which such conditions produce. Along with simple records and images critical of working conditions, there also emerged a celebratory view of the American worker—an imagery concerned with the dignity of work and the probity of individual laborers, which suggested that without these qualities American industrial production would not have been possible. In the work of both amateur and professional photographers, these goals have created a richly diversified body of images of American labor at work and in their homes. While by no means intended as an exhaustive survey, the photographs in this article have been selected to suggest the changing perceptions of working people and the different ways in which the camera has been and continues to be used as an emblem of the need for economic and social action.

The camera emerged as a pictorial tool in the 1840s at a time of changing relationship between workers and work. An agricultural economy of yeomen and small craftsmen, the United States was beginning the shift to industrial activity which, with the accumulation of capital wealth and the development of extensive transportation and communication systems, eventually would assume its modern corporate form. Photography's role in this transformation was unique in that it was both a beneficiary of the growth of science and industry and an observer and critic of the transformation that was to take place within the second half of the century.

The earliest images of laboring people were daguerreotypes—unique images on metal. From the 1840s until the Civil War, itinerant portrait daguerreotypists traveled throughout the land, recording with a range of competency such individual artisans as coopers, blacksmiths and makers of lace,

The Photographer Frances Benjamin Johnston at a County Fair in Virginia, May 1903

toleware and clocks in the East and, after 1840, gold miners in the West. Many occupational portraits were restaged in the photographer's studio, with simple tools of the trade brought in by the sitter. Other occupations, including blacksmithing and gold mining, were taken out-of-doors in the field, often including more than one figure and enough background and mechanical apparatus to indicate the nature of the work. Devoid of rhetoric and artfulness, these straightforward records are interesting for the attitudes about work which they reveal. Usually seen from the front, a view which emphasizes distinctive facial and bodily characteristics, the individual, whether seen singly or as part of the work force, is presented as upright and proud—neither cowed nor brutalized by work.

During this period of transition from Jeffersonian utopia to modern corporate capitalism, few images of mill interiors and workers were made, even though textile manufacture was among the earliest industrialized enterprises in the United States. In part, this was due to the difficulty of photographing in dimly lighted mill interiors but it also is true that such images were in little demand. An exception, an ambrotype of the spinning room of a small New England mill, made in 1850, shows women workers standing besides the looms while the male supervisor remains seated.

As a method involving considerable handcraft which resulted in a unique and nonduplicatible image, the daguerreotype (and, briefly, the ambrotype) was destined to vanish in the manner of other hand-tool technologies. During and after the Civil War, the wet-plate collodian process took over as a means of recording, besides the war itself, aspects of developing industrialization. While popular as a technique for making portraits, collodian also was employed for the

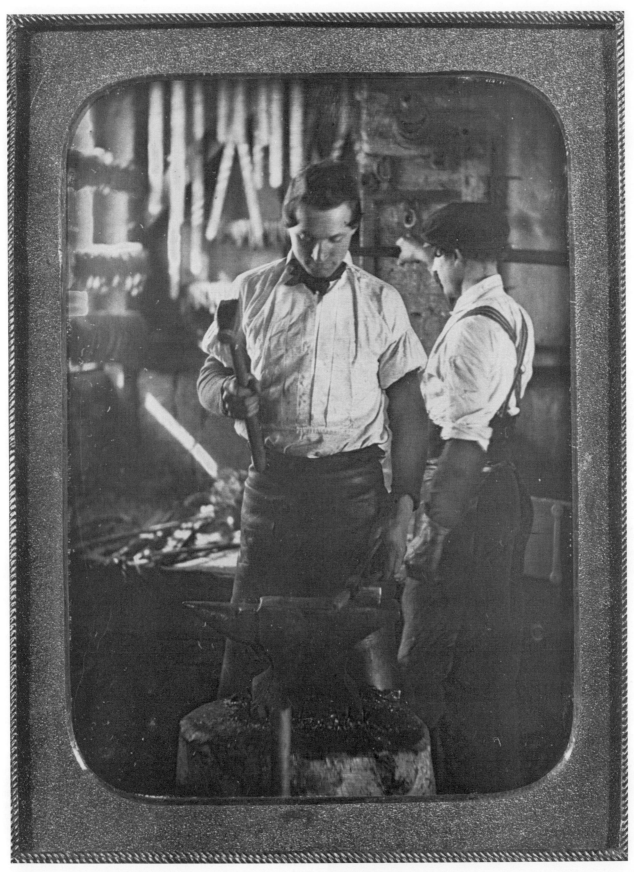

Blacksmith, hand-colored daguerreotype, c. 1850

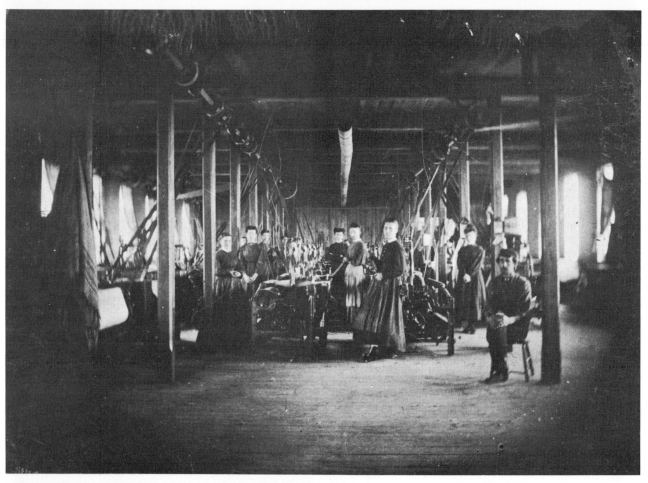

Spinning Room in New England, c. 1850. Ambrotype. Drake Well Museum

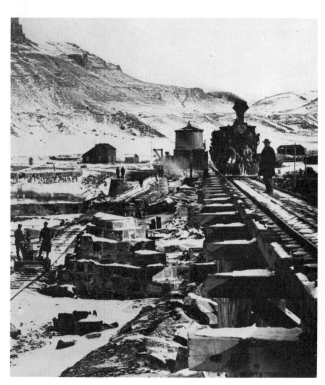

Charles R. Savage. Promontory Point, Utah, 1869

documentation of developments in transportation and the exploitations of mineral and lumber resources. Even before 1860, artists and photographers had been invited by railroad companies to ride the eastern routes and depict the surrounding terrain in drawing and silver print but in the late 60s experienced photographers, among them William Henry Jackson, Andrew J. Russell and Charles R. Savage were commissioned to record the actual laying of the western routes. The joining in 1869 of the east and westbound portions of the transcontinental system at Promontory Point, Utah, photographed by Savage, presents a unique celebratory occasion with workers, engineers and financial backers mixing together. But railroad images more commonly were concerned with portraying a wild and difficult terrain to be conquered. The working men, many of them imported from China for the tasks of rock-cutting, grading and track-laying, were secondary considerations, figuring occasionally in middle grounds of images only to suggest the nature of the work or to provide a sense of scale.

On the other hand, camera images of mining, lumbering and construction operations made during the post-Civil War years frequently included the work force. Seated or standing in neat ranks around or on equipment, or posed in a kind of tableau of work, there seems at first glance to be little in these photographs beyond the description of outward appearances—clothing, tools, machinery, terrain. Nevertheless, as Professor Jack Hurley has suggested in Industry and the Photographic Image, the upright stance and forthright demeanor of men bent on turning natural wealth into profitable commodities, suggest that both workers and photographers regarded this labor as an heroic enterprise in tune with national economic ambitions. Certainly Darius Kinsey, photographer of the "timer stiffs" who felled the gigantic trees in the logging camps of the

Pacific Northwest was conscious of this character of work as he carefully positioned loggers, with their axes and cross-saws, and himself, with a large plate camera and tripod, to produce prideful images of the operation of tree felling. In common with many photographers of work activities during this period, Kinsey's goal was to sell the pictures to the men themselves, rather than to impose a tendentious point of view on the material. But as an entrepreneur who also was a "worker"—in that field photography in the collodian and early dry plate eras required physical effort as well as visual sensitivity—Kinsey shared with his subjects the view that hard work was the ordained destiny of Christians who wished to create the good life on the American continent.

Until around 1890, it is rare to find views of working people in the United States that suggest that they are downtrodden or unhappy, or that work is anything but an honorable activity, but several developments changed labor imagery during the last decade of the 19th century. One involved technological advances which made dry film, hand cameras and better flash-powder equipment available, giving photographers greater flexibility in their choices of where and when to photograph. Taking pictures inside mills and mines became possible. Photographers could now depict workers at benches, looms, furnaces and breaker chutes instead of having them pose stiffly out-of-doors as in an 1878 view of mill workers in Amoskeag, situated in Manchester, New Hampshire—at the time the largest textile mill in the world.

As was true of the Amoskeag photographs, which were commissioned by the Company to provide records of its forward-looking policies of manufacture and treatment of workers, photographs made between 1884 and 1895 by George Bretz for the Girard Estate and Philadelphia Reading Coal and Iron Company were meant to inform about techniques and processes. Using available light in some cases and electric light in others—a first in photographing mining operations—Bretz produced images that described the interior of the mines for curious viewers at the Industrial Fairs and Expositions held at intervals in the United States and Europe at the end of the century. With rare exceptions, the workers in these records appear as bland and uninvolved adjuncts of the chutes, troughs and piles.

The tendency to treat the worker as a cipher became even more pronounced in the stereograph views of occupational situations which began to be published in the hundreds of thousands toward the end of the 19th century. Widely used as both an educational tool and an entertaining diversion, these sets of two almost identical images, mounted side-by-side on a card which was designed to be inserted into a special but inexpensive viewer in order to create the perception of three-dimensionality, were the era's equivalent of television. Ostensibly information, they provided "laundered" views of factory interiors, machinery and occupations, avoiding the depiction of sweatshops, unsafe machines or unhappy wage earners. Popular during a time of increasing agitation by labor, no strikes, picket-lines and demonstrations were visible in these representations; indeed stereographs of work presented an idealized and vacuous view of American labor, far removed from the conditions pictured by photographers engaged in reform programs or the actualities of working class life.

With hand cameras and dry film available, non-professional photographers began roaming city streets to capture unposed views of working Americans engaged in street trades and out-of-doors occupations. Taken casually, these images usually are interesting only as information but on occasion photographers made more significant contributions, capturing some of the affective quality of street labor. For example, Alice Austen, brought up in a well-to-do Staten Island family, used the camera in this fashion, enriching for herself what otherwise would have been a stuffy and restricted bourgeois existence. Crossing New York Bay, she photographed incoming immigrants at Castle Garden and ventured into the crowded streets of the Lower East Side to record food vendors, scissors grinders, shoeblacks and street sweepers. Made as personal gratification, these candid images of working people capture

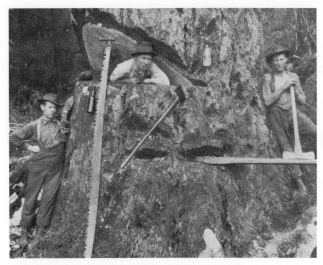

Darius Kinsey. *Undercut of 10-Foot Fir, California, c. 1900*

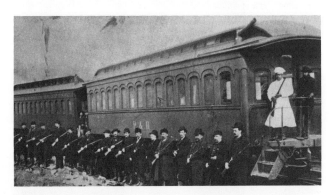

George M. Bretz. *Philadelphia & Reading R.R. and Coal & Iron Police Quarters, Gordon, Pa., February 23rd, 1888*
Special train for moving company police into the coal and iron regions

Hauling Logs into Lake Chelan, Washington, c. 1900
Stereograph

the liveliness of street activity among the urban working poor of the 1890s without suggesting any of the pain of their condition.

The photography of social conditions, labor among them, was aided and abetted by another technological development. Soon after the new dry-film technologies appeared, half-tone or process-plate printing was perfected to a stage where a direct transcription of the photograph could be printed in the same operation as the type. Even before this achievement, magazine illustrators had used photographs as a basis for engravings and lithographs, but the appearance of the photograph itself in print suggested that such images might henceforth be regarded as truthful evidence rather than artistic fancy. Starting in about 1890, periodicals

Johann Hamann. Emigrants Check-In for Departure to U.S.A., Hamburg, c. 1900

Health Inspector Checks Immigrants on Ellis Island, New York, c. 1909
Museum of The City of New York

designed to appeal to the largely literate middle-class, began to feature stories on working conditions in the nation's industrial plants. For example, in 1890, Demorest's Family Magazine commissioned Frances Benjamin Johnston of Washington, D.C. to photograph workers in the United States Mint, reproducing the illustrations both in line engravings and photographic half-tones. Continuing interest in the theme of work led to assignments for photographs to illustrate stories on coal mining in Pennsylvania, ore mining in the Mesabi range in Minnesota, women operators in shoe factories in Lynn, Massachusetts and cigar workers. Johnston admired the "bright-eyed youngsters" whose "keen vision" in the dimly lighted breaker-house interior left no slate attached to the coal nuggets, but as the privileged associate of politicians and society folk she seems to have been oblivious to the fact that these children sat doubled over troughs in gritty damp mines scrabbling for coal for 12 hours each day. And while she praised the dignity of individual women workers seen leaving the factory in late sunset in one of her most expressive images, her comment that they lived comfortably on four dollars a week (pay for a 12-hour day) suggests her distance from the concern of the working poor.

Her attitude toward work as an upright and honorable activity no matter what the conditions, is clearly seen in a series of photographs made in 1900 in Tuskegee Institute, a school for Southern Black students who ostensibly were being vocationally prepared for jobs in American mainstream industries. In the lucidity of lighting, arrangement and pose, a view of carpentry students repairing the staircase of the Director's house suggests an idealized vision of the actualities of work in America, especially for Afro-Americans.

During the early 1900s, demands from an expanding pictorial press for topical material resulted in a greater number of assignments to writers and photographers for stories and images of labor activities. Many of the images which appeared in World's Work (and no longer exist outside the pages of these publications) not only were visual records of the processes and activities required to load ships, build bridges or provide the nation with minerals and timber, but endeavored to capture pictorially the dramatic excitement involved in such work. For instance, Arthur Hewitt, whose photographs illustrated stories such as Ernest Poole's "The Ship Must Sail" and "Cowboys of the Skies," dealing with the work of longshoremen and bridge builders respectively, concerned himself with problems of composition, tonality and framing in order to make illustrations which are expressive of the idea of exciting activity rather than descriptive of sober fact.

The growth of unions and the agitation for the eight-hour day also were timely, if controversial, issues from the 1880s on, although at first few images other than portraits of leaders such as Eugene V. Debs, Terrence Powderly and Samuel Gompers appeared in the press. When the camera did record strikes, demonstrations and organizing activities, the pictures were for the most part undistinguished by visual sensitivity or distinctive point of view; they frequently were used by graphic artists as the basis for satirical or commendatory line drawings and lithographs. By the first decade, however, photographs of the increasing agitation for relief

Frances Benjamin Johnston. Students Repairing the Staircase at the Director's House, Tuskegee Institute, Alabama, 1899

Scene from the Garment Workers' Strike, New York, 1916

"Picket(s)-Ladies Tailors Strikers", New York, 1916. Library of Congress

from long hours and low pay, symbolized in the massive strikes of silk workers in Patterson, New Jersey, textile workers in Lawrence, Massachusetts, and miners in Ludlow, Colorado, which were reproduced directly in half-tone without the intervening hand of the graphic artist, resulted in greater public awareness of the ferment among industrial workers, despite the anti-labor attitudes of the press.

The most significant factor inspiring compassionate images of labor around the turn of the century was the changing situation in regard to unskilled work. As industrial capacity expanded, newly introduced mass-production methods increased the need for low-paid laborers who were solicited from southern and eastern Europe as well as from Scandinavia, Germany and Ireland, countries that had supplied immigrant labor earlier in the century. The great influx from non-Nordic and non-English speaking nations gave rise to outbursts of prejudice against foreigners who were held responsible for depriving native Americans of jobs, for polluting the Anglo-American bloodstream and creating urban social problems. In addition to long hours and poor pay, immigrant laborers and their families were housed in the most dilapidated buildings and neighborhoods. Lowest on the economic and social scale, they were the first to suffer the effects of the cyclical depressions which had occurred with some regularity between the Civil War and the First World War. Some turned to rag picking, scavenging and piece work and others to prostitution in order to make a living. Strangers in an inhospitable land, some were prone to disease and alcoholism, while the most destitute were forced to apply for charity which was largely administered by Protestant religious organizations who exchanged meager rations of bread and soup for promises of piety.

In the late 19th century, reformers began to recognize that the social problems of the working-class poor were inseparable from the problems of the workplace. To redress the situation, they set about reorganizing the forms of charity; by emphasizing improvements in both housing and working conditions they suggested that anti-social

Chrysler Ladies Auxiliary No. 5 during the Successful UAW Strike in Detroit, 1937

During the Shipyard Workers' Strike in the New York City Area, June 1937. Wide World Photos

behavior would be impeded. Their weapons in this campaign were the pen, the brush and especially the camera, with photography eventually taking over the graphic artist's role of pictorial documentation because of its perceived effectiveness as a 'mirror' of truth.

This development was initially the work of Jacob Riis, police reporter for the New York Tribune in the late 1880s, who was determined to demonstrate the actuality of "How the Other Half Lives," the name he gave his articles and a book on living conditions among the working-class poor, published in 1890. Convinced that the photograph presented incontrovertible evidence, he hired photographers and finally learned the techniques himself in order to picture conditions of housing, street and home life, of work in unsafe and poorly ventilated sweat shops and in tenement apartments where women and children worked on piece goods to augment low wages. Besides being published both in direct half-tone and in line engravings made "after" the photographs, his images reached viewers through an active schedule of stereopticon (slide) lectures, where the conditions they exposed frequently were met with gasps of disbelief from the audience.

An immigrant himself with experience as an unskilled and destitute laborer before he became a reporter, Riis approached his subjects and the task of presenting their plight with a mixture of Christian moralizing and compassion. Because he looked on the photograph as a means of presenting a perceived truth, he selected subject and vantage point

thoughtfully, guided by what he believed would arouse complacent middle-class viewers who had little idea of the circumstances in which the poor were forced to live. In a recent article on Riis, Peter J. Hales points out that in Rag-Picker's Wife, a picture of a seated Italian woman and her baby in a tenement interior without a window, the begrimed walls, the hat hung up high for safety, the bedding removed from the floor were included as evidence both of actual conditions and to signify the concern by the immigrant woman for decent habitation.

Riis's most significant work was done around 1890; his remaining years were spent lecturing and promoting reform programs in New York and throughout the nation. In the opening years of the 20th century, this movement received an infusion of strength from the activities of enlightened progressives who understood that with even greater immigration—13 and one-half million between 1900 and 1914—social problems including those of the workplace, required even greater attention. And "social photography" as it came to be called by Lewis Hine, its foremost advocate at this time, played a decisive role in efforts to legislate state-by-state regulations of conditions of work, housing and school attendance, especially for child workers.

Unlike Riis, Hine was native-born, coming to New York from the Midwest around the turn of the century to teach in a school experimenting with theories of progressive education. Educating youngsters to relate to the world around them through both action and thought, Hine used the

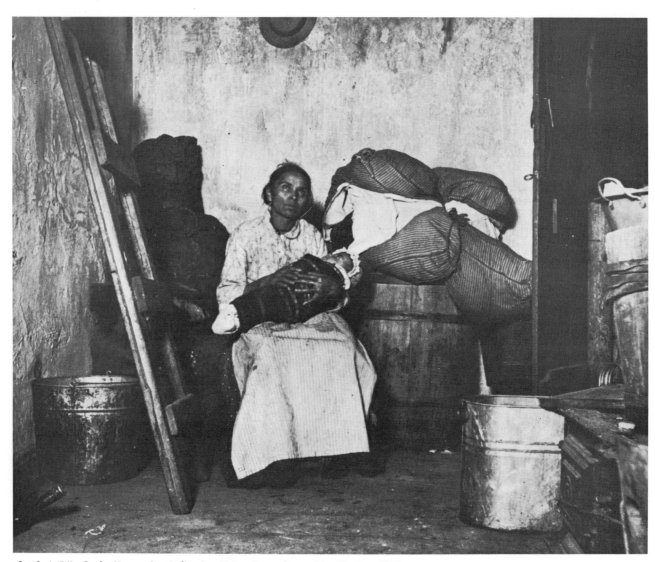

Jacob A. Riis. In the Home of an Italian Rag-Picker, Jersey Street, New York, c. 1889
Museum of The City of New York

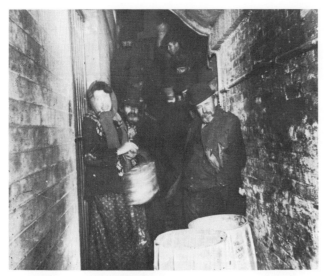

Jacob A. Riis. Police Station Lodgers Waiting to be Let out, New York, c. 1890

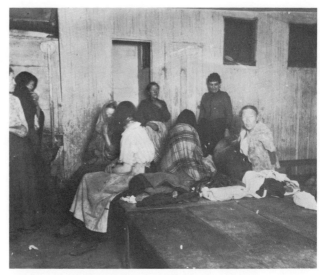

Jacob A. Riis. Women in Elizabeth Street Police Station, New York, c. 1889

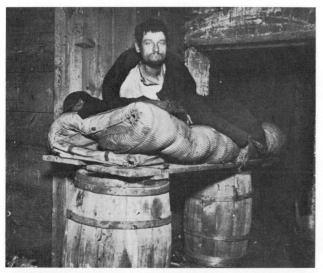

Jacob A. Riis. The Man Slept in this Cellar for Four Years, New York, c. 1890

Jacob A. Riis. Street Arabs in Sleeping Quarters, Mulberry Street, New York, c. 1889

Jacob A. Riis. Shoemaker, Broome Street, New York, c. 1889

Jacob A. Riis. Street Arabs in Night Quarters, New York, c. 1889

All photos: Jacob Riis Collection. Museum of The City of New York

Jacob A. Riis. *Didn't Live Nowhere, New York, c. 1889*
Museum of The City of New York

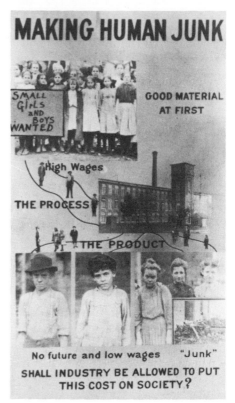

Lewis W. Hine. *Poster for the National Child
Labor Committee, 1904*

camera as a teaching device, taking students outside the classroom to photograph. On a trip to Ellis Island in 1904, he began to photograph immigrants, hoping to counteract the prejudicial and often scurrilous descriptions and graphic images appearing in newspapers and popular magazines. As a consequence, the individuals and groups he selected, arranged and photographed, using a 5 by 7 view camera on a tripod and flash powder, often seem to emphasize nobility, weariness and bewilderment, qualities consciously aimed at portraying universally shared emotions rather than pointing out ethnic differences. From these early works made under difficult circumstances, it is apparent that Hine had an extraordinary capacity to put people at ease and make them forget the posturing which standing before the lens often evokes, a quality which was to be of significance in his later images of work.

Immigrants from Ellis Island were swallowed up in sweat shops and in mills and mines throughout the eastern and middle States; in 1906 Hine started to follow them to their places of work and residence. While still teaching, he sought out charity organizations in the hope of providing them with photographic evidence of work and living conditions. His first assignments, which appeared in Charities and the Commons magazine, were to picture situations in which women and children were engaged in piece work and street trades. As in the Ellis Island images, his objective was not only to document conditions but also to present immigrants as dignified rather than degraded. Drawing on art training which had acquainted him with the acknowledged masterpieces of Western art, these early images, sometimes labeled by Hine with the word "Madonna", at times recall the work of the painter Raphael. Eventually, mastery of the medium enabled him to select less conventional poses and to capture the spontaneity of unposed street activities.

Hine's first important commission to photograph outside of New York was for a documentation of working-class life in Pittsburgh, Pennsylvania, the archetypal American industrial city. Supervised by sociologist Paul Kellogg, the Pittsburgh Survey was a pioneering study published eventually in six volumes, illustrated by photographs and the graphic work of Italian-American artist, Joseph Stella; it detailed the working, housing, recreational and educational conditions of workers in steel mills, canneries, laundries and cigar factories.

Between 1908, when Hine left teaching to devote himself entirely to the new field of social photography, and 1918, when he went abroad to photograph war relief activities in Greece and Serbia, he made thousands of images of the exploitation of child workers for the National Child Labor Committee, a group of reformers endeavoring to lobby for regulative legislation. His objectives were twofold: to convince viewers of the unsavory actuality of work in mills, mines, on the streets and in the fields; and, to arouse compassion for youngsters being turned into what he and the NCLC termed "human junk". By this, they meant children whose young lives and future working careers were so thwarted by exploitation that they would be unfit for labor as adults. While Hine's images frequently show the dangerous machinery on which youngsters stood barefoot— to remove bobbins and tend threads, for example—he concentrated on gesture and facial expression. Even when machinery surrounds or dwarfs the individual child, he or she is the focus of the picture, whether standing and looking at the camera or caught in a moment of joyous freedom, escaping the confines of the mill after work.

Hine's photographs of young mine workers are especially moving as he penetrated behind faces and bodies begrimed by coal-dust to reveal the longing for childhood experiences denied youngsters whose waking hours were entirely spent below ground or in dreary breaker houses. Photographs he made in the Pennsylvania hard-coal mines around 1910 document not only situations as they existed but evoke a "vision" of what might be—a conscious objective on the part of Hine and the reform movement in general.

Along with the photographs, Hine kept records of the work situations and individuals, noting names, ages, type and hours of work and any other information he could glean from children whose activities were closely watched by plant foremen. The pictures were reproduced in local newspapers, NCLC publications, turned into slides for lectures and into display panels for exhibitions at religious and social work conferences throughout the nation. Hesitant

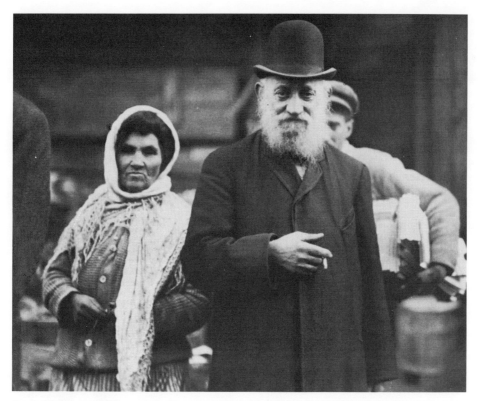

Lewis W. Hine. East Side, New York, c. 1910. Collection Naomi and Walter Rosenblum

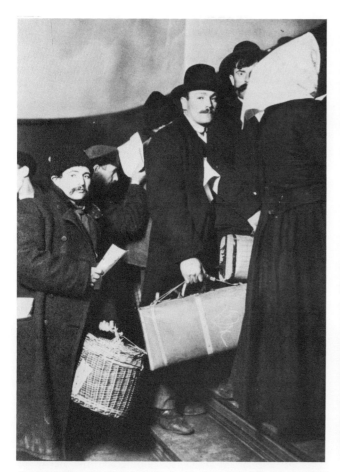

Lewis W. Hine. Climbing into the Land of Promise, Ellis Island, 1905
Ewing Galloway, New York

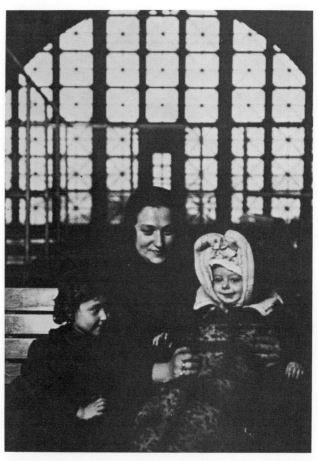

Lewis W. Hine. Madonna of Ellis Island, 1905
Ewing Galloway, New York

at first about the role of the photographic image, the NCLC ended by assuring its Board members of the significance of camera images in convincing viewers of the truth of their assertions. These images still have meaning for contemporary viewers because they not only reveal historical conditions but crystalize the emotional effects of these circumstances on innocent children.

Industry and labor as such were of little interest to aesthetically oriented photographers in the pictorialist movement although Photo-Secessionists Alfred Stieglitz and Alvin Langdon Coburn were attracted by the dynamism of urban work experiences and by industrial formations. Neither regarded the individual worker worthy of photographic depiction. One of the best known pictorialist photographs, The Steerage by Alfred Stieglitz, is a view of a working-class group of immigrants (returning to Europe) who form a motley crowd whose energetic interchange, while admired from afar, is barred to both photographer and viewer. The title of Stieglitz's well known Hand of Man acknowledges the human role in the creation of industry and energy but the image itself is a symbolic mixture of the practical and the cosmic. Coburn, photographing construction in New York around 1910, and, later, industrial plants in Pittsburgh, includes workers in several images but their forms are shadowy ciphers enveloped in a steamy haze—not more significant than the machines they operate or the structures they build.

The conflict in Europe in 1914 signaled the end of the great labor migrations to the United States. Though industrial capacity continued to expand to meet both war demands and the growing interest in automobile transportation, the reform spirit foundered and with it went the outlets for criticism of exploitation or compassionate images of laboring people. Photographs of industry concentrated on process and product, an approach which continued through the 20s despite interludes of economic crisis and agitation for improved labor conditions.

Standardization, along with newly rationalized methods

Alfred Stieglitz. The Hand of Man, New York, 1902
George Eastman House, Rochester, NY

Alvin Langdon Coburn. Locomotive and Steam Shovel, Pittsburgh
George Eastman House, Rochester, NY

of industrial production such as devised by Frederick Winslow Taylor and Frank B. Gilbreth, created systems that turned individual workers into cogs while promising investors more profitable returns. Advertising, an emerging field at this time, also abetted the concentration on product and process rather than on labor. This enterprise, which turned to photographic images of mass-produced commodities as more convincing than graphic depictions, was eager to set forth the material aspects of American capitalist technology rather than to suggest that these products were the result of human effort.

Early in the 20s, significant groups of artists and writers as well as corporate and advertising interests began to regard science and technology, as well as human endeavor and personal feeling, as basic to the reasonable functioning of industrial societies. Responding to these perceptions, photographers took a cue from Paul Strand's plea for the use of the camera as an objective rather than an emotive instrument and from his pioneering images of automobile and machine tool parts. They concentrated on geometric form and volume, organizing their images of machinery, factories and industrial sites in such a way as to exclude palpable atmosphere and minimize human involvement. The most coveted industrial assignment of the decade—a commission given Charles Sheeler in 1927 to photograph the newly reorganized Ford Motor Plant at River Rouge, Detroit—resulted in images that typify this approach. Among them,

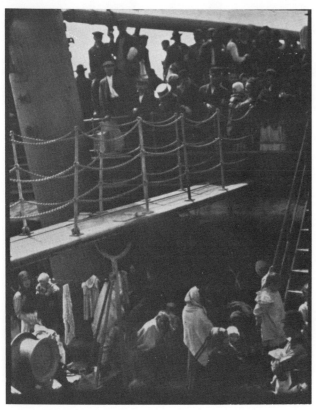

Alfred Stieglitz. The Steerage, 1907

views of the blast furnace and convector tower omit the work force entirely while other images show workers from behind or dwarfed by massive machines.

In similar fashion, Margaret Bourke-White, the era's most prominent photographer of industrial subjects who portrayed the operations of major enterprises—steel, copper, paper, textile and flour mills, and automobile plants—for Fortune, the semi-official publication of the corporate structure, selected angles and lighting effects which dramatized processes but played down operators. In an interesting contrast, however, her focus when she photographed mining and logging in the United States was on the workers who were not yet part of completely mechanized operations. Similarly, Bourke-White's picture essays on industry and construction in the Soviet Union made around 1930, depict the individual worker as central to the production. Other American photographers who portrayed machines without people, concentrating on geometry and function, included Anton Bruehl, John Mudd, Thurman Rotan, Howard Scandlin, and Ralph Steiner.

During the 1920s, Hine was the only photographer of significance to continually stress the "human element," as he called it. This emphasis can be seen in an unusual picture book, published in 1932 with the title Men At Work, a testimony to his conviction that the nation's strength resided in an intelligent, respected and adequately paid work force. From the early 20s on, he attempted to interest large corporations in a photographic campaign depicting workers as intrinsic to the industrial process but aside from a handful of companies, including Western Electric and the Pennsylvania Railroad which featured Hine's work portraits in their publicity materials, he was only moderately success-

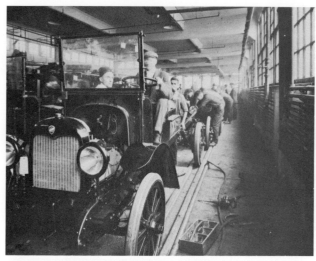

Assembly Line at the Maxwell Motor Co., Detroit, c. 1918
The National Automotive History Collection

Center: Electric bulb designed by Gilbreth in 1912 for photographic motion studies
Bottom: Cyclographic motion study of a worker folding paper. Gilbreth and Lillian started these studies at the New England Butte Co. in 1910

Frank B. Gilbreth with a model for efficient movements in assembly-line production based on motion studies

Paul Strand. The Lathe
George Eastman House. Rochester, N.Y.

Margaret Bourke-White. Textile Mill
Anoskeag, New Hampshire, 1934
University of Syracuse, N.Y.

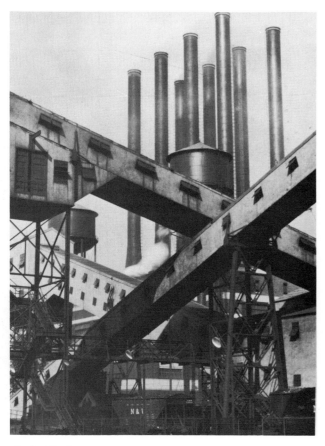

Charles Sheeler.
George Eastman House. Rochester, N.Y.

ful. In 1930, however he was given the commission to photograph the construction of the Empire State Building—a "white elephant" which during the depths of the Depression was to arise 108 stories to become the tallest structure in the world. Similar building projects were being photographed at about the same time, among them the Chrysler Building by Margaret Bourke-White and Rockefeller Center by Berenice Abbott, but his are the only images to consistently integrate worker, structure and process into an expressive whole. As Hine, then in his 57th year, followed the progress of construction from below street level to mooring mast, he found the means to imbue the hundreds of images with a sense of drama, danger, excitement and promise. Taken as a whole, this extraordinary accomplishment transformed descriptive documents into a celebration of work.

The rosy view of the beneficence of unregulated technology became insupportable when six months after the stock market crash in 1929, four million American workers were unemployed. By 1932, despite pleas by corporate interests to maintain the faith, "one third of the nation" was judged to be "ill-fed, ill-housed and ill-clothed." Photographs could not avoid mirroring this situation, in part because the camera was called upon to supply reportorial images to the press and to document the work programs of newly created government agencies such as the Civilian Conservation Corps, The Rural Electrification Administration and the Tennessee Valley Authority. Appearing in daily papers and periodicals the pictures of the unemployed awaiting handouts of bread and soup or selling apples, of sitdown strikes and corporate and police brutality, and of displaced workers building dams and clearing forest lands generally are politically and aesthetically unfocused—competent records of events and situations requiring the written

Opposite: Lewis W. Hine. Powerhouse Mechanic, 1920
Collection Naomi and Walter Rosenblum

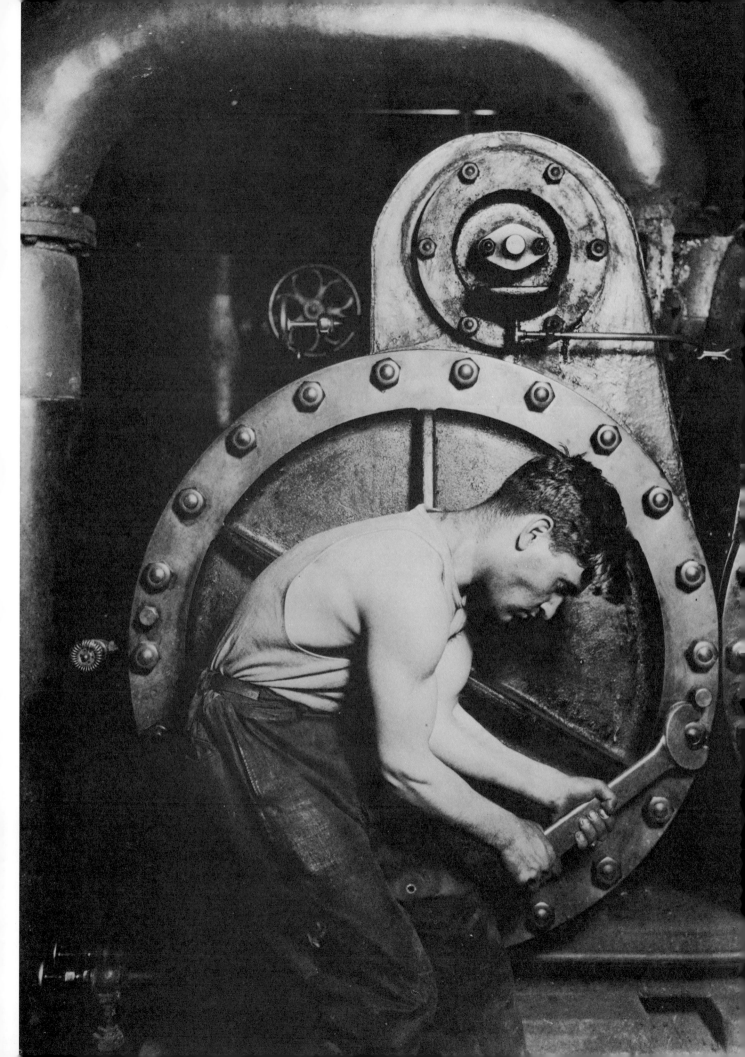

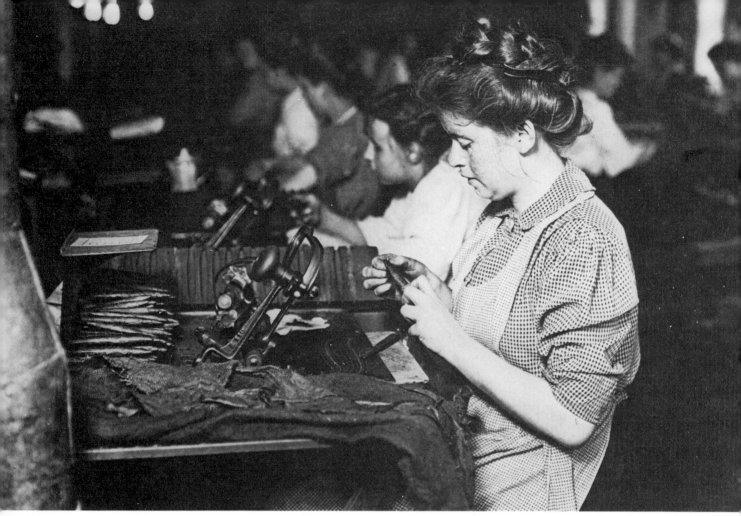

Lewis W. Hine. Cigar Factory, 1908. Collection Naomi and Walter Rosenblum

Lewis W. Hine. Mother with Nine Children, c. 1908. Collection Naomi and Walter Rosenblum

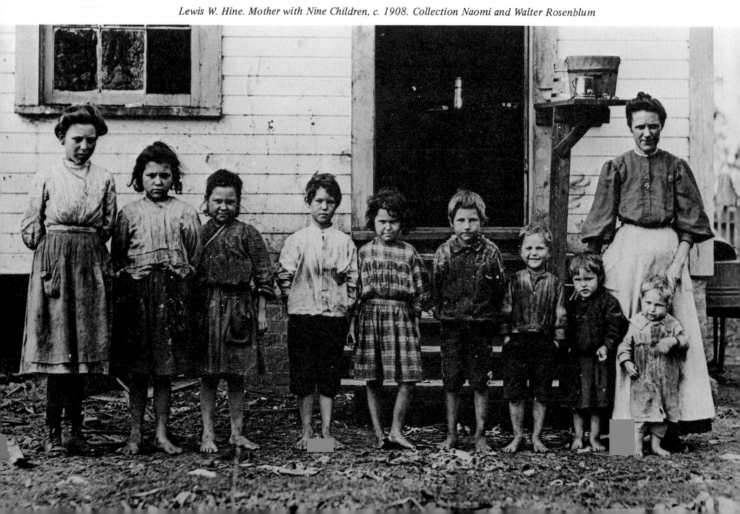

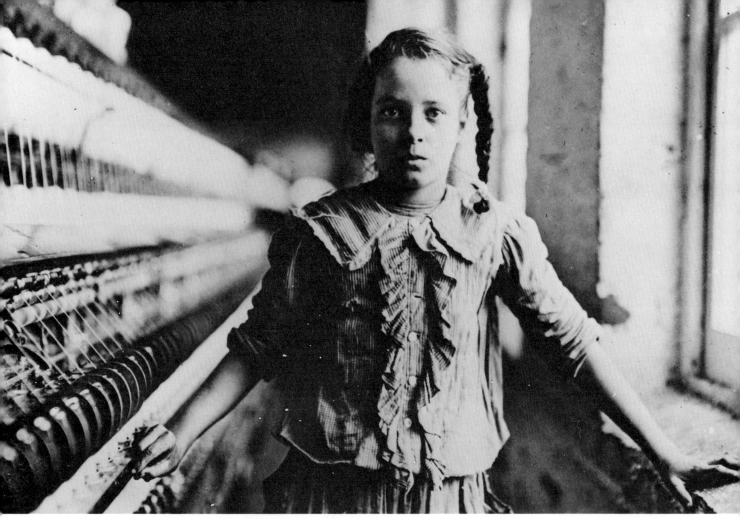

Lewis W. Hine. Sadie Feifer, 1908. An undernourished "poor white", 48"tall, one of the many young workers in a cotton mill for half a year. Ten-year old spinner in a North Carolina cotton mill. Collection Naomi and Walter Rosenblum

Lewis W. Hine. Textile Workers, c. 1910. Collection Naomi and Walter Rosenblum

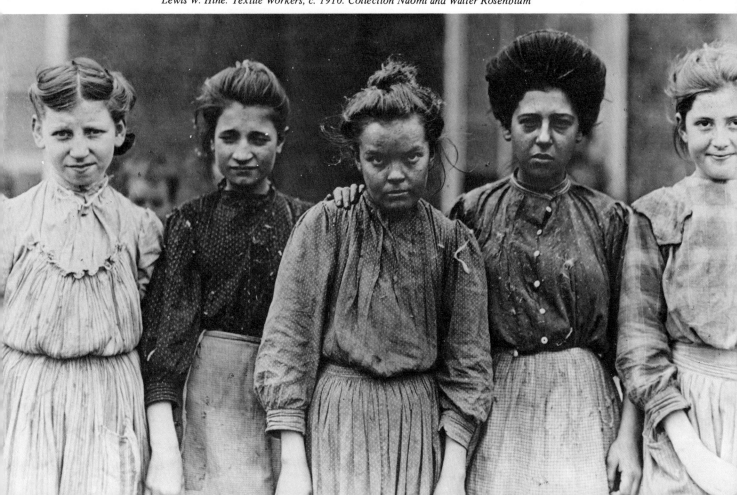

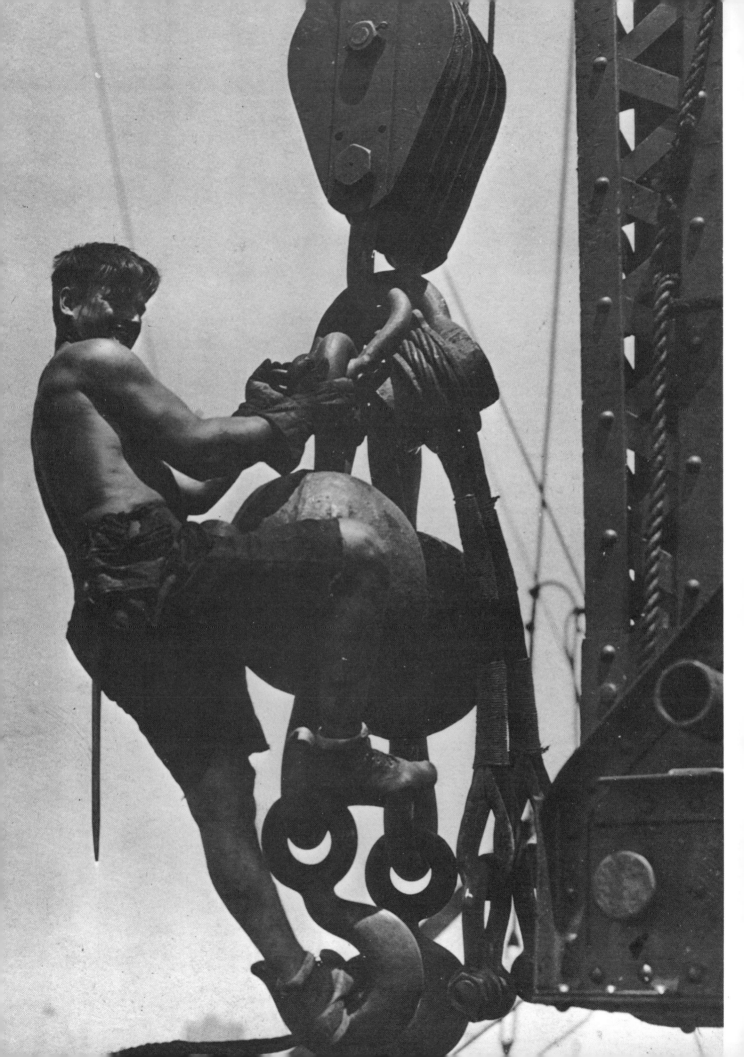

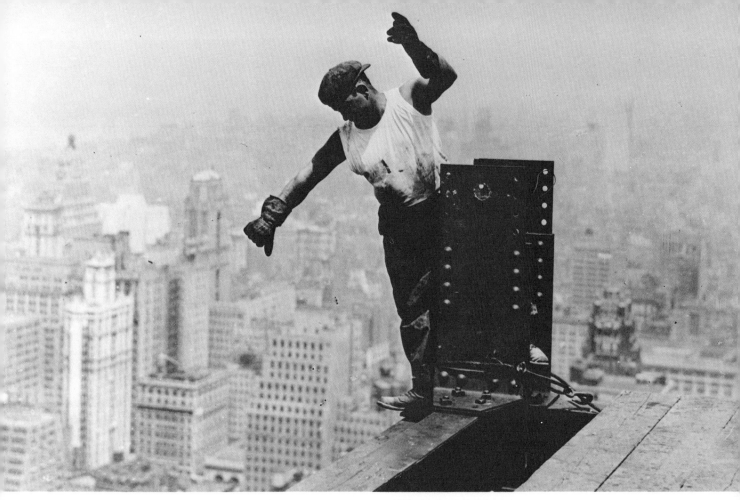

Lewis W. Hine. Empire State Building, 1931. Collection Naomi and Walter Rosenblum

Opposite: Lewis W. Hine. Another Connector Goes Aloft, 1931

Lewis W. Hine. Steelworkers at Russian Boarding House, Homestead, Pennsylvania, 1908. Collection Naomi and Walter Rosenblum

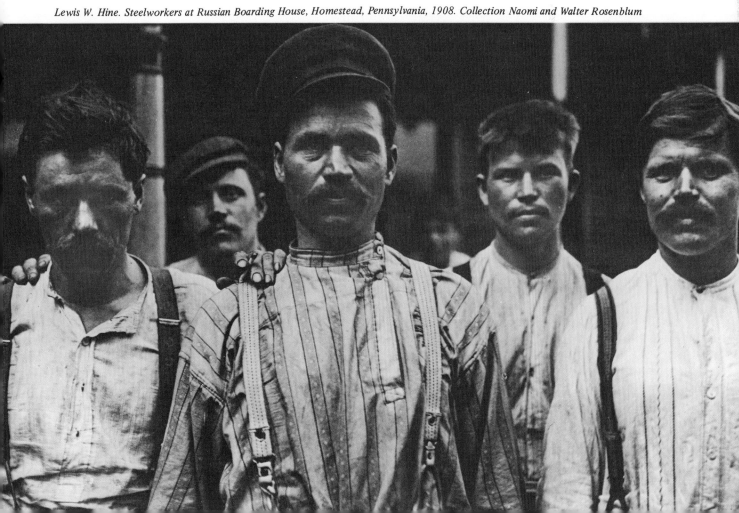

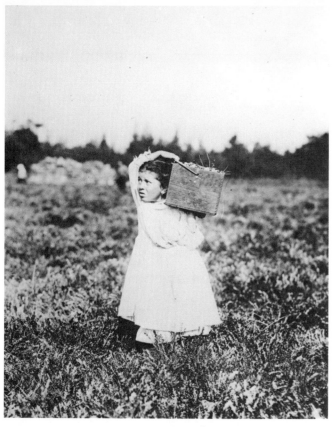

Lewis W. Hine. Cranberry Picker, Turkeytown, NJ, 1910

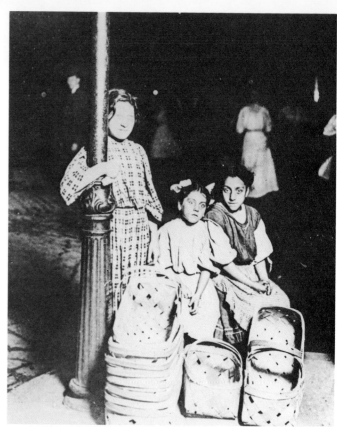

*Lewis W. Hine. Street Vendors – Italian Immigrants
Collection Naomi and Walter Rosenblum*

Opposite: Lewis W. Hine. Carrying homework. Italian immigrant woman carrying home materials for the entire family to process at starvation pay. Lower East Side, New York, 1910. Collection Naomi and Walter Rosenblum

Jacob Riis. Mountain Eagle, an Iroquois and his Family, 1890. Museum of The City of New York

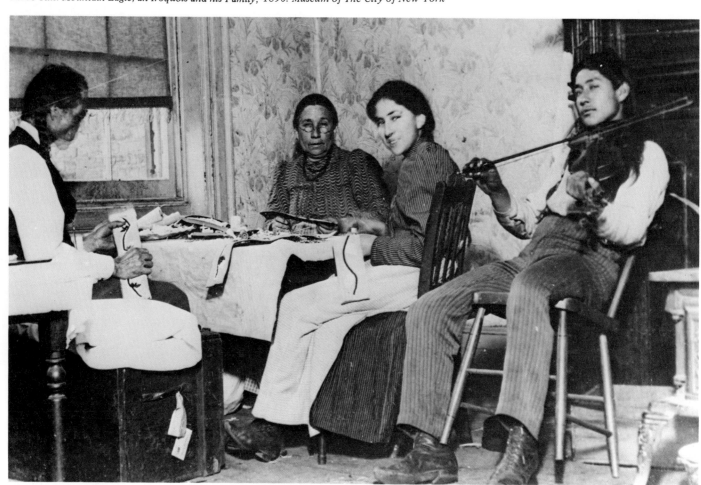

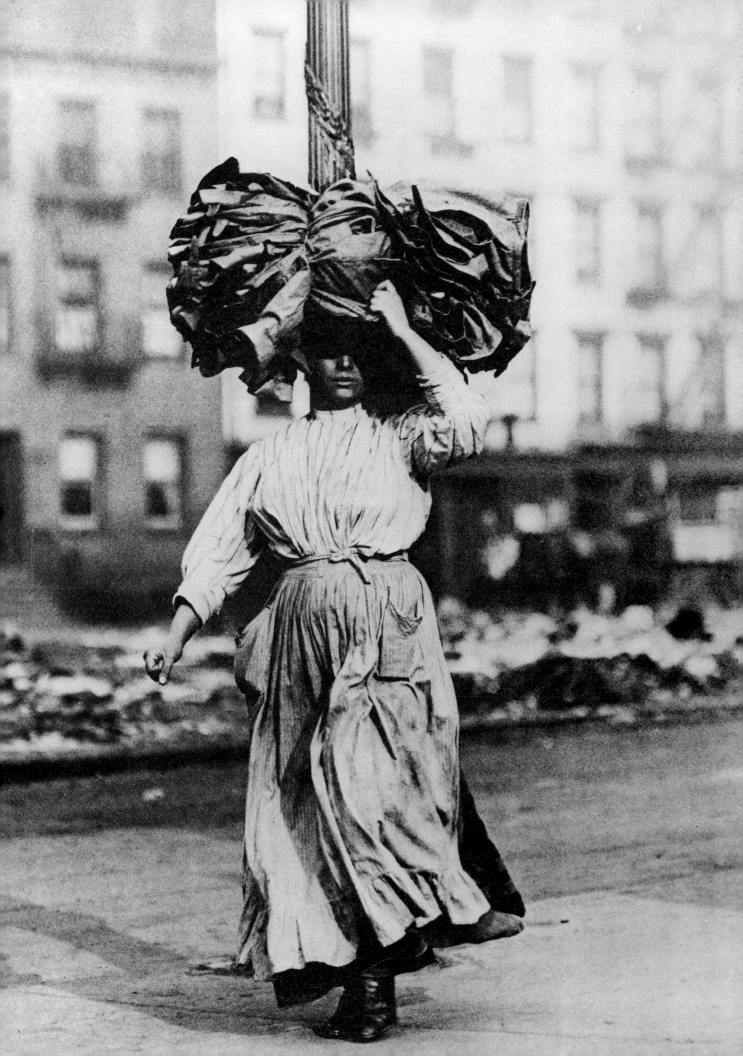

Lewis W. Hine. Engineer, 1921
"Forty years in the cab, and I've never killed anything, human or animal"
Collection Naomi and Walter Rosenblum

Lewis W. Hine. Cowboy of the Yards, 1921
Freight Brakeman, New York Central Railroad
Collection Naomi and Walter Rosenblum

Opposite: Otto Hagel
Tom Mooney, 1936
Sentenced to death in a 1917 frame-up trial following a bomb explosion at a San Francisco pro-war Preparedness Parade, Mooney was only released from prison in 1937, and died a few months later

Jack Delano. Sheet Metal Worker

Ben Shahn. Lottie, Pulaski County, Arkansas, 1935

Arthur Rothstein. Women Canning

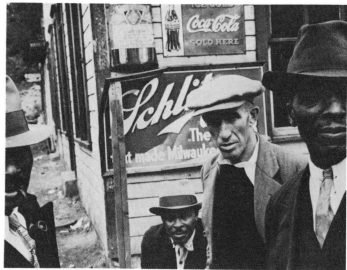

Ben Shahn. Sunday, Scott's Run, West Virginia, 1935

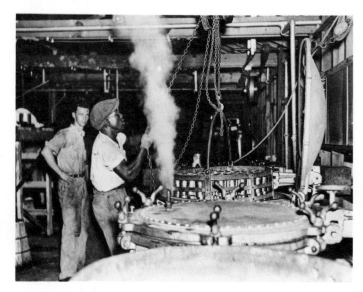

Arthur Rothstein. Boy Canning
All photos: FSA Collection, Library of Congress

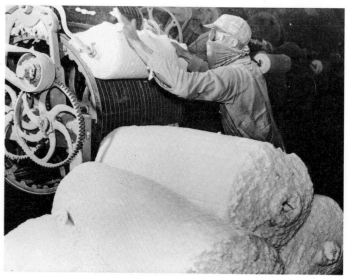

Marion Post Walcott. Cotton

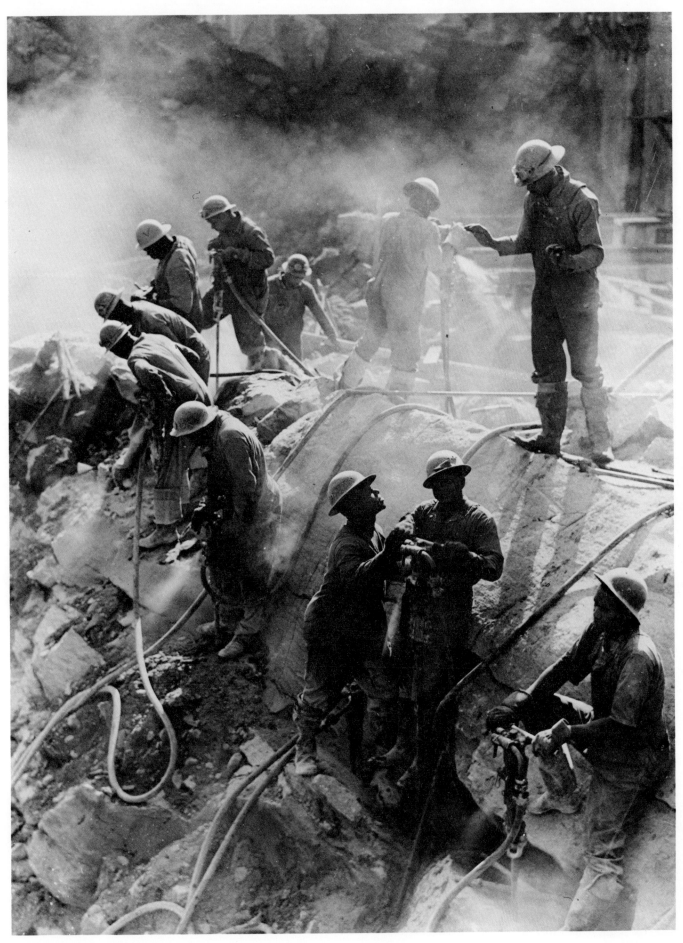

Jack Delano. Drillers. Library of Congress

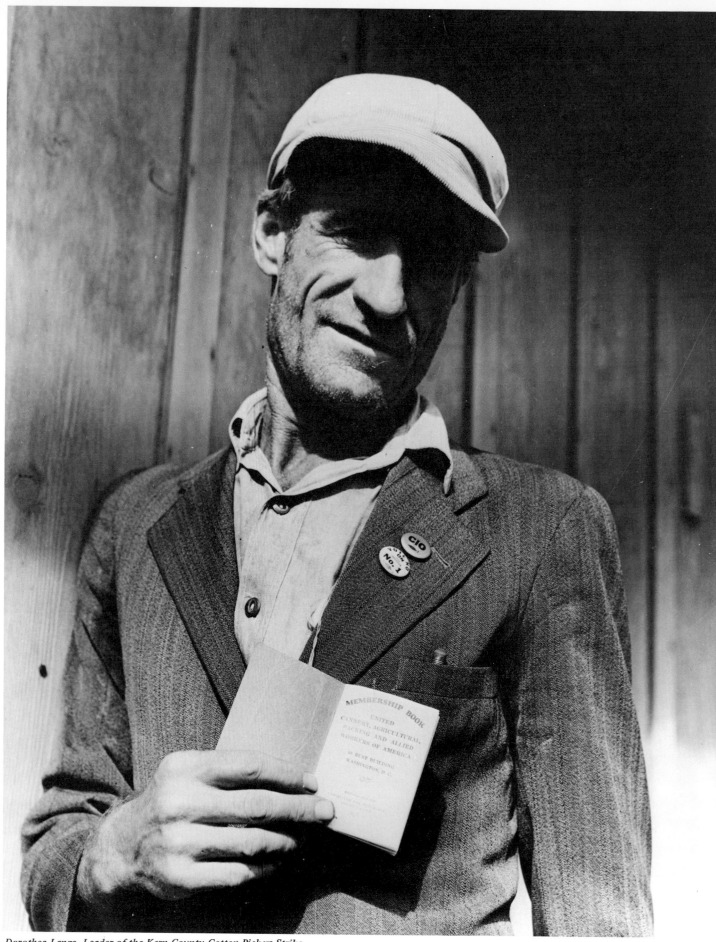

Dorothea Lange. Leader of the Kern County Cotton Pickers Strike in California, 1938

Opposite: Arthur Rothstein. Chicano Hauling Peppers. Library of Congress

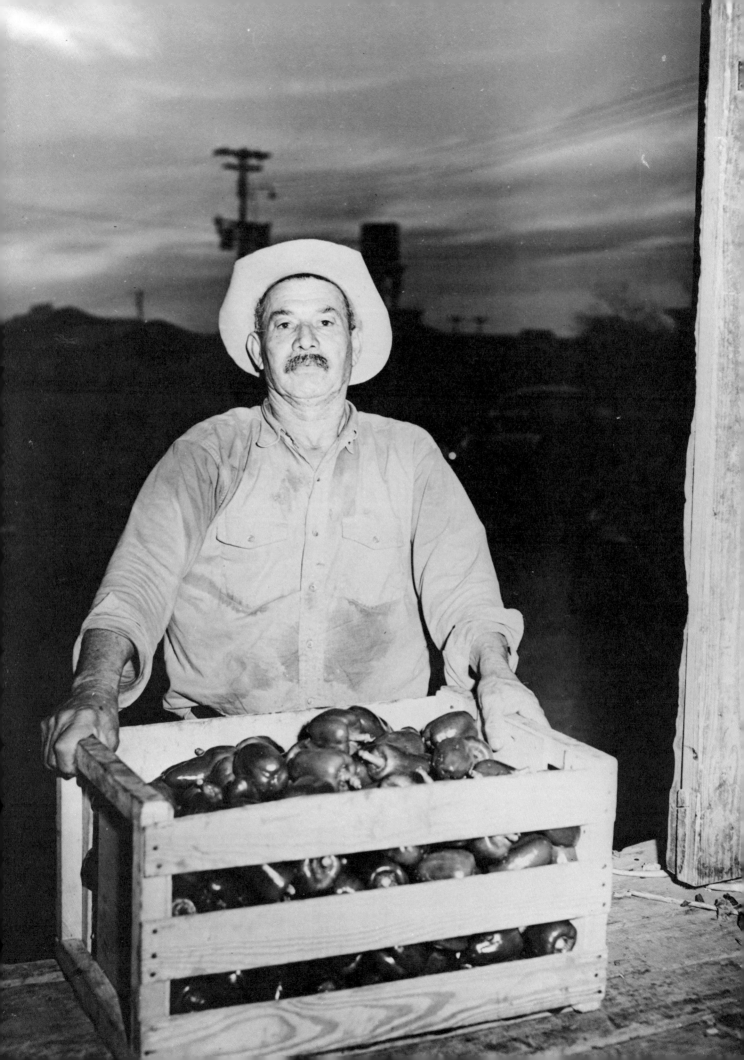

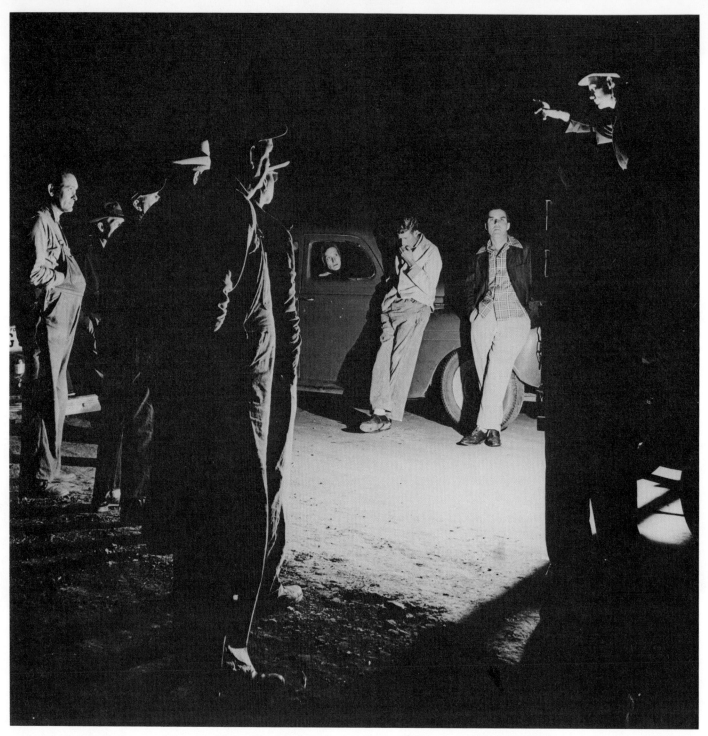

Hansel Mieth and Otto Hagel. Night Meeting, 1939. Striking cotton pickers at the cross-roads, San Joaquin Valley, California

Opposite: Hansel Mieth and Otto Hagel. Unemployed Meeting, North Platte, Nebraska, 1938

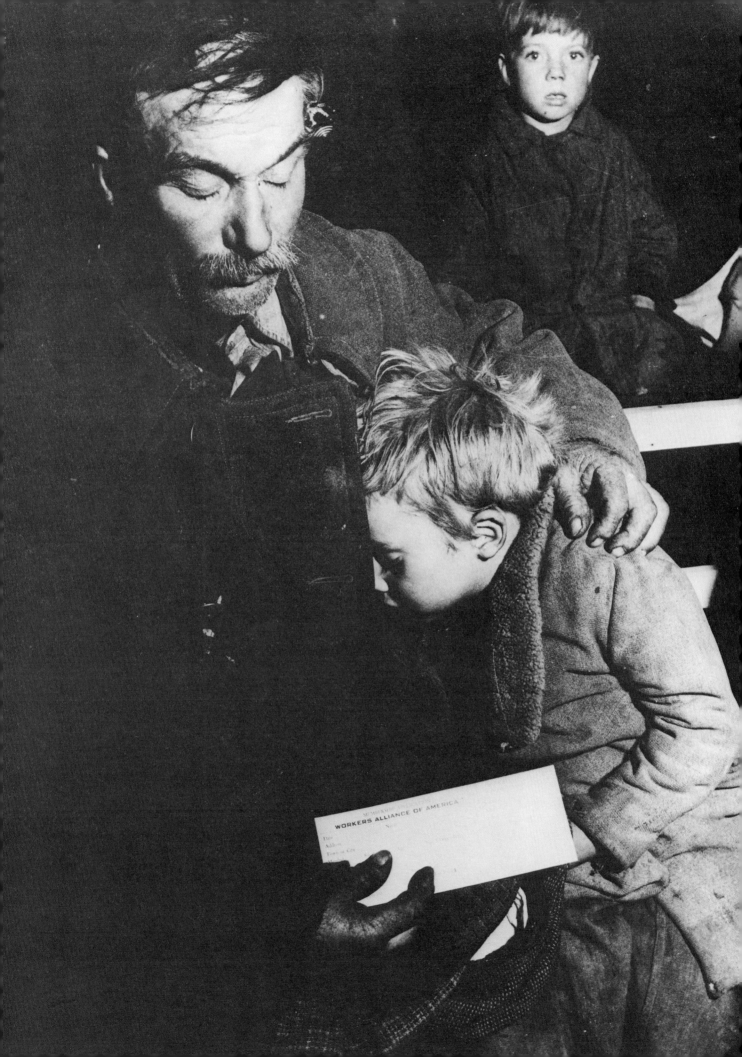

Ann Rosener. Dockworker. Library of Congress

word to explain contexts and provide interpretations. Nevertheless, despite the lack of programmatic direction, these images made Americans everywhere conscious again of the human factor in the industrial scene.

The photographs made under the aegis of the Farm Security Administration—a project initiated in 1935—were part of a purposive endeavor to use photographs in the furtherance of social and educational goals. Supervised for the Department of Agriculture by Roy E. Stryker, the F.S.A. photographic document drew its inspiration from the experiences of Progressive Era reformers—Hine in particular— and its strengths from a shared vision of what might be accomplished if the predicament of the nation's agricultural workers could be made poignant to more privileged Americans. Sent to southern, mid-western and Pacific states, photographers compiled a record which imbued fact with an added dimension of compassion. Between 1935 and 1942, 11 photographers took some 80,000 images of agricultural workers, their families, homes, lands, recreational activities, with the objective of encompassing their hopes and disillusionments. Images in which no individuals appear, among them interiors of poverty-stricken shacks in the south by Walker Evans, or eroded flat-lands pierced by untraveled roads, by Dorothea Lange, are as important a part of the story as views of tenant farmers, migrant pickers, packinghouse and tobacco workers and day laborers by Jack Delano, Lange, Russell Lee, Marion Post Wolcott, Arthur Rothstein and Ben Shahn. Historically, Rothstein's photograph of a farmer and his two sons caught in a blinding dust storm have come to symbolize the natural forces which provoked the national disaster, while Lange's image of the destitute wife and children of an itinerant pea picker at a migrant camp in Nipomo, California, summed up the human dimensions of the Depression. However, the effectiveness of the FSA documentations resulted from the widespread reproduction of these and many other images in news media and books. More than just testimonies of fact, these works endowed nameless people and unknown places with capacity to move others, leading to heightened awareness and to action.

Margaret Bourke-White. Brakeman Spearville, Kansas 1941

Lewis W. Hine. Workers on the Empire State Building, 1931
Center: The Bolter
Bottom: Riveters on a Tower

129

Walker Evans. Kitchen-wall,
Farmworkers' Hovel in
Alabama, 1936
Library of Congress

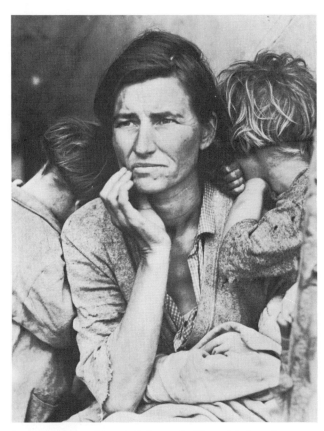

Dorothea Lange. Wife and Children of a Migrant Worker, Nipomo,
California (detail), 1936
Library of Congress

Unemployment and the effects of the Depression on urban and industrial areas also provided themes for photographers during the 1930s but the pictorial records were intermittant, poorly organized and much less effectively used. Local projects were sponsored by the Works Project Administration or undertaken by socially or politically committed individuals and organizations. While the WPA projects in New York and other cities amassed a large file of photographs, the images are unexceptional—records rather than revelations. Early in the 30s, the Workers' Film and Photo League, a leftist group of still and motion picture photographers, similar to organizations of politically committed photographers emerging in England, Germany and France, became active in a number of large American cities. Participants undertook to document on 16 mm film demonstrations by the unemployed in order to make the public aware of the depth and extent of the crisis. Historically important if visually unsophisticated, it is difficult to determine the extent and effectiveness of this footage.

In 1936, after the film section had broken away from the New York group and formed a production unit (Nykino, later Frontier Films) to deal with the rise of Fascism in Europe and anti-labor activities in the United States, the remaining still photographers reorganized themselves into the Photo League. Dedicated to the "profound and sober chronicling of the external world"—the words are those of art critic Elizabeth McCausland, one of the League's advisors—they broadened the concept of documentation in terms of craft and theme, maintaining that besides significant subjects, formal resolution was a necessary aspect of photographic expression. Rather than making records only of the political activities of the unemployed, League photographers called for an extensive portrayal of all aspects of life in New York's working class neighborhoods. The projects which emerged from this reorientation were called Feature Groups; they included the Harlem Document, on which Morris Engel, Jack Manning and Aaron Siskind worked, the Chelsea Document by Sid Grossman and Sol Libsohn, the Pitt Street Document photographed by Walter Rosenblum and images of Coney Island—the working people's playground—by Sid Grossman and Lou Bernstein.

Dorothea Lange. Mills, New Mexico, 1935

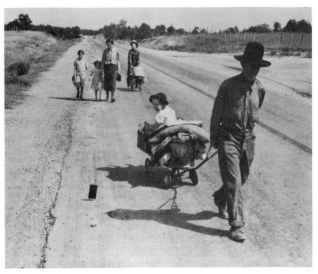

Dorothea Lange. Family from Idabel on the Road to Krebs, Oklahoma, 1939

Jack Delano. Mr. and Mrs. Andrew Lyman, Polish Tobacco Farmers, Winsor Locke, Connecticut, 1940

All Photos: FSA Collection, Library of Congress

Jack Delano. Mrs. Mary Willis, Widowed Tenant Farmer with Two Kids in Woodville, Greene County, Georgia, 1941

Russell Lee. Pecan Pickers in a Union Hall, Texas, 1939

Russell Lee. Tenant Farmers, Oklahoma, 1940

Marion Post Wolcott. Hanging Muskrats

All Photos: FSA Collection, Library of Congress

Arthur Rothstein. Picket at the Phillips Packing Company, 1937

Arthur Rothstein. Grapefruit Packers

Arthur Rothstein. Montana Cowboy

Arthur Rothstein. Police Evict Tenant Farmers, New Madrid County, Missouri, 1939

All photos: FSA Collection, Library of Congress

Arthur Rothstein. Gee's Bend, Alabama, 1937

John Vachon. Strike at King Farm, c. 1934, Library of Congress

John Collier. Assigning Workers, New Jersey, 1942. Library of Congress

Even though subjects encompassed street play, tenement interiors, subway scenes and relationships between families and friends, empathy with the working class was the common denominator. With few exceptions, League members active on these projects sought to arouse compassion for the deprived and to celebrate work and human dignity. Individuals who were not involved with the Feature Groups (which in any case were not as well organized or as productive as planned) also were motivated by similar ideas. Typified by Shoeworker's Lunch, Newark, New Jersey, by Bernard Cole, himself a former worker and union organizer in a shoe factory, such images expressed the widely held trust in the capacity of the working class to surmount exploitation and inhumanity. Cole, a free-lance professional photographer and teacher until his death in 1982, continued to portray individual workers with dignity and grace whenever the opportunity presented itself.

Often critical of exploitive working conditions during the late 30s, photographs by League members became more positive after the United States entered the Second World War, an approach which accorded with changes in the national ethos. In response to the realignment of forces in Europe and to the menace of fascism, progressive photographers joined with the nation as a whole in creating an assessment of work and working class existence which was considerably less class-conscious in orientation. For example, by 1942 when Native Land, a Frontier Films production directed by photographer Paul Strand and based on the virulent anti-union activities of large corporations, was released, its message had become somewhat of an embarrassment—no longer considered urgent in view of mounting employment and the need for increased industrial production for the war.

In the decade following American entry in the War, opportunities to photograph industrial workers increased greatly. Picture magazines, notably the recently launched Life and Look and the more established Fortune, provided outlets for picture essays celebrating industrial production. Such are the images of Andreas Feininger who, soon after his arrival from Europe, began a project for the Office of War Information on war industries. Later, as staff photographer for Life between 1943 and 1962, he specialized in industrial coverage. Enthralled by the forms and scale of machinery and manufacturing plants, he produced images of mining, hydroelectric operations, oil, steel and coal production in which the inanimate machines and their products often seem more alive than the expressionless workers.

Even before the start of the war, however, a new sensibility had permeated magazine photography. The first issue of Life in 1936, featured a story by Margaret Bourke-White which portrayed the work force, engaged in the construction of the Fort Peck Dam, in both recreational and job related activities. This shift in emphasis—from mechanism to humanism—signified a personal realization by Bourke-White that the technology which she and others had worshipped had proved inadequate to prevent an economic and social catastrophe. But after the start of the war, editors and photographers recognized also that images of machinery alone would be insufficient inducement to the increased production made necessary by the conflict. In addition, the influx of women into heavy industry and the movement of black and white families from the rural South to in-

Magazine of the German Workers' Photo League October 1929

Covers of Filmfront (Workers' Film and Photo League) and Photo Notes (Photo League)

dustrial centers in the North and West precipitated profound social transformations which neither magazine editors nor photojournalists could avoid treating in word and image.

For example, five million women entered the American work force between 1941 and 1944, with more than one quarter of a million working in heavy industry—traditionally a male preserve. The domestic problems, tensions and camaraderie resulting from this momentous change are suggested in Dorothea Lange's 1942 series of photographs made at the Richmond, California ship construction yards. Her sensitive eye caught not only the new mix of male and female, Black and white, old and young, as they streamed into and from the workplace, but the interpersonal dramas and tensions which the unprecedented work situation provoked.

The number of women employed dropped after the war from 36 to 29 percent and then rose in the 70s to 39 percent of the work force. While stereotypical ideas of what constitutes women's work had been shaken during the war years, most women's jobs still are concentrated in the low-paying dead-end range of work. Photographer Betty Medsger's effort to show the variety of jobs which women do hold and to suggest that a woman "should be able to choose

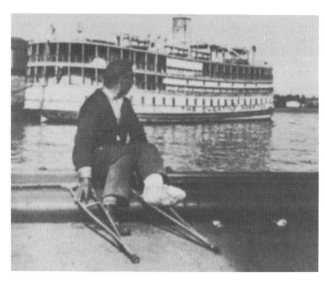

Hospital Ship, East River Dock, New York, 1932

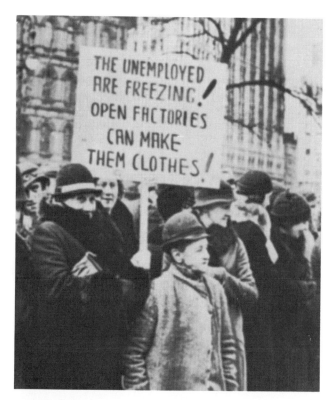

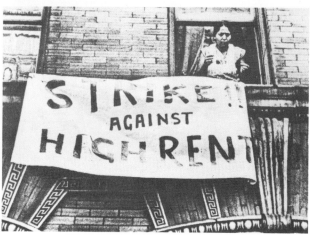

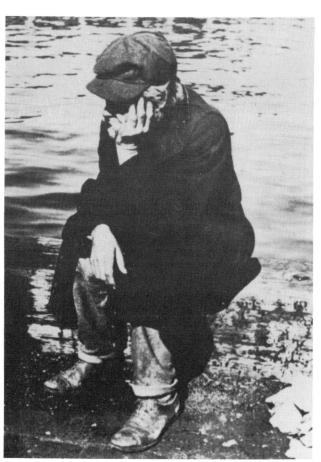

Center left: Unemployed Women demonstrating at New York City Hall, 1932
Bottom left: Rent Strike, Upper East Side, New York, 1933
Bottom right: Unemployed, East River Dock, New York, 1932

All photos by Leo Seltzer, member of the Workers' Film and Photo League

136

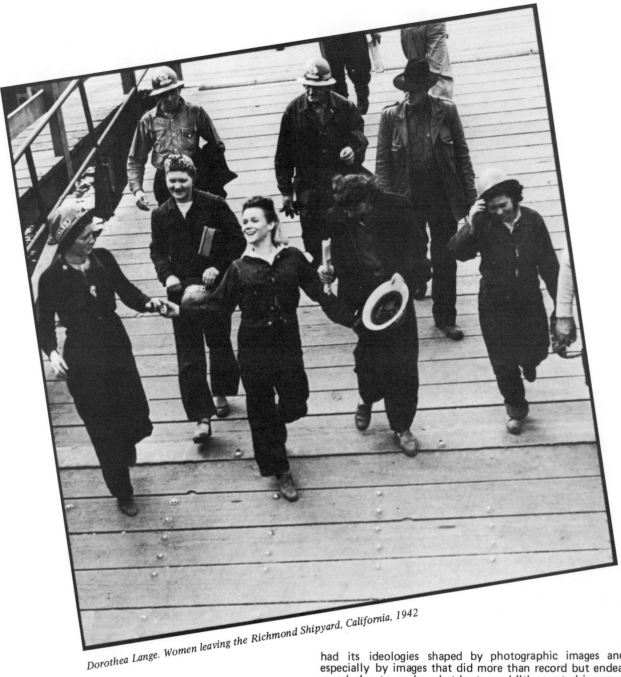

Dorothea Lange. Women leaving the Richmond Shipyard, California, 1942

work that she simply likes and is capable of doing" resulted in a book of photographs entitled, Women at Work. This compendium of images of women doing every imaginable kind of job, from blacksmithing to lobster fishing to mining, takes its cue from Hine's 1930 celebration of labor, Men at Work. While most of the images are reportorial, several portrayals hint at troublesome social problems, among them the isolation suffered by women who insist on competing with men for the relatively few well-paid but difficult jobs such as those in mining.

Active photojournalists of the 1950s whose assignments often led to images of work and workers included Fenno Jacobs, Wayne Miller, Carl Mydans, Homer Page, George Silk and Dan Weiner. The last named, a former Photo League activist, worked on a free-lance basis for Colliers, Life and Fortune, reporting on Apartheid in South Africa, life in the Eastern-bloc nations of Europe, the rising militancy of the Civil Rights movement in the United States and the operations of large American industrial enterprises. Weiner realized that his was the first generation to have

had its ideologies shaped by photographic images and especially by images that did more than record but endeavored also to probe what he termed "the central issues of our day". Nevertheless, he could not escape the subtle effects of photographing for publications whose position on social and economic issues reflected the attitudes and commitments of the business community. While his images focus on the "human element", portraying work as exciting and sociable, they avoid the issues which were emerging at the time as "central"—the boredom, lack of safety measures, absence of worker input into manufacturing operations, to name only a few.

An interesting comparison with the generally bland, industry-oriented portrayal of working people is offered by the images of Pittsburgh taken by W. Eugene Smith on assignment for the picture agency, Magnum, in 1955. Fascinated by this quintessential industrial center, with its enormous steel mills, metal working factories and nearby mines, Smith extended his study beyond the limitations of the project—an illustrated history of the city being compiled by former Munich Illustrated editor, Stefan Lorant. During two years of work (financed by himself and a grant from the Guggenheim Foundation) he selected some 2,000 photographs as a portrait of this commun-

Newsweek
THE MAGAZINE OF NEWS SIGNIFICANCE

FEBRUARY 16, 1942

10c

Glamor in Overalls: War Work Draws Women

Steelworker in a War Plant
Collection Ellen Kaiper

Collection Ellen Kaiper

ity. Though only a portion are concerned with work and working people, Smith's essay remains the most compelling photographic evocation of American working-class life in mid-century. Views of mills and working-class neighborhoods in East Pittsburgh and Homestead make the dismal surroundings and polluted atmosphere palpable. Through lighting, angle and choice of background, the sense of what it means to work in heavy industry—the boredom, dangers, meticulous attention, the noise, heat, effort and exhaustion—have become manifest. Individualistic to the core and romantic by nature, Smith endowed his images of the American worker with tragic dimension—an element missing from other depictions of the time.

Besides picture magazines, public-relations specialists also played a role in subsidizing images of .labor during this period. Called upon by large corporations, in part to counteract unsavory reputations based on the evidence of anti-labor activities which had been brought to light in the late 30s, public relations firms devised photographic projects to convince employees and the public of the paternalistic aims of major corporations. The same interests that promoted the concept of the Family of Man, a world renowned exhibition of pictures stressing global unity, sought to minimize domestic antagonism between labor and industry. The most prominent project of this nature, underwritten by Standard Oil of New Jersey, was modeled on the F.S.A. and indeed employed its former Director, Roy E. Stryker. Despite the participation of many fine photographers, among them Esther Bubley, Harold Corsini, Sol Libsohn and Edwin Rosskam—all former Photo League members—as well as former F.S.A. participant John Vachon and Life photographer Gordon Parks, the large body of photographs—some 8,000 in all—reveals greater interest

Some of the more than 2,000 women welders at the Calship Shipyard during the launching of the S.S. Philip C. Shera No. 300 People's World Archive, Berkeley, CA

138

Boots for the War
People's World Archive
Berkeley, CA

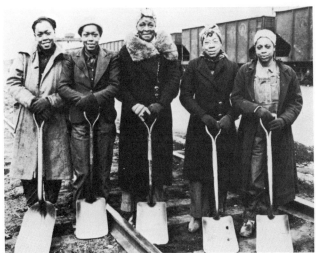

Trackwomen on the Baltimore & Ohio, 1943

Dorothea Lange. Billboard, 1942, Oakland Museum

Somebody is crossing a phone-strike picketline in New York
Newsweek, May 12, 1947

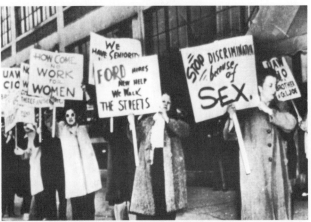

Women Workers demonstrating against the Ford Co., Detroit, 1946
Collection Ellen Kaiper

Linda Miller, Heavy Equipment Operator at the Alamitos Generating Station, Long Beach, California, 1974

Anita Cherry Leaves the Mine after a Night's Work, Virgie, Kentucky, 1974

Cynthia Bates, Cement Mason in Washington, D.C., 1974

Above photos: Betty Medsger

Jenny Cirone, Lobsterwoman, South Addison, Maine, 1974

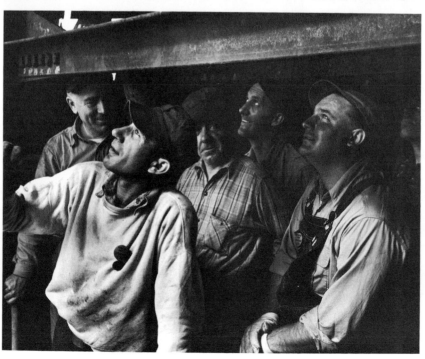

Dan Weiner. Launching of the USS Constitution, 1953

in the shapes and patterns of industrial formations than in the feelings and conditions of working people. A later project, sponsored by the Jones and Laughlin Steel Company and also directed by Stryker, who had moved on from Standard Oil, endeavored to portray the relationship of worker and machine in the manner of Hine's work portraits of an earlier era. Clyde Hare and Ivan Massar photographed all aspects of steel production: their images, with the exception of some fine close-ups, point up the alienation between worker and process which was becoming prevalent in technologically advanced industries.

For a number of reasons, the theme of labor did not inspire many of the well known photographers who were working on their own in the period following World War II. For one, opportunities to photograph in places of work were limited to those on assignment from magazines, unions and government agencies. Another factor was the sense of detachment among artists and intellectuals—an attitude which made a heroic view of any human activity unacceptable. On the whole, photographers either viewed post-war American culture, including working class life, as conformist and consumer-oriented or they were concerned with formal and conceptual attitudes about photography itself in which subject matter was either of symbolical significance or secondary to their aesthetic concerns.

W. Eugene Smith. Steel Production, Pittsburgh, Pennsylvania, 1955

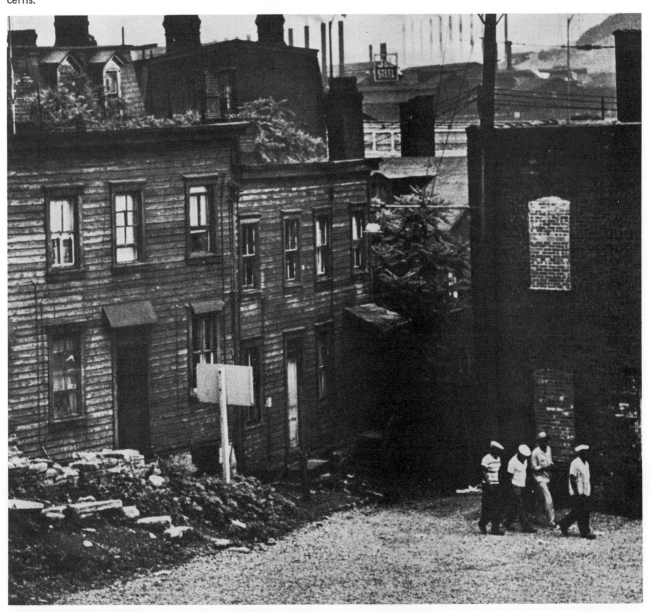

W. Eugene Smith. Working Class Neighborhood, Pittsburgh, Pennsylvania, 1955

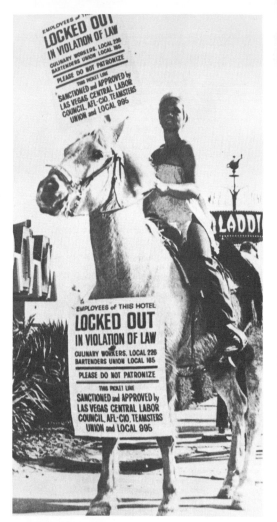

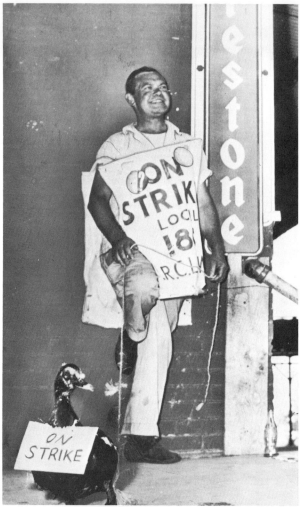

Top: Fox. Culinary Workers, Local 226 and Bartenders Union Local 165 on strike in Las Vegas, c. 1960
Bottom: Riding the Picket Line, St. Louis, Missouri, 1955
Strike of 14 employees of the Holiday Drive-In Theater for union recognition
Both photos: AFL-CIO Archive

Top: Two Strikers. Tom, Muscovy duck, helps his master, a member of CIO Rubber Workers on strike at Firestone warehouse in Memphis CIO News, May 10, 1954
Bottom: Dan Miller. Pickets at the Debutante Fur Co., New York, 1967
Local 1-FLM Archive

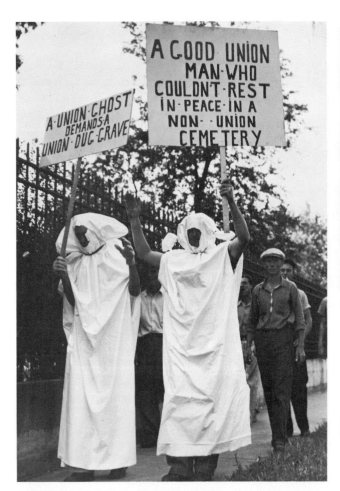

Cemetery Workers' Picket Line, Detroit, 1940

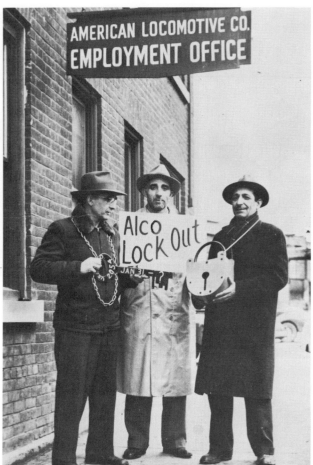

Alco Lock Out, Schenectady, New York, 1951. Members of the United Steelworkers Union demonstrating against the American Locomotive Co.

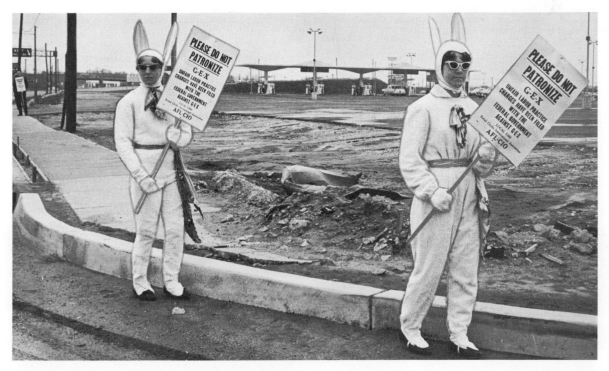

Bob Noble. Pickets, Retail Clerks Local 1360, Pennsauken, New Jersey, 1962

Left: Arthur Lavine. Center: Gjon Mili. Right: Henri Leighton. Family of Man Exhibition created by Edward Steichen for the Museum of Modern Art, 1955

Clyde Hare & Ivan Massar. Steelworker at Bessemer Converter, Pittsburgh, Pennsylvania, 1955

The sardonic detachment of Robert Frank, whose irreverent images of American life were published in 1959 as The Americans heralded one facet of the new sensibility. The working people pictured by Frank on his photographic odyssey across the United States are mainly service personnel—waitresses, attendants, drivers—who seem disconsolate and disconnected, at odds with themselves and their surroundings. One of the few images of this series which transcends a sense of life's inconsequentiality is the portrait of a pensive Black working woman in South Carolina—a nursemaid holding an incredibly doll-like white infant in symbiotic embrace. Following in these footsteps, Bruce Davidson and Danny Lyon, photographers of the "social landscape" as it came to be called, translated Frank's detached view into individual visions which were at once less witty and at times more impassioned. While workers at work seldom appear in these images, their recreational activities, the struggle for civil rights and the character of their personal and social existence—all aspects of working class-life—were depicted.

Influenced by stylistic ideas centering around the intrinsic photographic character of the snapshot, the treatment of social themes tends to be less iconic and idealistic than earlier social documents. Nevertheless, Lyon's commitment to basic humanist values can be sensed in Conversations With The Dead, a photographic study of prison life in Texas which includes labor on state-owned farms and roads. Davidson, who photographed in the homes of Hispanic-American working people, published in 1970 as East 100th Street, went on to portray subway-riders—including working people—in color.

From the boycott of segregated buses in Selma, Alabama in 1955 to the recent campaigns in the 80s to insure the employment of Afro-Americans on construction projects, jobs and civil rights have been seen as indivisible aspects of the same struggle. Led by the Reverend Martin Luther King until his assassination in 1968, and by the Student Non-Violent Co-ordinating Committee, Southern and Eastern workers were mobilized around issues of jobs, unionization and the right to vote, while in the West, Cesar Chavez was the catalytic force around which California agricultural workers rallied. The emblematic events of these campaigns—The March for Jobs and Freedom, which took place in the nation's capital in 1963, the Selma to Montgomery March of 1965 and the Farmworkers March from Delano to Sacramento in 1966—were photographed by a number of photographers including besides Davidson and Lyon, John A. Kouns, a free-lance photographer whose work appeared in Life, Newsweek and Time.

Exhileration and deeply felt aspiration, the exponential qualities of this experience, are mirrored in the expres-

sion of a woman with closed eyes and in the face of a singer clasping the hands of participants at the Washington event. Two images of Chavez, taken 11 years apart, provide a testimony of accomplishment. In one, he is seen on the final day of a 25-day fast in 1968, physically weakened but surrounded by strong supporters (among them family and union members and Robert Kennedy) all of whom, during a period of set-backs, share a determination to continue the campaign to organize the large numbers of Mexican-Americans who work in the nation's agri-business. In the other, made in 1979, Chavez is shown speaking with the force and authority of a successful leader of unionized workers. A fine image of a striding nun, bearing the standard of the Farm Workers Union with its strike motto "Huelga" symbolizes the resolve of a wide sector of the population that this organizing drive should succeed.

Mirrors and Windows, an exhibition organized by the Museum of Modern Art in 1978 to sum up the main currents in American photography in the two previous decades, included only two photographs of working Americans. One, by Lyon, was a poetic image of convict laborers. The other, by Jerome Liebling, was one of a series taken in a slaughterhouse in Minneapolis. Liebling, a former Photo League member, who has continued to show concern for ordinary people, imbued these workers with an unusual dimension—that of accessory in the butchering of animals, an occupation ordinarily viewed as unspeakably repulsive. Neither cowed nor heroic, the blood-bespattered men seem to share a melancholy sense of the inevitability of this kind of work. Liebling also has photographed migrant

Ester Bubley. Workmen Adjusting Casing Centralizers, Hobbs, New Mexico, c. 1944
Standard Oil Collection, University of Louisville, KY

Robert Frank. Nurse with Baby, South Carolina, 1959

Edwin Rosskam. Charles P. Wright, Mate of the Steamer Sam Craig on the Ohio River near Pittsburgh, 1945

John Vachon. Laying Track for the Construction of the Brooklyn-Battery Tunnel, New York, 1947

Gordon Parks. Thomas Owen Pouring Hot Pitch, Bayonne, N.J., 1945

farm pickers, and women working on the assembly lines of canning factories, their expressions suggestive not only of strength and competency but of an ineffable longing for more challenging experiences than can be found in modern food-processing plants.

Whether working on their own or with the support of trade unions and arts endowment grants, photographers who seek out working-class themes are motivated by several factors. Among them is the need, in a society increasingly dominated by electronic and print media, to establish a kinship with, in Ken Light's words, "the forgotten people, the real people who make real things." Another is the desire that photographs serve a useful purpose other than as purely visual artifacts, either by awakening workers' consciousness to their own worth or by providing evidence to convince the public and their legislators of the need for regulation of exploitive or unsafe conditions. The following section will deal with a number of young photographers who have chosen to photograph work and workers despite the fact that this theme has found relatively little support in museums and gallery exhibitions or in the critical literature of the period. As was true of a number of social documentarians of the past, this purposiveness is conjoined to a sense of the intrinsic potentials of the medium—the range of tonalities possible on negative and print, the incisive delineation of form in light, the capacity to focus on telling detail or capture fleeting expression.

With television supplanting picture magazines as the source of news for most Americans during the 1970s, the role of the photojournalist has eroded considerably. Institutional forms of support that have taken the place of picture journals are the trade unions and the government agencies which up until the present national administration were involved with regulating health and safety conditions in mines and factories. State and national arts endowments

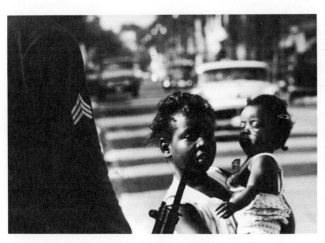

Fred Ward. The National Guard in Cambridge, 1963
The Guard was called out against demonstrators shortly after Medgar Evers, the leader of the Mississippi NAACP had been shot by a racist assassin

Top: John A. Kouns. Cesar Chavez After a 25-Day Fast for Nonviolence in Delano, California, 1968 (Left: Robert Kennedy)
Below: John A. Kouns. Cesar Chavez, President of the United Farm Workers of America, 1973

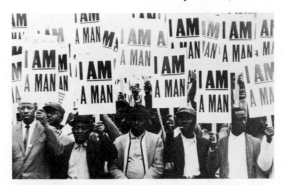

Del Ankers Photographers. Strike of the Municipal Employees under the Leadership of the American Federation of State County Municipal Employees, Memphis, Tennessee, 1968

147

Jerome Liebling
Top: Green Giant Co.—Le Seur Muire, 1953

Bottom: Packinghouse Worker, Minneapolis, Minnesota, 1962

also have aided photographers whose concern is with aspects of labor and the life of the working class.

Earl Dotter is a young photographer of laboring people who has turned to both trade unions and government agencies for support. Starting as a graphic designer, he soon found himself combining graphic and photographic means when, as a Vista Volunteer in 1972, he became involved in a campaign to promote democracy in the mines of West Virginia. The following year he became a full-time photographer for the United Mine Workers, a trade union then beset by the shrinking use of coal as fuel and by internal organizational problems. Working with miners for four years, Dotter became an accepted member of their communities, a rarity for outsiders and a situation which enabled him to move with ease from workplace to home. Like Hine, his credo is simple, involving a need to express his outrage at the unsafe and exploitive conditions under which miners and other workers are expected to live and work.

Made in the cramped and dark interiors of mines, many of Dotter's images contrast the dangers and discomforts of the occupation with the dignified mien of the miners. His images force the viewer to experience the work process emotionally and physically, as miners are shown crawling under a 30 inch high coal seam that makes standing impossible, or erecting temporary roof supports to contain the restless rock which, crumbling, might engulf them all in disaster. Indeed, the imminence of this fate seems written on every face, giving individual portraits a tragic cast.

In a photograph of a funeral following a mine disaster at the Scotia Mine in Letcher, Kentucky in 1976, entitled Her Husband Survived Vietnam But Not the Coal Mine, Dotter has fashioned a pure and certain evocation of the tragedy of needless death. Forming millions of cubic feet of explosive gas daily and never venting the mine adequately, the Scotia Mine Company virtually invited the explosion that in 1976 took 26 lives. Dotter's image shows the dead miner's wife embracing the American flag, a symbol not only of her husband's army service but of the gift of his life to national economic greed. The frieze of mourners hints at the community's concern for a family which now must sustain itself without a working father and husband.

Workers in both mines and cotton textile factories are victims of diseases directly related to conditions of work, a situation which Dotter has sought to vivify in his images for the governmental Occupational Health and Safety Agency. Factory noise levels which destroy hearing, unvented dust in mines and mills which cause black and brown lung diseases are major factors in the injuries suffered yearly by 435,000 or so individuals in these occupations. Dotter's portrait of a bed-ridden miner—a victim of black lung disease—gazing longingly at the light-filled foliated landscape beyond the dark prison of his pain is a poignant emblem of avertible tragedy. Though Dotter works in the tradition of photojournalism, where the exigencies of the moment might lead to superficial images of transient values, he has developed the capacity to sense the exact instant when form and expression combine to create a statement of lasting power. Beyond the importance of the subject itself is an aesthetic sensibility which makes the content expressive and significant.

Hal Mathewson. Installation of a Windowpane at 42nd Street and 3rd Avenue, New York, 1963

Miner on Strike for the Recognition of the UMWA, McCreary, Kentucky, 1976

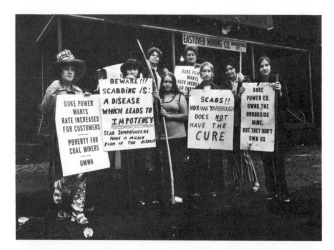

Miners' Wives Picketing at the Brookside Mine, Harlan County, Kentucky, 1973

Her Husband Survived Vietnam But Not the Coal Mine, Scotia Letcher County, Kentucky, 1976

All photos: Earl Dotter

Made on assignment for District 1199 of the National Union of Hospital and Health Care Workers, Georgeen Comerford's photographs were part of a program entitled Bread and Roses, devised by the union in 1979 to enable its members to participate in cultural programs at the work place and in union headquarters, and to bring hospital personnel greater awareness of their contributions to American society. Comerford, a teacher of photography and a resident of the South Bronx, had spent much of her free-time photographing in her immediate neighborhood which also is home to many of New York's hospital workers. Empathy with people, combined with a strong sense of visual organization and a poetic feeling for light informs her images which are carefully printed to take advantage of full tonal possibilities of photographic materials.

Americans whose knowledge of hospitals is gained either from personal visits or popular television serials have little idea of the extensive network required to run a modern health care establishment. In pursuing the project, Comerford spent a year visiting hospitals and nursing homes with the objective of encompassing the variety of occupations, numbering over 100 which comprise the work force of such facilities. Her visual document explores the kinds of work, the ethnic backgrounds, the attitudes of workers in unseen occupations as well as in the more visible ones of nursing and therapy.

Through the expressions and relationships portrayed, Comerford's photographs reflect the self-respect, pride, competence, warmth and essential humanity without which modern health care would be a travesty. Even in images showing the daunting trappings of modern technology, such as a mechanism which lowers a patient into a bath, the photographer has endeavored to capture the gentle touch of humanity. She also has evoked the loneliness of certain behind-the-scenes occupations. Surrounded and isolated by a never diminishing avalanche of linen, a hospital worker copes with this basic necessity which is taken for granted by patient, visitor and medical staff alike. In her essay, Comerford has turned cold statistics into feeling form, providing union members with a visual record of their achievements and larger audiences which a poignant documentation of aspects of labor which usually are ignored or taken for granted.

Paul Calhoun and Robert Glick are two young photographers working with historians at the Chinese-American Research Institute, an agency supported by public and private funds, which directs its attention to preserving on film and paper the economic and social contributions to American life of the Chinese-American community of New York. Photographing workers employed mainly in laundries and garment factories, often at substandard wages and in indecent conditions, these two photographers also reveal the isolation and social trauma caused by barriers of language and custom. A haunting disquietude pervades Calhoun's images of laundry workers—men whose tired lives are lived daily in the shadow of mountains of soiled linen. Glick's more bouyant images of the children and families of working class Chinese-Americans are imbued with a sharp sense of the drama occasioned by the conflict between old and new, East and West—a result of the intrusion of American popular culture into this formerly stable, if conservative, ethnic community.

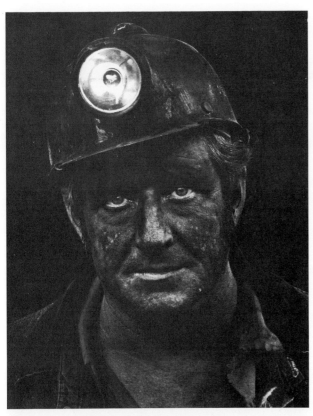

Coal Miner, Logan County, West Virginia, 1976

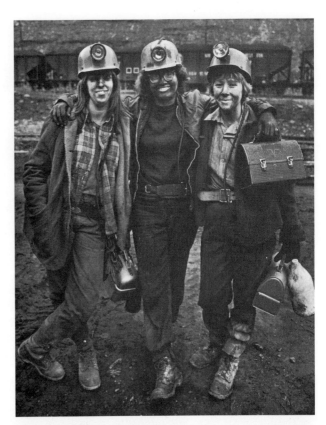

Women Coal Miners, Virginia, 1976

Bed-Ridden Black Lung Victim, Mingo County, West Virginia, 1976

All photos: Earl Dotter

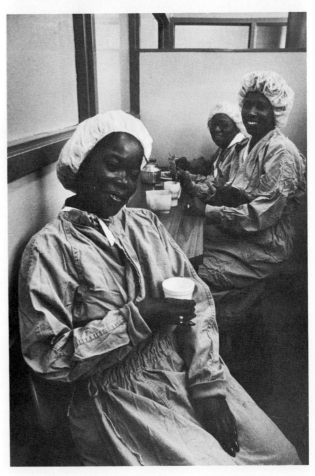

Workbreak in the Hospital, Brooklyn, New York, 1979

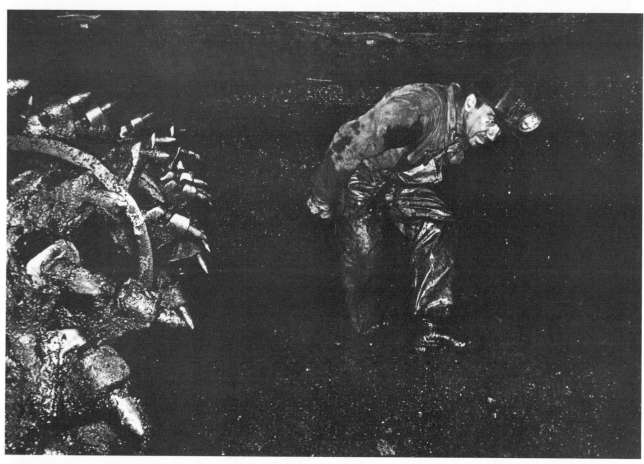

Earl Dotter. Miner and Machine, Clearfield County, Pennsylvania, 1976

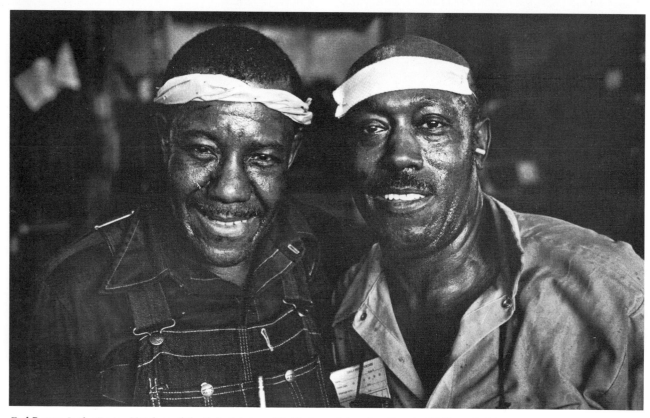

Earl Dotter. In the Forge—Members of the United Automobile Workers of America, Detroit, Michigan, 1979

Working class imagery on the West Coast often includes those engaged in agricultural labor. Ken Light is one of a group of West Coast photographers whose choice of subjects ranging from industrial workers to migrant farmers, are the result both of personal preference and assignment. On the basis of photographic documentations made in the early 70s, Light became one of 12 photographers hired in 1975 by the State Employment Development Department's CETA program to provide images for a project entitled Workers in California. Active also in film, he completed Working Steel in 1976; this depiction of a day in the life of a steel worker, made for the Labor Occupational Health Program, has been widely shown throughout the United States and in Europe.

Like Hine some forty years earlier, Light sees his industrial photographs, taken inside foundries, shoe factories, sheet metal works and printing establishments, as a way to make the public aware of the human spirit behind the machine. The contrast between work-place and worker's attitude, between a shabby and dispiriting ambience and individual dignity and pride is manifest in portraits and in close-ups of worker's hands. Intrigued as well by the intrinsic beauty of machine forms, Light's objective is to suggest, through a poetic use of light, that it is human energy and competence that created these objects as it makes available the abundance of industrial and consumer products which are considered the hallmark of advanced capitalist society.

In his image of migrant workers, Light again has followed a beacon illuminated by Hine. Photographing "men, women and young children laboring in the fields and orchards of Texas, Arizona, California, Washington, Ohio, New Jersey and North Carolina," he notes that he has "witnessed first-hand their poverty, their endurance and their struggle for survival." As with photographs of factory workers, his aim is to make Americans conscious of where their food comes from, of the undocumented workers of Mexico and Haiti, the refugees from the Far East, the migrant Americans from Puerto Rico, Florida and Texas, all of whom plant and harvest, their basic needs and children's education largely neglected, in order to sustain the most affluent nation on earth.

Roger Minick, Reesa Tansey and Richard Bermack are three West Coast photographers who are similarly motivated by the tradition of social documentation, but also are part of a movement that wishes to explore avenues of change as well as to celebrate individual strengths in confronting adversity. Minick's photographic project is centered on a single 300 acre farm which employs from 150 to 250 male laborers who plant and harvest two crops—tomatoes and strawberries—in an endless rotation of bending and stooping. Planting Strawberries, a depiction of a single worker, seen up-close against a frieze of distant figures, evokes a sense of the rhythms of agricultural work, the interdependence of the group, the individual endurance required and the lushness of the landscape. While as surely composed, other works, among them Buying Lunch From a Catering Truck, are more dependent on text materials to elucidate their specific meanings—in this case the exhorbitant prices field workers must pay for their own food while at work. This integration of word and pictorial images derives form the long tradition of social documentation. From Riis to Hine to the F.S.A., efforts to ameliorate conditions of work, housing and sanitation have depended on factual explanation combined with illuminating visual evidence, a conjunction of idea and feeling which Minick and social photographers in Europe as well as the United States have recognized as a valuable weapon for change.

Reesa Tansey, whose first brief experience with farm labor was as a recruit who hoped to earn some money while working outdoors, returned with a camera some three years later to document the monotonous round of work she had experienced. She also sought to explore options which might enable farm laborers to break out of the near peonage which migrant conditions impose. Therefore, she photographed Mexican-American families who worked the land not only as laborers but also as owners and managers of farming operations in a small agricultural co-operative. As Tansey describes her subjects, they are people who are "fighting a trend . . . who have emerged from the cycle of

Georgeen Comerford
Top: Taking Care of an Unconscious Patient, Beth-Israel-Nursing Home, New York, 1979
Bottom: Attendant, Operating Room, St. John's Hospital, New York, 1979

153

Mexican Workers on Their Way to the U.S., 1942 Library of Congress. Under the bracero agreement of 1942 large numbers of workers were brought into the country due to the pressing need for manpower

Worker Shot by Farmers during Strike in Pixley, California, 1933. Bancroft Library, Berkeley, CA

endlessly giving their labor to others, often to big business and industries so conspicuous in American agriculture." In seeking to capture the activities of men, women and children who are keeping alive what they feel to be their basic rights—to work their own land for themselves and their descendants—Tansey has focused on expressions and gestures which reveal the daily joys and sorrows that come with working the soil, or that evoke the pursuit of future dreams. Neither trite nor demeaning, images such as Assembling The Irrigation System, Cooperative Pajaro Valley, Watsonville, California, create a lyrical moment as she depicts an ordinary work scene bathed in the magic of ambient light.

Aspects of labor which appear in Richard Bermack's documentations are concerned with union organizing, strikes and civil liberties actions. Photographing the successful strike of a group of health insurance workers in Northern California—the culmination of an organizing drive lasting some twenty years—Bermack focused on the mainly women workers from ethnic minority groups who walked the picket-lines, participated in sit-ins and did the major organizational tasks. Another series by the same photographer, entitled Winter Soldiers—Portraits of Old Radicals, is projected as a publication which combines text and image to "honor men, women, radicals who stuck with the struggle through decades of triumph and depression, who endured and kept on fighting to build a more just world."

Hansel Mieth and Otto Hagel are two photographers from this older generation of radicals who have worked in California since the early Depression years. Newly arrived from Germany, they started out homeless, living in a tent and following the crops like so many others. With the little cash they could spare they bought film and documented the life and struggles of the farmworkers. After moving to San Francisco in 1934 they started to record the life of the unemployed and the longshoremen fortunate enough to have received a one-day work slip. When Hansel Mieth got on a WPA Project, she photographed the homeless, unemployed youths roaming the country.

Early in 1937 Life offered Hansel Mieth a job on their photographic staff. Otto Hagel preferred to work for the magazine as a free-lancer and both were sent to the Ford plant in Dearborn, Michigan after the successful sit-down strikes in the automobile industry had brought the recognition of the union.

Since the time they moved to San Francisco, Otto Hagel was closely associated with organized labor on the waterfront. His photos from the early struggles to organize the ports in the Bay Area were used to illustrate Men and Ships—A Pictorial of the Maritime Industry, published in 1937 by Council No. 2, Maritime Federation of the Pacific Coast under the leadership of Harry Bridges.

During the McCarthy period Hansel Mieth and Otto Hagel found that their photo-assignments from commercial magazines had completely dried up. They then started breeding chickens for a co-op near Petaluma which was not unlike other labor radicals who had lost their jobs due to constant harassment and settled in this part of northern California.

In 1965 Otto Hagel provided the photos for yet another labor pictorial, Men and Machines.

Summing up their lives in the U.S. Hansel Mieth shared these thoughts in 1982:

"Otto came to the U.S. in 1928 as a seventeen year old. He walked off the boat he had hired himself on. Was here illegally until 1940. I, Hansel, followed him in 1931, having to wait for my immigration papers. I was twenty by then. We were young, searching for an undefinable something—and we were broke. The meaning of life. What was the meaning of life? This question bothered us. We had left a bankrupt Germany. We were homeless in the U.S. People, people—their motivations—their ways in this land. Somehow, back in Germany we had become interested in Jack London's writings. We went to his 'Beauty Ranch' to see what we could see. We became friends with Charmian, the widow of Jack—a strange person. We kept on searching and we got our knocks . . .

I joined the photographic staff of Life and went to N.Y. Otto preferred to free-lance, but also came to N.Y. We always lived together. In 1940, after I got my citizen's papers, we married. Otto left the country to enter legally, President Roosevelt helped him to re-enter. He wanted him to do a campaign poster.

With the start of the war we moved back to California. Eventually I quit Life, and we both free-lanced.

Otto died of a stroke, suddenly, in 1973. I keep on living on the land, in Sonoma County, trying to make a go of it by photography and farming."

One of the great professional photographers in the Bay Area is Jerry Stoll—a man of many talents. In 1955 he founded the Bay Area Photographers organization, wrote screenplays and authored with David Castro a Profile of Art in Revolution, a prospectus for the establishment of non-profit media organizations, as well as the History of the American Women's Movement, commissioned and published by the National Organization for Women as a report to the International Women's Year Conference in Mexico City.

The films he produced, directed or photographed include: The Pentagon Papers & the American Revolution and Sons & Daughters.

(The above text was added by Reinhard Schultz.)

While support from labor organizations, magazines and government agencies has made it possible for a number of photographers to pursue their concern for American working class life, other individuals have had to finance such projects completely on their own, subsidizing their interest from incomes earned at other occupations. Milton Rogovin, an established optometrist in Buffalo, New York, now retired, has, with his wife, spent summers between 1962 and 1971 photographing coal mining communities in West Virginia and Kentucky. In 1972, he began a pictorial study of a six-square block area of his native city—an area that was home to Hispanic and Afro-Americans. Native Americans and other ethnic groups—hoping to document the transition of people who usually pass unnoticed from ethnic insularity to a role in the American working class.

Taking this idea one step further, Rogovin obtained permission to photograph in automobile and steel fabrication factories, portraying workers whose jobs ordinarily are considered rough and demeaning. Establishing close rapport with his subjects, he was invited by them to photograph in their homes as well. These "icons of humanity," as Robert M. Doty, Director of the Currier Gallery called them in an introduction to Rogovin's exhibition, consist of paired images—one, a portrait of a frontally posed worker surrounded by the artifacts of occupation, the other, a single or family group portrait taken in the personal environment. Designed to be seen in conjunction with each other, Rogovin means these images to suggest the wider dimensions and dichotomies of working class life.

Workers, a portfolio published in 1974 by Louis Stettner, displays a similar ideological attitude towards working people although all the images were made in places of work. Stettner, an established photographer and critic as well as a former Photo League member, sustained his project with a small grant from the Creative Arts Program of New York. Photographing workers on assembly lines of automobile and textile plants, at mining and construction sites, he emphasizes a quality of inner grace and decorum. In capturing the animation sparked by working with others or the intense concentration needed to perform critical tasks, these images are more nuanced than Rogovin's iconic works.

A number of younger photographers also have been impelled to capture the quality and character of working-class life even though their efforts have not been supported by outside agencies. Builder Levy, a young New York teacher, has subsidized his own excursions to the mining communities of Appalachia in order to lend his support to the struggle by miners for more equitable conditions of work and living. An outsider who at first was looked on with suspicion, Levy has endeavored to go beyond journalistic reportage of the strikes and work conditions which he confronted on

his several visits to the region. His goal has been to recreate the texture of life in mining communities, to suggest the blighting presence of coal tipples and chemical works which dominate the isolated towns and the play areas of the young.

Levy's portraits reveal the courage of miners and their families who sustain existence in bleak mining towns but the photographer also is sensitive to the pride in indigenous history, represented by a display of mining artifacts in a local inn, and the desire, for embellishment seen in the small collections of decorative objects in miners' homes. A photograph of coal camp near Grundy, West Virginia is descriptive of an environment—a few frame houses straggling along a running creek—but in addition, is a revelation of the strange and ethereal beauty of the countryside, an evocation, in a sense, of the special quality of life lived in these regions. Alongside his intense feelings for his subject, Levy displays an equal love of the craft of photography, producing prints of subtle yet forceful tonal scale which seem to have an inner spirit of their own.

Another young photographer who on his own chose to portray working people is Al Balinsky. While completing graduate level studies at Brooklyn College, he began to photograph in his family neighborhood—Coney Island, the traditional recreation and entertainment precinct for New York's laboring poor. In 1977, he took a position as as photography teacher in Milwaukee and became involved in a documentation of inner city, or ghetto, areas—a study which included the activities of a group of mechanics in a tire assembly plant. His portraits of workers whose jobs are among the least skilled and lowest paid, capture the rough energy and abundant force expended on unrewarding work which takes place in an atmosphere of grimy disorder. In common with Dotter, Levy and Rogovin, Balinsky has been able to establish a relationship with workers which led to invitations to photograph in their homes and places of recreation and worship, enabling him to produce a sober if limited study of aspects of life among a small group of unskilled workers.

Within the last decade or so, several factors have transformed the situation for photographers of labor and working class activities. From the 1890s through the 1960s, camera images made in the context of activist campaigns depended largely on the printed page and their own replicative technologies to make their images and messages visible. The photographs of Riis, Hine and the F.S.A. group reached

Builder Levy. Coal Camp near Grundy, Virginia, 1970

receptive viewers through publication in news dailies, periodical journals, sociological tracts and poetic works as well as being shown at public meetings and exhibitions. After World War II, images of working people, while not focused in the same ideological direction, continued to appear in Life and Look, informing and touching the immediate post-war generation. Even when this visual material was not especially distinctive or did not advocate programatic activity, scenes involving workers, factory and living conditions, labor and civil rights confrontations evoked a reactive chord in a public not yet sated with photographic images.

Following the war, however, two developments began to affect socially motivated imagery. For one, cinema and video took over the task of critical documentation, using a powerful combination of realism and creative imagination to explain and vivify social issues, among them the conditions of labor and the working class. In addition, as print and electronic media vied for the attention of the public, the photograph, in monochrome and color, became an ubiquitous object, harnessed to extensive (and expensive) campaigns to sell products, ideas and attitudes and political candidates. Camera images appeared everywhere in great numbers—not only in daily papers and picture magazines, but on posters, billboards, car-cards and television screens, diminishing by their redundancy their power to inform, to move and to incite action on issues of significance.

Another factor which emerged in the post-war decades, has been the changing perception of labor and the role of the working class. Despite pockets of poverty which continued to exist in a number of industrial areas of the country (mining communities especially), the general economic well-being and compulsive consumerism which characterized American society for several decades (now being undermined by the national and world economic crisis) altered traditional attitudes about the vanguard role of the working class. What once had been perceived as essentially clear-cut distinctions between white and blue collar workers, between union labor and the unorganized, between social and individualistic notions of industrial production have

Garry A. Watson. Oversized Itch

become clouded over. Added to this incertitude are problems arising from the increasing numbers of women seeking equally paid work in industry, from the incapacity of ageing plants and outmoded technologies to sustain production and from the disposal of industrial and nuclear waste materials in the atmosphere and in the ground. And surmounting all is the threat posed by nuclear weaponry. How to encompass these complex issues, to vivify the real concerns of working people in freshly seen and persuasive images that both inform and inspire, and how to couple these works with provocative and effective campaigns is the challenge faced by today's photographers of labor and working class life.

Al Balinsky. Tirefitter for a Small Shop, Milwaukee, Wisconsin, 1978

Arbeiter-Illustrierte Zeitung. Vol. 7, No. 41, 1928
Arrest of textile workers in Bedford, Massachusetts, 1928
Werkbund-Archiv, Berlin

Labor Defender. June 1930
Monthly magazine of the International Labor Defense

Photo-History, Vol. 1, No. 2, 1937
Crowd in Aliquippa, Pennsylvania, celebrating victory over
Jones & Laughlin Steel Corp. after signing contract for pay
rise and 40-hour week

Friday. Vol. 2, No. 14, 1942
John L. Lewis, President of the United Mine Workers of
America

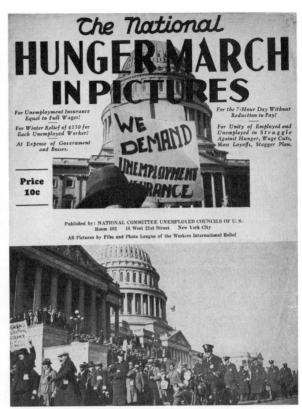

March of Labor. Vol. 4, No. 9, 1952
Monthly Magazine for the Active Trade Unionist
Arrest of George Scott at the International Harvester Twine
Mill, Chicago, after protest against relocation of the plant
to New Orleans

The National Hunger March in Pictures, published by National
Committee Unemployed Councils of U.S., New York, 1931

Steve Cagan. Youngstown Plant, 1980

Sandy Thacker. Women in Industry, 1982

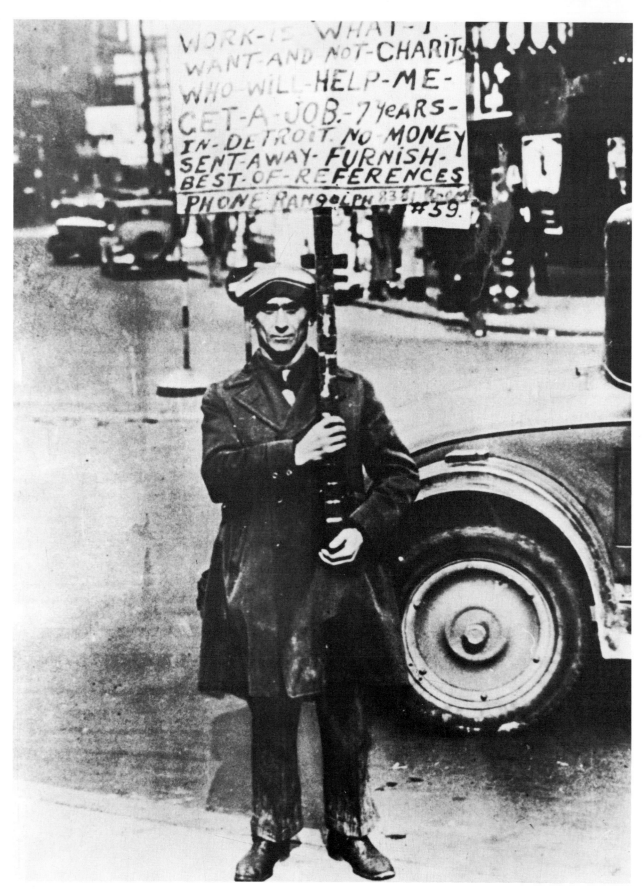

Unemployed in Detroit, c. 1930

Lonnie Wilson. Free Season on Photographers, Oakland, California, 1946. Scene from the general strike provoked by the police at Kahn's and Hastings Department Stores

John A. Kouns. March for Jobs and Freedom, Washington, D.C., 1963

Richard Bermack
Left: Strike Meeting—Carry On, 1977
Scene from the organizing drive at Blue Cross Health Insurance Co. The struggle for unionization was initiated by the Office and Professional Employees Union in 1969 and succeeded in 1978

Right: El Fantastico—Luchell McDaniels, c. 1980
He fought with the Abraham Lincoln Brigade in the Spanish Civil War where he earned his nickname. Hemingway wrote a short story about him. After the war he was an organizer for the Marine Cooks and Stewards Union

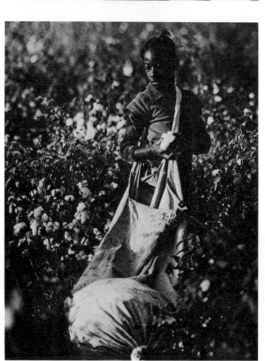

Left: Richard Bermack. Tom Scribner, c. 1980
At the age of 14 he joined the Industrial Workers of the World (Wobblies) as a lumberjack. Life long trade union organizer and political activist. There is a statue of Scribner playing the musical saw in Santa Cruz, California

Right: Earl Dotter. Cotton Picker (10 years old), 1970s

Left: John A. Kouns. Pilgrimage to Sacramento, 1966. The 25-day, 300-mile walk of farmworkers from Delano in protest against the reign of terror against their strike was supported by many Catholic priests and nuns

Right: Georgeen Comerford. Union Rally, Hospital Workers, District 1199 New York, 1979. Protest against the closing of hospitals

Dan Weiner. Trucking Story, 1954

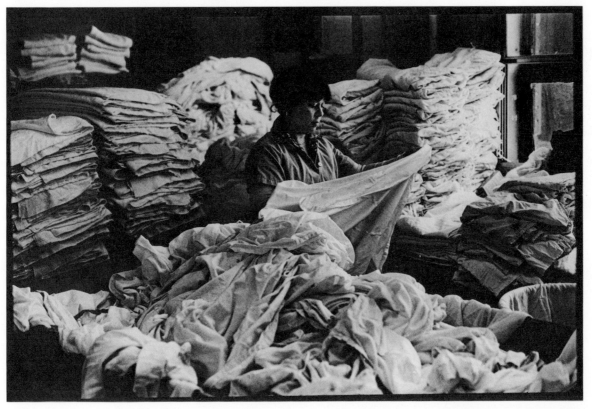

Georgeen Comerford. Laundry-Room Worker, Montefiore Hospital, New York, 1979

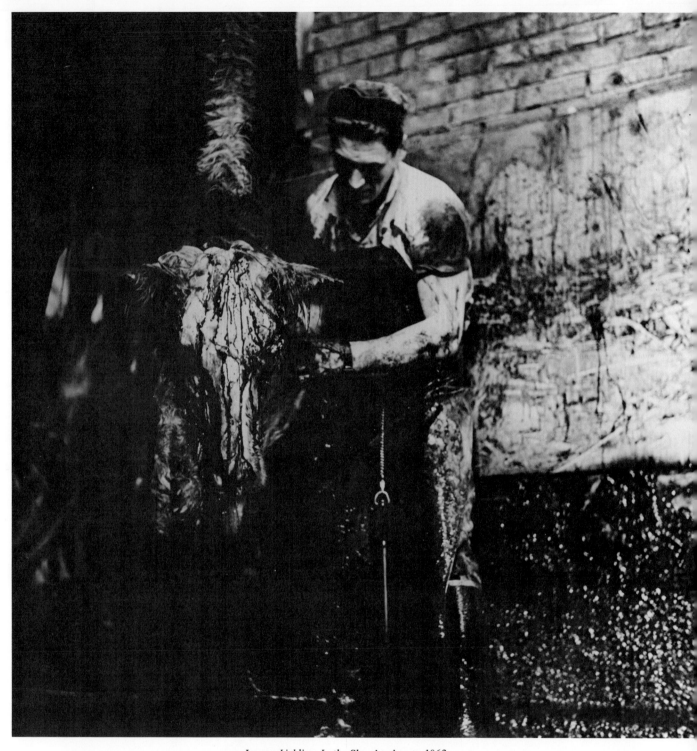

Jerome Liebling. In the Slaughterhouse, 1962

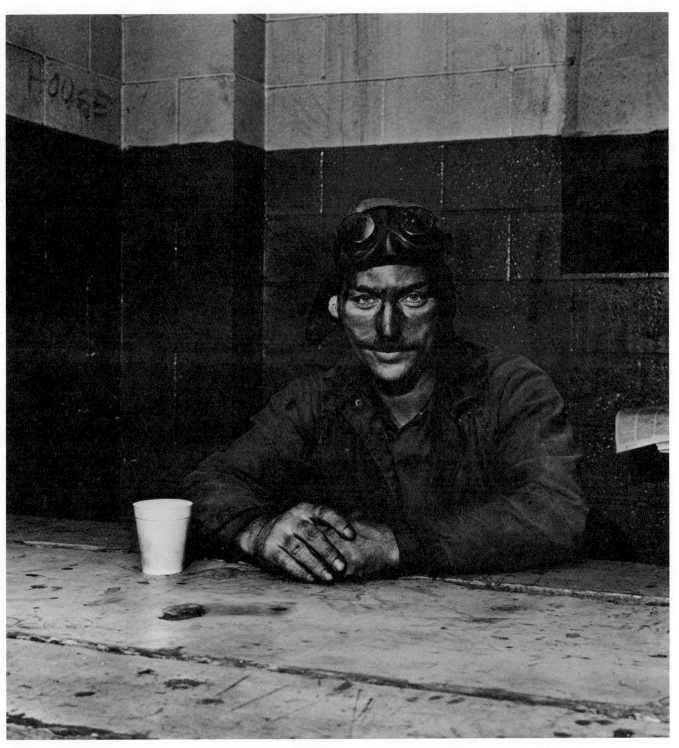

Milton Rogovin. Coffee Break, Buffalo, New York, 1979

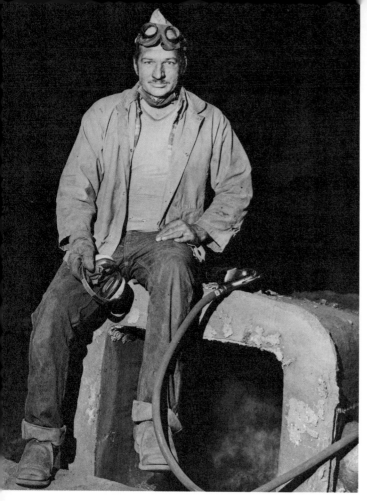

Milton Rogovin. Steelworker, Buffalo, New York, 1979

Milton Rogovin. Coal Miner, West Virginia, 1977

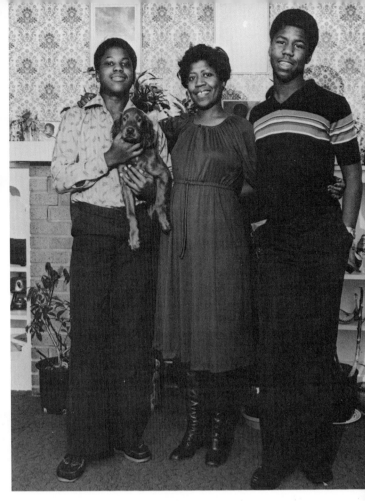

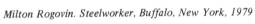

Milton Rogovin. Woman Working at the Republic Steel Plant, Buffalo, New York, 1979

Milton Rogovin. Steelworker, Buffalo, New York, 1979

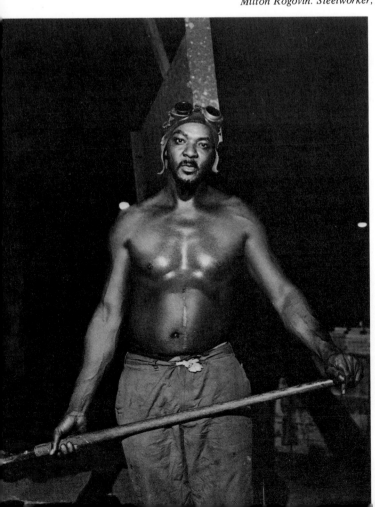

Sandy Thacker. Ironworker, 1982

Ken Light. Forge Worker's Hands, Oakland, California, 1977

Paul Calhoun. Freight Movers 1982

Paul Calhoun. Sun Wek Restaurant, 1982

169

Builder Levy. Red Robin Inn, Mingo County, West Virginia, 1971

Builder Levy. Men and Women Coal Miners at the Montego Lounge, Allen Junction, West Virginia, 1982

Earl Dotter. Coal Miner Testing the Roof Support Bolts, Clearfield County, Pennsylvania, 1976

Builder Levy. Brookside Women on Strike: Harlan County, Kentucky, Day after Thanksgiving, 1973

Frank Silva. Dockworker, 1981

Edmond Scola. Red Cap, 1980

The photos were taken by young dockworkers at the port of Richmond, California

Brian Nelson. Automated Container Terminal, 1979

Rick Hill. Native American Ironworker, 1982

Bernard Cole. Brickyard Worker, 1975

John A. Kouns. Cotton Farmer, Tulare County, California, 1961

John A. Kouns. Farmworkers' Strike, Delano, California, 1966

Ken Light. Child of the Fields, Rio Grande Valley, Texas, 1979

Reesa Tansey. Miss Susie Walker, Beat 4 Cooperative, Mashulaville Mississippi, 1981

Bernard Cole. Shoeworker's Lunch, Newark, New Jersey, 1944